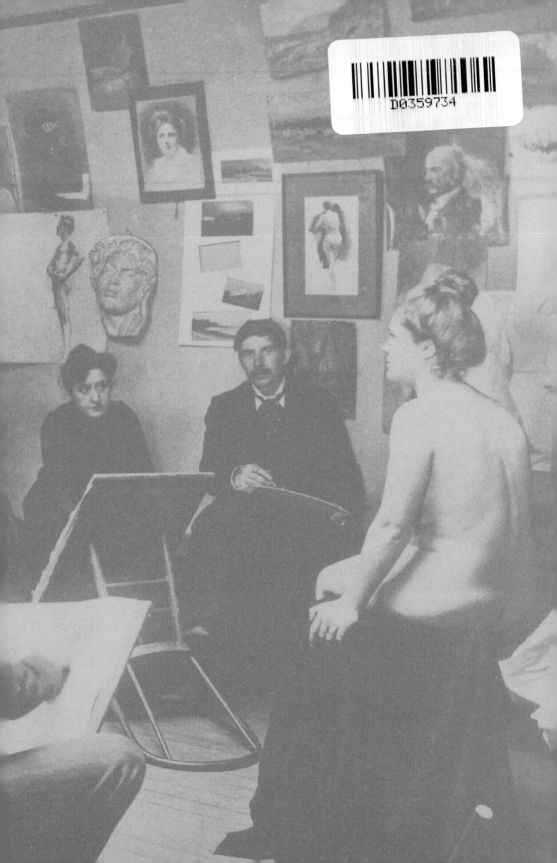

ARTFUL
PLAYERS

ARTFUL PLAYERS

ARTISTIC LIFE
IN EARLY SAN FRANCISCO

BIRGITTA HJALMARSON

BALCONY PRESS • LOS ANGELES

To Helga
(1910 – 1992)

CONTENTS

"It is an odd thing, but everyone who disappears is said to be seen in San Francisco. It must be a delightful city, and possess all the attractions of the next world."

OSCAR WILDE, *The Picture of Dorian Gray* (1891)

FOREWORD

William H. Gerdts

P robably no region in this country offers a more fascinating history of its artistic development than does 19th-century Northern California. In one sense, of course, it is part of America's "regional art history," in so far as the artists are affiliated, some primarily, some temporarily, with that region stretching from the Bay Area to Sacramento and the Monterey Peninsula. Many associated with Eastern artists, both in New York and Boston, as well as during their travels abroad, where they went both for training and for the cultural experience. Conversely, Eastern artists — probably the most notable was Albert Bierstadt — spent sufficient time in San Francisco that they may rightly be considered members of the art community there. Yet, San Francisco, along with its surrounding region, established its own traditions, initiated its own art organizations and art schools, launched its own periodicals, produced its own art critics, and enjoyed exceptionally supportive local patronage, to a degree unmatched by any other city or region of the period.

The history of the arts in pre-20th century San Francisco is quite well researched and published, thanks to the efforts and achievements of highly competent scholars such as Alfred Harrison, Harvey Jones, and others, who have traced the work of most of the major and a good many of the lesser painters and sculptors, comparing them and coordinating their

experiences with those of their Eastern counterparts. Birgitta Hjalmarson has taken a different, and equally intriguing approach, by integrating this community with the "larger picture" of San Francisco cultural and communal life. By adopting such a program, Hjalmarson has created a study as engaging to the general reader as it is to the scholar-specialist. One comes away after a very rewarding experience, with an understanding of the nature — one might say the unique nature — of artistic life in late 19th-century San Francisco, and I know of no other study which offers such a fascinating assessment of the art community and its place in the overall cultural picture. In reading this book, I'm drawn back to such studies as Oscar Lewis' *Bay Window Bohemia* of 1956, or even B. E. Lloyd's *Lights and Shades in San Francisco*, published over a hundred years ago, in 1876, though now, in Hjalmarson's volume, the focus is squarely upon the city's artistic culture. It's a tremendous achievement.

William H. Gerdts is Professor of Art History at the Graduate School of the City University of New York. Internationally known as a leading authority on American painting, he has written numerous books, including *Art Across America, American Impressionism, American Still-Life Painting, American Neoclassic Sculpture, The Great American Nude*, and *Painters of the Humble Truth*.

PREFACE

U p to the time of the Civil War, America had little use for art. More pressing matters took precedence: pushing west, farming the land, building a new country. Only a wealthy few took an interest in art, mainly in the genteel fields of history painting and portraiture. After the war, however, money flowed more freely, settlements became cities, leisure increased. Art exhibitions turned fashionable; on opening nights elegant carriages formed close lines along the curbs outside as the rooms filled with leading citizens in full evening dress. Before long, it seemed as if everyone were talking about "sentiment" and "broad effects." In a sense, affectation replaced indifference. Art was seen as vaguely mysterious, looked at askance, invited in but rarely made to feel at home. In short, it was the birth of the American art scene, much as we know it today. Some of us still have problems calling art by its first name. We tend to associate it with receptions and refreshments, perhaps with a glimpse of the artist in a doorway. Art is still not quite to be trusted — the emperor might well be naked after all.

No American city took up art quite like San Francisco. A new city on the western edge of the continent, San Francisco saw itself as second to none. It believed in progress; this was indeed the best of all possible cities, if not quite yet, at least in the future. Despite graft, corruption, riots, and

urban squalor, San Francisco still flew the banners of equality and liberty for all. Whitmanesque in its faith in the masses, it was Nietzschean in its cult of Superman, the strong loner, the misunderstood genius tortured by the pettiness of others. It was a city, some said, with too much oxygen in the air, the last stronghold of the American Dream, already in retreat back East. Called the insane asylum of the world, San Francisco kept believing in fresh starts and happy endings. Throughout the 19th century it remained the quintessential American city — ambitious, expansive, exploitative, and wasteful. It was a city to be admired, if for nothing else, for the sheer strength of its convictions, and for a well-nigh sublime confidence in its ability to handle its own affairs.

Thus the setting for *Artful Players*, a lively social history with focus on art. Drawn from original sources, some blatantly irreverent, it features high-handed patrons, shoddy dealers, sharp-tongued critics, cunning art thieves, and a fickle public. But the main characters are the artists themselves. Many studied in Europe, where they won medals and honors at the official academic exhibitions. They sketched at Barbizon, in the South Seas, and in the Orient. They gathered at the Munich beer halls, the Paris bistros, and the London coffee houses. In San Francisco, far from major European and East Coast art centers, they were free to stretch, experiment, even fail. Gertrude Atherton, for one, saw the city as full of "cleverness," rarely realized. But art was there too. In high-ceilinged studios — amidst the smell of turpentine and fixative, with dirty brushes in the washstands, floors piled with books by John Ruskin, Hippolyte Taine, Théophile Gautier, and the brothers Goncourt — the artists battled their private demons and posed the same questions artists always ask. At their best, they worked as if moved by an inner law, formulating answers that were most defiantly their own. Some are still "names." Others are forgotten, the victims of a change in taste. No longer, though, will they be understudies waiting in the wings: in this book they are back to claim the stage. They have been splendid company and I shall miss them.

ARTFUL
PLAYERS

Albert Bierstadt

THE TROUBLE WITH BIERSTADT

he stagecoach came tearing down the slopes of the Sierra. It was mid-July 1863, the summer of the Battle of Gettysburg. Among the passengers were two young New Yorkers, artist Albert Bierstadt and writer Fitz Hugh Ludlow. West of Salt Lake City Indians had killed the stage driver and one of the passengers. The arrow that had bored through the driver lay in Ludlow's trunk next to a copy of Charles Darwin's *Origin of Species*, published four years earlier. After the attack, soldiers boarded the coach to ensure safe passage. The rest of the journey, as recorded by Ludlow, remained grim. All that was left of one of the station houses was burning timber, the smell of roasted horse flesh, and the mutilated bodies of six white men. From then on, night and day, both soldiers and passengers traveled with rifles in their hands, the muzzles sticking out of the windows. Near Virginia City one of the passengers, a young man, lost his sanity and had to be kept in the coach by force. Ludlow and Bierstadt did not fare much better, "growing madder all the time through deprivation of sleep and frightful jolting." Now, two months after leaving New York, they finally approached San Francisco, thankful to be alive.[1]

The city that greeted them seemed untouched by the war. In 1849, with the discovery of gold, the world had converged on this lonely spot, in those days nothing but a Spanish-speaking outpost with a small mission church. Now the greatest boom town in American history, San Francisco was the financial and commercial center of the west, with some 115,000 inhabitants (most of whom were male), 12 daily newspapers, 6 ocean steamship lines, 444 hotels and boarding houses, 7 theaters and "places of amusement," and 1,231 dealers in liquor.[2]

Bracing winds carried the jangle of barrel organs, the clatter of different languages, and the pounding of pile drivers along the waterfront. Men of business raced down Montgomery Street at a hand-gallop. Coachmen yelled and cracked their whips, horses neighed and swerved and arched their necks. From dry goods boxes at the street corners, newsboys shouted the latest headlines. Chinese hurried by, their baskets of fish and pork suspended from poles balanced on their shoulders. Women in crinolines and bonnets lifted their skirts to avoid the splinters in the wooden sidewalks. Their less respectable sisters, in flashy Parisian gowns, drew stares from miners in high boots and red flannel shirts. Everyone made way for the Emperor Norton, who strode through the crowd in his navy blue coat, his hands folded behind his back, a wooden staff under his arm, and a fresh rosebud in his buttonhole. At one time he thought he had cornered the rice market but found he was wrong. From that moment on, he imagined himself the ruler of California and Mexico. All of San Francisco played along: newspapers printed his sweeping *pronunciamentos*, bank tellers cashed his worthless drafts, theater audiences stood up as he took his seat.

Fitz Hugh Ludlow was delighted. "It is the only New York out of New York that I ever saw," he wrote.[3] He ranked the city newspapers as having "no superiors at the East in the excellence of their technical makeup—and very few in the interest of their matter or the ability of their editorials."[4] *The Golden Era*, a literary weekly counting among its contributors Bret Harte, Mark Twain, and Charles Henry Webb, he called "an intriguing mix of California cleverness, Nevadian *naiveté*, and New York naughtiness."[5]

Their hotel, the Occidental, surpassed anything he had ever seen, "for elegance of appointments, attentiveness of servants or excellence of *cuisine*."[6] Montgomery Street, lined with "palatial structures," was more like New York "than any other grand thoroughfare on the Continent."[7] And only San Francisco — not Boston or Philadelphia — shared with New York that high-toned "Urban Nonchalance," that sophisticated "one's-own-business-minding," which "marks the traveled man of the world" and allows each man "to do exactly as he pleases within the limits of public safety."[8]

In one respect, though, San Francisco disappointed. "I do not find, thus far in California, the cultivation of taste or the love of art-products, to which the wealth of your citizens might so nobly minister." No doubt Ludlow had listened to complaints from local artists Enoch Wood Perry and Virgil Williams. Bierstadt had known them in Düsseldorf and Rome, where both "passed years of education and gained deserved praise." In San Francisco, to make a living at all, they found themselves reduced to portrait painting, "the business which occupies the lowest department of their art."[9]

By early August, accompanied by Perry and Williams, Bierstadt and Ludlow were on their way to Yosemite, a giant chasm of perpendicular granite walls located in the Sierra Nevada some two hundred miles east of San Francisco. The East Coast papers had carried Thomas Starr King's descriptions of the valley; Goupil's had exhibited Carleton Watkins' photographs. Yet nothing could quite prepare them for the moment they stepped onto the edge of a precipice and saw Yosemite spread out below them. In Ludlow's words, they "did not so much seem to be seeing from that crag of vision a new scene on the old familiar globe as a new heaven and a new earth into which the creative spirit had just been breathed."[10]

After a frightening descent—their horses and mules "had constantly to stop, lest their impetus should tumble them headlong"—they pitched their first camp in a meadow near the Merced River. During seven weeks in the valley, they moved camp several times. Otherwise their routine, as recalled by Ludlow, remained the same. They rose at dawn, bathed in the river, and

breakfasted on coffee and slapjacks. Shortly after sunrise the artists rode off with their color boxes balanced on their pommels. According to Ludlow, "they learned more and gained greater material for future triumphs than they had gotten in all their lives before at the feet of the greatest masters."[11] Bierstadt, rather more to the point, wrote in a letter to a friend: "We are now here in the garden of Eden I call it. The most magnificent place I was ever in, and I employ every moment painting from nature. We camp out altogether, get no news, and do not care for any, for we are perfectly happy with the fine scenery, trout, ducks, deer, etc."[12] (PLATE 1).

Late that fall Bierstadt and Ludlow were back in New York, opting to return by sea rather than by land. In the next few years, Bierstadt went on to enjoy a popular and financial success such as no other American artist before him. The public stood in line to see his paintings. His patrons were powerful men who saw their own visions and egos reflected in his grand, heroic views. Bierstadt, in turn, managed his affairs with "an unusual share of common sense, business shrewdness, and practical tact — qualities as valuable and praiseworthy in a painter or a writer as in a broker."[13] In 1866 he married Rosalie Ludlow, recently granted a divorce from Fitz Hugh, whose drug addiction would bring an early death. The newlyweds moved into Bierstadt's new villa on the Hudson River, named Malkasten after an artists' club in Düsseldorf. Described in rapturous terms by journals of the period, the house was three stories high and built of granite and wood. From the drawing room windows one could see West Point and New York. Mrs. Bierstadt's room was "exquisitely furnished" and filled with furbelows, bric-a-brac, and *objets d'art*, all that "one would expect the wife of a fine artist to possess and appreciate."[14]

Critically, however, Bierstadt came more and more under attack. His was a kind of hybrid aesthetic, precariously poised between the real and the ideal. On one hand, he took great pains to reproduce specific aspects of flora, fauna, and geology, working up his details in a tight, almost photographic manner. In this respect he was a realist, following John Ruskin's

advice in *Modern Painters* (1843) to work directly from nature, "rejecting nothing, selecting nothing, and scorning nothing."[15] At the same time, however, he had no qualms about making a mountain higher, a sunset brighter, a vista more expansive—whatever it took to suit his notion of what ideal nature must look like. Here he worked in the tradition of Nicolas Poussin and Claude Lorrain, the great 17th-century French classicists, who believed that art is above nature, and that it is up to the artist to perfect what nature can only begin. By no means was he the only American landscape painter who worked this way. However, he was by far among the most audacious and thus singularly successful at stirring up the feelings of the purists. Indeed, when discussing the same painting, one critic might hail him as the "best of masters" while another denounced him as the "worst of pretenders."[16]

Thus, when "Looking Down Yosemite Valley," measuring some five by eight feet, went on display at the National Academy of Design in 1865, the New York *Day Book* reporter was close to ecstatic. "It looks as if it was painted in an Eldorado, in a distant land of gold; heard of in a song or story; dreamed of, but never seen. Yet it is real. This valley has in it some of the most remarkable scenery in the world, and Mr. Bierstadt has placed all lovers of the beautiful under lasting obligations to him for this 'glorious touch of nature.'"[17] The New York *Leader*, conversely, responded with indignation and disbelief. "No such colossal mountains exist in this world! Mr. Bierstadt has painted far better works than this impossible Californian valley; for he has studied nature well and carefully. Whatever he learned thus, however, he ignored at the time of producing this great acre-and-a-half of slovenly and monstrous stage scenery."[18]

When a second painting, "Domes of Yosemite" (PLATE 2), was exhibited at the Tenth Street Studio Building in 1867, it caused a critical controversy referred to as "the fiercest conflict of modern times," second only to the Civil War.[19] Inspired by a $25,000 commission from financier Legrand Lockwood of Norwalk, Connecticut, the painting measured about nine by fifteen feet, Bierstadt's largest work to date. It represented a view of the

valley from a ledge next to the Yosemite Falls. Down below flowed the Merced River; in the far distance rose the peaks of Clouds Rest, barely visible through the mist. Spectators viewed the painting from two raised galleries, which further heightened the sense of distance and space. The painting itself was flooded with gaslight, the walls around it draped in black.

"It would be wrong to say that it does not look well now, after all the elaborate preparations of the carpenters and the upholsterers," wrote the New York *Evening Post*. "But really good art does not need such machinery to assist us in looking at it, and the very presence of these contrivances gives the spectator a feeling of distrust."[20] Clarence Cook, one-time editor of the now defunct *New Path*, published by the "Society for the Advancement of Truth in Art," offered a resounding no. Comparing the paintings with photographs, he railed at Bierstadt's repetitiousness, particularly in his rendering of trees. "In the trees of the foreground we recognize old acquaintances, as a stunted sort of vegetable made after a recipe of Mr. Bierstadt's own invention, and apparently warranted good for any situation. No such tree forms are found in the photographs, for the very reason that there are none such in nature."[21]

Mark Twain, on his way to Europe, was equally disappointed. Where Twain expected "cloud-shadows like unpoetical ink spots," Bierstadt had Yosemite floating "in a lustrous, pearly mist, which is so enchantingly beautiful that I am sorry the Creator hadn't made it instead of him, so that it would always remain here." The effect was "altogether too gorgeous": "As a picture, this work must please, but as a portrait I do not think it will answer. Portraits should be accurate. We do not want feeling and intelligence smuggled into the pictured face of an idiot, and we do not want this glorified atmosphere smuggled into the portrait of Yosemite, where it surely does not belong."[22]

Shortly thereafter Bierstadt left with Rosalie for a two-year tour of Europe, having made arrangements for several paintings to follow. On the whole, Europe treated them well. Rosalie, "a wife young and fair, a lady of rare culture," charmed everyone.[23] Bierstadt himself, "gifted with consum-

mate social and business tact," appeared as much at home in the ballrooms and the salons as in the mountains.[24] In Rome Liszt performed for them in private. They heard the Strauss brothers in Vienna. In Paris, Louis-Napoleon presented Bierstadt with the cross of the Legion of Honor. The Emperor, noted Rosalie, looked "old and care worn" while the Empress was "very beautiful" and carried herself with "perfect grace and elegance."[25] Bierstadt hosted a London dinner in honor of Henry Wadsworth Longfellow at the fashionable Langham Hotel. Robert Browning, Edwin Landseer, William E. Gladstone, and several members of the Parliament were there, as Bierstadt and Longfellow sat side by side, "on terms of the closest friendship."[26]

A few months later, in the spring of 1869, "Among the Sierra Mountains, California," measuring six by ten feet, painted by Bierstadt in Rome, went on view at the Royal Academy. At a subsequent banquet, amidst toasts to the Queen, Her Majesty's Ministers, the House of Lords and the House of Commons, the painting was cheered as "one of the finest landscapes that adorn our walls" (it had already won a gold medal in Berlin).[27] The London *Art-Journal* apparently agreed. "No finer landscape than that representing the Sierra Nevada has, so far as we are aware, been produced in modern times; none in which the merits are so marked, the originality so decided, and the room for adverse criticism so difficult to discover."[28] Other critics, however, all but ignored it. The London *Times*, rather cautiously, tried to explain its less than enthusiastic response. "[I]s it merely the 'too much' of the subject, the multiplicity of features and incidents of mountain landscape, which overtaxes the receptive capacity of the mind?"[29]

Just about that time, somewhere in Utah, two locomotives pulled up engine to engine, and the signal went out to a waiting America that the great Transcontinental Railroad had been completed at last. From then on, traveling from New York to San Francisco was no longer a matter of months but of days. The effect on San Francisco would be almost instant. "Bierstadt's success with Pacific Coast subjects has infected several

American artists with a desire to come here," wrote the San Francisco *Bulletin* only a few weeks after the trains began rolling.[30] A number of these artists were allegedly "engaged on special commissions,"[31] as many wealthy San Franciscans were "building fine dwellings" and "decorating them with pictures, statues, and bronzes."[32]

Yosemite, too, was changing. San Francisco stores sold special "Yosemite suits," quite fetching with "trowsers, a short skirt, and a loose shirt plaited in at the waist."[33] At Murphy's, near the Big Trees, children sold tarantulas' nests as "curiosities." At Calaveras Grove Hotel visitors could buy, "for a trifle," pieces of sequoia bark formed into pincushions, "an agreeable souvenir of the journey."[34]

Ambrose "Bitter" Bierce, from his vantage point at the San Francisco *News Letter*, took a dim view of the development. When he heard a rumor that Bierstadt's "Domes of Yosemite" had burned, he was only too pleased. "It is with grim satisfaction that we record the destruction by fire of Bierstadt's celebrated picture of Yosemite Valley. The painting has been a prolific parent of ten thousand abominations. We have had Yosemite in oils, in water colors, in crayon, in chalk and charcoal until in our very dreams we imagine ourselves falling from the summit of El Capitan or descending in spray from the Bridal Veil cataract. Besides, that picture has incited more unpleasant people to visit California than all our conspiring hotel-keepers could compel to return."[35] As it turned out, the rumor was false and "Domes of Yosemite" was very much intact. But painting or no painting, California's isolation was over. Before long, San Francisco would be a flourishing art center where European and East Coast artists would compete with local talent for the attention of railroad barons and bonanza kings. As always when art meets money, the result was bound to be mixed.

A GROWING APPRECIATION

he début of art in San Francisco was hardly modest. Ever since the early gold rush years, the more elegant saloons offered paintings of nudes, brought around the Horn along with mahogany bars and crystal chandeliers. Likewise, at the better-class gambling houses, where men flaunted diamond shirt studs and staked their bets at tables piled with gold, the nude was as certain as the hollow-eyed faces of the losers. The subject matter, according to a German traveler, covered "most of the phases of sexual life, from the scene in paradise to that of the harem."[1]

As art, most of these paintings, by obscure European artists, were second-rate. In fact, according to the German eyewitness, art "has been pilloried here, degraded to an agent of obscenity, offensive to morals and feelings." Another visitor from Germany agreed: "I have traveled far and wide through the world and have been among many nations who, partly from the effect of climate, and partly from the absence of religion and of education, are much given to sensual excesses; but such open and shameless enticements to evil I have never seen anywhere else, and I really believe they are only found among Christian nations and under civilized governments."[2]

San Francisco Hoodlums

"Samson and Delilah," by Paul Emil Jacobs of Munich, was different. The painting was imported by merchant John C. Duncan in 1853 to be sold at his salesrooms by the waterfront. Measuring about eight by ten feet, it showed Samson captured by the Philistines, defiant and nude except for a lion's skin covering his loins. Delilah cowered on a bed, clutching a sheet against her naked body, shears and Samson's shorn locks at her feet. The *Alta* pronounced it the best picture in California, and one of the best in the country. With all the leading saloons and gambling houses clamoring to buy it, Duncan decided to hold a drawing where the ticket with the highest number would entitle its holder to the last buying bid at a subsequent auction (memories of the 1851 Vigilance Committee, when men were hanged without undue ceremony, were still fresh in everyone's mind; Duncan was wise to ensure a fair procedure). In the end the painting, along with two smaller nudes, went to the Bank Exchange in the Montgomery Block for $20,000.

"The design is spirited and natural, the drawing accurate, the relief excellent, the coloring harmonious, the flesh tints of rare merit," com-

mented John S. Hittell in the *Pacific Monthly*. "This magnificent picture, which would be a valuable addition to any of the great galleries in Europe, is here condemned to serve as an attraction to the liquor saloon known as the Bank Exchange. Perhaps it would have found some better place, were it not that the squeamishness of American society makes ladies afraid to look at human figures partly nude, even though the general idea be chaste."[3]

Another place to view art was the What Cheer House, a hostelry on Sacramento Street, owned and operated by Robert B. Woodward. Back in 1849, this resourceful New Englander had sailed around the Horn to San Francisco with provisions he aimed to sell to the argonauts. After running a successful store for a couple of years, Woodward opened the What Cheer House, where, for a modest price, he put up miners and sailors in rooms about ten feet square, sparsely furnished with mahogany bedsteads and curled-hair mattresses. A believer in wholesome living and in the theory that what was out of sight would also be out of mind, Woodward resolutely banned females, both as employees and guests. To make up for the loss, he hung California landscapes in the lobby, started a small museum of natural history, and filled the library with books on gardening, ranching, and viticulture, along with novels by Charles Dickens, James Fenimore Cooper, and Sir Walter Scott, all of "good moral tendency."[4]

Around 1860 Woodward left for a tour of Europe, returning to San Francisco after a year and a half with some five hundred boxes of new treasures for his natural history collection. His appetite for paintings had increased as well. While in Europe, according to the *North Pacific Review*, he decided to take on the "the laudable project of laying in San Francisco the foundation for a gallery of art which may one day vie with the best collections of the eastern cities." He commissioned Virgil Williams, Albert Bierstadt's sketching partner, to "select such pictures as might prove suitable to the purpose in hand."[5] Williams, who was in Rome to learn old Venetian glazing techniques from his father-in-law, William Page, spent a year or two working on his commission. In 1862 he journeyed to San

Francisco to help hang about sixty paintings in Woodward's new villa on Mission Road. A couple of years later Woodward opened both the villa and the grounds to the public.

Woodward Gardens was an instant success, with Woodward's horse-drawn trolley line stopping right outside (there was a great deal of method in everything Woodward did, and he never allowed his philanthropy to stand in the way of business). Over the years, the exhibits came to include a headless rooster, a two-tailed horse, Fiji cannibals, Roman chariot races, and a salt-water aquarium with its own fish-hatching machine. The art gallery featured several old master copies such as Rafael's "Madonna Della Seggiola," Ferrari's "Linda Di Chamouni," and Guido Reni's "Aurora," as well as a few original paintings by Williams himself, among them "Beppo, King of Beggars," "Ruins of the Claudian Aqueduct," and "Aqua Acetosa," a scene on the Tiber some two miles north of Rome. The collection never did reach the stature Woodward had intended. Yet, as historian John P. Young pointed out, the gallery was "a great attraction" and "the care with which the visitors inspected the contents indicated a growing appreciation of art even though the opportunities to gratify it were limited"[6](PLATE 3).

Art was also in evidence at the Mechanics' Fairs, organized by the Mechanics' Institute in support of its library. The first fair was held in 1857, in a temporary building at the corner of Montgomery and Post. Here paintings competed with steam engines, quartz crushers, furniture, bed quilts, dental specimens ("ingeniously and tastefully arranged"), and what-nots (quite a number of those).[7] "The art gallery became our favorite rendezvous," wrote Amelia Neville, one of the early fair-goers. "After dinner we would throw on our paisley shawls and walk up from the Oriental to meet friends at the fair and watch the passing pageant from settees in the art room." The only painting Neville remembered was by Charles Nahl, a German artist who had studied under battle painter Paul Vernet in Paris and later tried his hand at gold mining in California. Neville described his work as "an enormous canvas depicting the royal family of Hawaii on

horseback, all of the figures, including the horses, life-size. As a work of art its proportions made a profound impression, which is quite the fact and not at all an attempt at satire."[8]

Scale was important again at the Mechanics' Fair of 1865. The fair opened with the customary display of fireworks in front of the new pavilion in Union Square. Afterwards the crowd poured into the building to attend the main event, the unveiling of a nine-foot sculpture of the recently assassinated Abraham Lincoln. Standing atop a ten-foot pedestal, placed in the middle of a splattering fountain, Lincoln wore curved pantaloons with instep straps, a short vest and tail coat (much too tailored, said those who had seen the real Lincoln). In his left hand, arm extended, he held the *Emancipation Proclamation*; his right foot rested on a serpent and a broken chain. The audience applauded, the band played, and the speeches went on and on, as Pietro Mezzara, the gnome-like sculptor, sat on the stage keeping a very low profile indeed. The *Bulletin* heralded the work as the "first colossal [sic] statue ever moulded in California."[9] The *Alta* found the proportions "in every particular mathematically correct."[10]

Bret Harte, however, found little to like about this "monstrous effigy." The size of the statue, he wrote, was "inconsistent with the natural humility of the original" and "a little too large for the heart." Still, after touring the agricultural part of the fair, he was inclined to forgive Mezzara: "His mistake is perhaps the more pardonable in a country where Nature is apt to fall into the same errors.... Not far from the statue will be found pumpkins, beets, apples and pears, quite as exaggerated in outline, and I am willing to believe as inevitably sacrificing delicacy, sweetness and refinement for coarser fibre and size."[11]

That same year, 1865, above the art store of Jones, Wooll & Sutherland at 312 Montgomery, the California Art Union opened the first San Francisco art gallery truly worthy of the name. The occasion was duly celebrated by a small gathering of artists and patrons, joined by alleged newspaper critics, who, according to the acerbic *News Letter*, walked about the room, "looking as wise as a flock of parboiled owls," far more qualified to

drink the champagne than to review the art.[12] Organized by eighteen artists and eighty-seven patrons, "well known citizens of taste and refinement," the California Art Union was modeled on similar organizations in Paris, London, and New York.[13] While private collectors were expected to loan paintings to the exhibitions, the main intent was to give local artists an opportunity to exhibit and sell their work. Membership was open to the public for an annual fee of $5, which included free admission to the gallery and a chance to win paintings in lottery drawings to be staged by the union at regular intervals.

Of the more than one hundred paintings exhibited in the opening show, about two-thirds were from private collections. One, ascribed to Guido Cagnacci, showed a female saint with a book and a skull. According to the *Alta*, it was "treated in a manner which does not suit the taste of the present time."[14] August Riedel's "The Bather" and "Albano Girl" had been entered in the catalogue as originals, although experts pronounced them to be copies, and only fair ones at that. Peter F. Rothermel's rendition of Hamlet talking to Ophelia was found lacking because "the heads of both are too large, and Ophelia is taller than Hamlet."[15]

Among the local artists, Gideon Jacques Denny showed a couple of "pretty sea pieces,"[16] one featuring a schooner, the other a brig, "all the nautical detail correct enough to satisfy the most exacting of chiefmates."[17] Born in Delaware, Denny was largely self-taught, yet thoroughly familiar with his subject from his time as a teamster on the San Francisco waterfront. Samuel Marsden Brookes showed portraits and still lifes with fish, a subject he would spend his life perfecting, searching for "that half astonished look that fish assume when out of water"[18] (PLATE 4). English-born, he grew up outside Chicago where he took a few art lessons from itinerant portrait painters. On a visit to England, he had copied masterpieces at Hampton Court and the National Gallery, but on the whole he too was self-taught.

Thomas Hill, also from England, showed "The Trial Scene from the Merchant of Venice," which featured Shylock, surrounded by some forty

figures, their grouping inspired by a recent performance at one of the local theaters. The California Art Union bought the painting, acclaimed as California's "first effort at historical painting," for $700 in gold. It was to be the grand prize in the first lottery drawing.[19] Hill's artistic provenance was quite impressive. In 1853 he had reportedly enrolled in the life class under Peter F. Rothermel at the Pennsylvania Academy of Fine Arts. A year later he was sketching in the White Mountains of New Hampshire with Benjamin Champney, Asher B. Durand, George Inness, and Albert Bierstadt. Champney had readily recognized his abilities. "Thomas Hill," he would one day write, "has all the faculties of Bierstadt, and can make more pictures in a given time than any man I ever met. In one afternoon of three hours ... I have seen him produce a study, *12 x 20* in size, full of details and brilliant light. There is his great strength and his mountain studies have not been excelled"[20] (PLATES 5,6).

A couple of months after the 1865 opening, Mark Twain arrived at the California Art Union. Recently returned from three months in the gold country, he had been assigned by the editor of the *Californian* to write an "elaborate criticism" of the paintings in the gallery. He had no misgivings about his ability to deliver: "I do not know anything about Art and very little about music or anatomy, but nevertheless I enjoy looking at pictures and listening to operas, and gazing at handsome young girls, about the same as people do who are better qualified by education to judge of merit in these matters."[21]

However, as Twain entered the gallery, he paid no attention to the paintings. Seeing a chance to make some extra money, he positioned himself by the door and began extracting a dollar and a half in admission from each new arrival. One man refused to pay, arguing that "the usual price was only two bits, and besides he was a heavy life-member and not obliged to pay anything at all." Twain let him in for a quarter, but only after a smug reminder that "we were not letting life-members in free, now, as much as we *were*." Next Twain ran into an old acquaintance, from whom he did not even try to extract an admission fee, "because I had cabined with him a few

nights in Esmeralda several years ago, and I thought it only fair to be hospitable with him now that I had a chance." The acquaintance introduced Twain to his crony Brown. Twain and Brown took an instant liking to each other, sat down on one of the cushioned benches placed down the middle of the room, and spent the next two hours talking about "Washoe and other things," including Twain's "gifted aunt Martha, who was a powerful poetess, and a dead shot with a brickbat at forty yards." In the resulting article, which appeared as "An Unbiased Criticism," Twain rambled on about life in the mines. Short of a brief but salutary remark on the Trial Scene, none of it had anything to do with art.[22]

Though Twain had been known to digress before, this time proved portentous. Initially the prospects of the California Art Union looked promising enough. After three months the society counted about five hundred members, and the gallery averaged almost a hundred visitors a day. However, it soon became evident that the Art Union had promised more than it could deliver. Sustaining the quality of the exhibitions proved more and more difficult as paintings on loan from private collections went back to their owners. New paintings by the artists themselves were also slow in coming. In fact, interest among the artists had been "luke-warm" from the start, as many had "but little faith in the experiment."[23] The ultimate obstacle turned out to be the lottery, which was deemed a violation of state law. Even so, a drawing took place in February 1866, with only eight winners instead of a promised forty. Shortly thereafter, the California Art Union closed.

About five years later, in early 1871, a much more successful society was born. Christened the San Francisco Art Association (the SFAA), it had "for its object the promotion of painting, sculpture, and the fine arts akin thereto, and the diffusion of a cultivated taste of art in the community at large."[24] Membership was open to "any respectable person," male or female, for monthly dues of one dollar.[25] The announcement had apparently been preceded by several rather stormy meetings, as some of the artists wished to run the new society themselves, unaided by "connois-

seurs" or "lovers of art." In the end, however, it was decided that self-rule was not the best choice. According to the *Alta*, the artists could ill afford to isolate themselves from potential patrons. Besides, they were notoriously jealous of each other and "would work together more harmoniously with the assistance of some outside influence." By its very nature, the new society "would never attract any but intellectual people"; the artists should welcome such assistance, not reject it.[26]

A string of exhibitions followed, at first held in the Museum Room of the Mercantile Library, as of late 1872 in rented rooms at 313 Pine Street. Opening night was for members only. Guests moved in little groups from painting to painting, as they "drank at the inspiration fount of the beautiful with an indescribable pleasure."[27] Later, there might be singing by the Carandini sisters, or original variations for the pianoforte on "The Last Rose of Summer" by a Professor Stockemeyer. As the rooms filled up, the crowd surged back and forth, the buzz of conversation grew louder, and the musical treats went largely ignored. Such was the case, for example, when a certain Herr Schlotte gave one of his "delicious" horn solos and was not "listened to as the merits of his performance deserved."[28] However, by the time the refreshment room was thrown open, pouring Landsberger and punch, the guests were back on their best behavior, their character being "a sufficient guarantee against jostling or other like inconveniences."[29]

The artists themselves took to the limelight like naturals. Among the new men was William Keith, a San Francisco engraver recently back from art studies in Düsseldorf. His views of Mount Shasta and Mount Tamalpais had been exhibited at the New York Academy of Design, where the *New York Times* praised them for their lack of "tricks" and "affectation."[30] William Hahn, one of the artists gathering around Emanuel Leutze in Düsseldorf, had followed Keith to San Francisco, where he now painted animal and genre scenes taken from his new environment: half-wild horses at a government corral (PLATE 7); crowded alleyways of Chinatown; gamins at the waterfront; a young woman receiving a visitor in a city parlor. The *Overland Monthly* approved: "The true artist will find good

subjects (as Goethe says the wise man will duties) near at hand, and such subjects, rightly treated, appeal to the public with all the force of novelties."[31] Italian artist Domenico Tojetti was less adaptable. A painter of palaces and cathedrals in the old country, he had been decorated by King Ludwig of Bavaria and made Marquis of the Church by Pope Pius IX. In San Francisco he called himself "Professor of Historical and Portrait Painting"[32] and specialized in rosy Venuses, haloed angels, and charming little cupids "in all conceivable attitudes on land, cloud and water."[33] Edwin Deakin seemed equally attached to old subject matter. Of blue-blooded British ancestry but scant artistic training, he drew on memories of his own genteel past: a street scene from medieval London; a haunting view of a castle; or a quaint English village, with lanes and hedges and an ivy-covered church. Soon, however, he would explore the ultimate in "California picturesque": Samuel Marsden Brookes, in long hair and sombrero, painting at his easel, surrounded by objects in various stages of decay, including a sagging couch worn out by friends in need of a place to sleep (PLATE 8).

At center stage stood Albert Bierstadt, who had returned to San Francisco in the summer of 1871, this time crossing the continent with Rosalie in one of Pullman's new railroad cars. "Noble, though somewhat cold in bearing," Bierstadt was soon a familiar man about town.[34] When not holding court at the SFAA, he might be yachting on the bay with the visiting Duke of Manchester, or drinking Pisco Punch at the Bank Exchange in the company of railroad tycoon Collis P. Huntington. Saturday afternoons he might be out on the Cliff House verandah with Rosalie and the cream of San Francisco society, sipping lemonade, listening to the band, and watching the seals of Seal Rock. In the fall he went back East to help arrange a buffalo hunt for the Grand Duke Alexis of Russia, teaming up with Buffalo Bill Cody, who, in exchange for a thousand pounds of tobacco, agreed to round up the buffalo and bring along a thousand Indians for color. He spent the winter sketching in Yosemite, "enveloped in furs and risking life from the 'awful avalanche'"[35] (PLATE 9). Escaping the summer tourists, Bierstadt found virgin country in the

remote, thus far unexplored Kings River Canyon in the South Sierra. He was also seen sketching at Donner Pass in the mountains east of Sacramento, in preparation for "Donner Lake from the Summit", commissioned by Huntington for a reported $20,000. By the time he left California, after a good two-year stay, he did so with "hundreds of elaborate studies" and the best of well-wishes. "We predict for him a career of renewed success in the scenes of his earlier triumphs," wrote the *Overland Monthly*. "He has never studied nor painted Nature more closely than during his last prolonged visit to this coast."[36]

By early 1873, the SFAA counted close to six hundred members. Of these, 65 were life members, each of whom had paid $100 toward the establishment of a California School of Design. A circular had gone out to academies, galleries, museums, and art societies throughout the world, soliciting contributions for the school library. The response was overwhelming: books arrived from as far away as St. Petersburg, and the SFAA was frantically looking for someone to "translate at least the titles."[37] As drawing from the antique was considered essential for all students — even those who might specialize in still lifes or landscapes — the association also placed an order with the French government for a set of plaster casts. France announced it would send the casts as a gift in gratitude for San Francisco's generous financial contributions during the Franco-Prussian War. Thus it happened that nine life-size casts, among them the Discus Thrower, the Borghese Gladiator, the Venus de Milo and Apollo Belvedere, voyaged around the Horn—accompanied by smaller versions of Jason, Achilles, Caesar and Socrates, and twenty of "the finest slabs" of the Parthenon frieze reliefs. Interpreting "Fragile" as having to do with bottles, the ship's crew had pried open several of the huge crates, but the casts arrived in San Francisco only slightly the worse for wear.

A problem immediately arose. Nearly all the figures were "in a state of Nature," too much so in the eyes of the SFAA.[38] Antique or not, they had to be made more presentable. Pietro Mezzara, of Lincoln statue fame, was in charge of the restoration, which seemed to be a great deal more than

straight repair work. Masking techniques were employed, and in some cases what was delicately referred to as "surgical transactions" were deemed necessary. Mezzara, in the meantime, reassured one reporter that "the superfluous appendages would be, at his suggestion, preserved and restored to the casts as soon as our young people could be made sufficiently familiar with the matter to enable them to accept the new departure with becoming modesty."[39]

The California School of Design opened in February 1874 in the rooms of the SFAA on Pine Street. Director and teacher, at an annual salary of $3,000, was Virgil Williams, recently back from Boston. Considered an excellent choice for the position, Williams was "an accomplished draughtsman, a pure, unmannered colorist, a hearty student of nature, and ... able to impart effectively what he knows."[40] Applicants to the school had to be at least 14 years old. No distinction was made as to sex, "the question was not even raised; and this is as it should be."[41] Nor was any distinction made as to talent. Barring endowment, the school was forced to accept any and all who could afford the tuition, which ranged from $10 a month for instruction in drawing to $12 a month for painting in oil. About forty students enrolled. Most of them were young women, "the veriest tyros,"[42] whose main reason for studying art was to acquire an "accomplishment," which would make them even more attractive to potential suitors.[43] The *News Letter* reporter predicted instant trouble, but hoped that Williams, "a man of most equable temperament," would treat his "inflated" and "stupid" pupils with as much tactfulness as those who were "humble" and "teachable."[44] Williams himself would take a long-term view. "When such girls leave and go out into the world, just think what an influence for good art they must have in any circle in which they may move," he said, summoning all his charm and reputed good nature. "And though my teachings may slumber in them, I have faith that they will waken in the next generation. Just think what talented children such mothers will have!"[45]

On the whole, San Francisco agreed. The SFAA and the California School of Design were part of a greater scheme. For all its posturing, San Francisco was still a city of self-made men with little reverence for anything but money. Art, argued the local press, would atone for the most glaring crudities, add some grace and polish, "hide in some measure the hard bitter world of business."[46] Beyond that, the introduction of art had even broader implications. In England, John Ruskin saw it as a moral force, which led to a better society. Love of beauty, he wrote, is "the direct adversary of envy, avarice, mean worldly care."[47] In America, James Jackson Jarves concurred. Art, he said, "tends to prevent crime, by proffering to the people new and exhaustless pleasures, which enlarge their faculties, stimulate their observation, and predispose them to brotherhood by a language intelligible to the entire civilized world."[48] Such ideas fell on good ground in San Francisco. "Every man, woman and child who can be interested in the hues of a rainbow; the sparkling scintillations of a dew drop; or the faithful representation of nature by art, is one more recruit in the grand army marching against vice, coarseness, sin and sensuality," decreed the *California Art Gallery*, a new journal out to enlist more marchers.[49] By the mid-1870s, art in San Francisco was off to a good start, but the big battle was yet to begin.

REALISM
REVISITED

 n the eyes of the period, "Elaine" was almost the perfect picture. Based on Lord Tennyson's *Idylls of the King*, it fell into the category of history painting, the noblest form of painting, including not only the depiction of actual historic events, but also scenes from high-toned world literature. The artist was young Toby Rosenthal, one of the first Americans to study art in Munich, a city which, throughout the 1870s, would rival even Paris as a place where new, fertile ideas were about to take hold. At the 1876 Philadelphia Centennial, "Elaine" drew crowds and won a gold medal. Critic Edward Strahan included it in *Masterpieces of the Centennial International Exhibition*, where he called it "so distinctly a representative of the Munich school of painting that it did not seem like a picture to be rightly called a work of American art."[1] This was high praise at a time when American artists were largely expected to echo what was being done in Europe, and for all their efforts never quite expected to succeed.

According to official records, Toby Rosenthal was born in Strassburg, Prussia, in 1848, shortly before his parents emigrated to America. Rosenthal apparently liked to think of himself as American-born and

claimed the event had taken place in New Haven, Connecticut. In 1858 the Rosenthal family moved to San Francisco. At age ten, Toby was already determined to become an artist. His father Jakob, a tailor of strained economy, scraped together enough money to send him to Louis Bacon, a French sculptor, who ran a small drawing school off California Street. Here the precocious boy copied magazine illustrations of famous paintings. The results were displayed at Jakob's tailor shop on Dupont Street. After four years Toby outgrew the well-meaning but limited Bacon. The ambitious Jakob wanted Thomas Hill to take over. Hill, however, charged $2.50 an hour, which was more than Jakob could afford. Enter Herr Hess, a well-off German baker, crusty on the surface but soft-hearted underneath. "Bah!" said Hess, taking one look at Toby's drawings. "I'll send him where he shan't be asked for anything but work like this. I know a good artist who loves art more than money."[2]

The artist was Fortunato Arriola, a Mexican portrait and landscape painter, whose studio was at the corner of Kearny and Clay. True to Herr Hess's prediction, Arriola was so impressed with Toby's work that he agreed to teach the boy for free. Given a corner in Arriola's studio, Toby set to work to copy portraits from daguerreotypes for clients more interested in a "good likeness" than in art. The task was monotonous, but the surroundings provided great material for Toby's future memoirs. Arriola, the son of a once-wealthy landowner, maintained close ties to his homeland. His studio doubled as a refuge for Mexican exiles and adventurers, among them the Mexican army captain who was to head the firing squad at the execution of Emperor Maximilian in 1867. It was an explosive environment; one of young Rosenthal's more exotic assignments was to hold the palette as his tall, "hidalgo-like" teacher painted over black eyes temperamental house guests incurred. In between, he assisted Arriola as he treated walk-ins from the street, cut and bruised in alley fights and bar brawls.[3]

After about a year and a half Toby became restless. Arriola, aware of his limitations as a teacher, told Jakob he had taught the boy all he could. Too proud to accept money from outsiders — offers were not lacking —

Jakob again dipped into his funds and managed to send his son to Munich. Largely thanks to the munificent patronage of King Ludwig I, Munich was already well on its way to becoming one of the main art centers of Europe. The museums offered outstanding collections of works by old masters as well as contemporary German and foreign artists. The city itself was a glorious assemblage of Gothic, Baroque, and Neoclassical architecture. In the early 1870s, after the German victory in the Franco-Prussian War, Munich would have its true moment in the sun, as Paris struggled to recover from the grueling siege and bloody months of the Commune. "Munich was radiant," wrote Thomas Mann. "Art flourished, art swayed the destinies of the town, art stretched above it her rose-bound sceptre and smiled There was a downright cult of line, decoration, form, significance, beauty."[4]

King Ludwig was not so fortunate. In 1848, as revolutions and uprisings rumbled through Europe, he was forced to abdicate in favor of his son. At least in part, his downfall was caused by his liaison with Lola Montez, a dancer whose political ideas were considered too liberal for the impressionable monarch (Miss Montez later surfaced in San Francisco, where, in the Spider Dance, she shook rubber spiders from her writhing body and pretended to stomp them to death). Though released from his formal duties, the aging king was still a frequent visitor at the Royal Academy, where Rosenthal spent his first few months drawing from statuary in the sculpture class. The king, judging by Rosenthal's recollections, had in no sense lost his appreciation of female beauty. On one occasion the professor was working on a nude, using a particularly appealing young woman as his model. The king let the professor know he was unneeded, then proceeded to "examine the model from all sides, with by no means disinterested pleasure." When done, "he slapped the girl on her rump, tested the firmness of her thighs and approvingly repeated, 'We are well built.'" Before leaving, he placed a gold coin at the model's feet as further proof of his royal sincerity.[5]

The spirit of revolution which characterized 19th-century Europe had extended to aesthetics as well. In 1848 a group of young English artists,

including Dante Gabriel Rossetti, William Holman Hunt, and John Everett Millais, had formed the Pre-Raphaelite Brotherhood in protest against the London Royal Academy, where art ideals laid down by Sir Joshua Reynolds some eighty years earlier had become stale and stereotyped. The emphasis of the Pre-Raphaelites was on feeling rather than intellect; their models were the Italian Primitives, such as Giotto and Fra Angelico, who painted with deep religious sentiment, bright colors, and close attention to detail.

In Paris, beginning in the 1820s, Ingres and Delacroix had clashed over line and color. Ingres, representing academic classicism, called drawing "the probity of art." Drawing, he said, "includes three and a half quarters of the content of painting."[6] Color, he said, must be restrained to a tint, the surface of the paint smooth and unobtrusive. To Delacroix, color was the point of departure. Only color could give "the appearance of life."[7] He drew with color, modeled with color, pushed each brush stroke into prominence, often choosing historical or exotic subject matter to match the drama of the paint.

Then, in the mid-1850s, Gustave Courbet burst on the scene, an artist of coarse appearance and sharp wit. Propounding not just a new way of laying on paint, he had introduced new subject matter as well. The art of painting, he believed, could "only consist of representation of objects which are visible and tangible for the artist."[8] For his subject, he turned to the peasants of his native Jura, portraying them as he knew them: strong and dour, inhabiting a harsh world of grime, sweat, and social injustice. "I cannot paint angels," he sneered, "because I have never seen one."[9]

Munich, as Rosenthal would recall, had its own share of factions. The "Nazarenes," known for "their pious look heavenward," were followers of Peter Cornelius, who had been brought from Rome to Munich by King Ludwig in 1819.[10] Their "shadowy academical idealism," which took the form of monumental frescoes, often with religious subject matter, was already under attack for being lifeless and out of date.[11] The man of the hour, rather, was Karl von Piloty, into whose class Rosenthal had been

admitted in 1867. A painter of heroic canvases such as "Seni beside the Body of Wallenstein" and "Tilly before the Battle on White Mountain," Piloty had spent his formative years in Paris in the early 1850s. Appointed professor at the Munich academy in 1856, he established himself as a "colorist" and brought about a revival of "painting for its own sake," based on intense study of works by Rembrandt, Frans Hals and Velasquez on display at the Old Pinakothek.

Piloty, too, would soon meet with opposition. After Courbet's work was shown at the Munich Glaspalast in 1869, several of Piloty's students formed their own group, separate from the Munich academy, called themselves "revolutionary," and let their hair grow under broad-brimmed "bandits' hats."[12] One of the more talked about was Wilhelm Leibl, a robust painter of German peasants, who, in the words of American critic S.G.W. Benjamin, seemed to "go out of his way to give us the most repulsive specimens of both sexes that he can find."[13] Leibl's soon-to-be disciples were American painters Frank Duveneck and William Merritt Chase, both of whom would greatly influence the course of American art through their bold technique and "low-life" genre subjects.[14]

Rosenthal, however, remained very much under the sway of Piloty. His dress was "gentlemanly" and "fashionable," and his hair was cut short.[15] When he painted peasants, they were of the old, "attractive" kind. One of his early paintings, "Affection's Last Offering," showed a dead child lying in state in the cold and stony vestibule of a Bavarian farm house. The grief-stricken old schoolmaster and the village schoolchildren—well-scrubbed and rosy-cheeked—had come to say their last good-byes. Hardly visible in the dark background was the bereaved mother, hiding her face behind her apron. In San Francisco, it was one of the most popular paintings at the 1868 Mechanics' Fair. It also caused bad blood among some of the local artists who claimed that "a mere boy" could never have painted such a picture and that Piloty himself must have had a hand in it. Confident of the powers of his former student, Arriola smiled an inward smile and muttered something about "the young eagle flying higher than the old jackass,"

which was an old Mexican proverb and hard to dispute.[16]

Other paintings by Rosenthal shared the same preoccupation with loss and decay. "The Exile's Return," exhibited at the Mechanics' Fair of 1869, depicted a nobleman outside a ruined castle, its crumbling walls overgrown with vines and mosses. "The Joys and Sorrows of Spring," also exhibited at the 1869 fair, was set in a glorious spring landscape and showed three children bringing fresh flowers to their mother's grave, which was sheltered by a blossoming apple tree and marked by a crude iron cross and withered wreaths. Even the paintings that were not shown in San Francisco were written up in the city newspapers, thanks to Jakob Rosenthal, who turned every letter from Toby into a press release and supplied the reporters with photographs of works in progress. The most talked about was "Morning Prayers in the Family of Johann Sebastian Bach," purchased by the city of Leipzig, and striking just the right patriotic chords when it toured Europe as part of the relief efforts during the Franco-Prussian War. Meanwhile, newspaper descriptions of Jakob himself were as moving as any of Rosenthal's paintings. Jakob's dingy tailor shop, with its smell of old clothes and cabbage, had now moved to Stockton Street, where it was wedged between a fruit stand and a rather seedy-looking laundry. Late at night, long after everyone else had gone home, Jakob could be seen toiling away in the dim light, "sitting upon his shop-board, mending, patching, and doing the humblest portion of his vocation." When too weary to go on, he would raise his tired eyes to the photographs and drawings on the walls—"his never-failing incentive"—and think about his boy among the artists of Munich.[17]

In late 1871 Toby Rosenthal returned to San Francisco for a short stay. Society lionized the modest and mild-mannered youth in a "whirl of dinners and receptions,"[18] and local notables came to his studio to have their portraits painted. A few months later, bored by both parties and portraits, Rosenthal prepared to go back to Munich. On the eve of his departure, Tiburcio Parrott, a wealthy merchant and art patron, commissioned him to paint the scene where the lovely young Elaine, dead from unrequited love

for Lancelot, is taken up the river to King Arthur's castle. The painting was to be a little less than three feet square, and the price was set at $1,000.

Back in Munich, as Rosenthal began to draft the composition, he soon concluded that "the subject could not be fully presented on a small canvas." Even after selecting a larger canvas, he ran into difficulties. "I sensed even more strongly the great beauty and the moods with which the poem is filled, and my painting pleased me less and less. In order to do justice to the spirit and the rhythm of the poem, I constantly tried new changes in line, tone, and distribution of the masses."[19] At one point, desperate for realism, Rosenthal smuggled the body of a dead woman into his studio, where he painted around the clock until ill health forced him to stop. According to one newspaper, Rosenthal grew sick from the smell of the corpse. Rosenthal, however, attributed his health problems to sheer frustration. Piloty apparently agreed, for he advised Rosenthal to destroy the picture and forget all about it.

Nonetheless, after a few weeks in the country, Rosenthal resumed his work on Elaine, now focusing on her face. This time a new problem arose: the lack of suitable models. "I had more trouble getting a model for that painting than I ever expect to have again," Rosenthal later admitted. "I met scores of beautiful subjects that would promise to fulfill my highest expectations. Their features were faultless. But when the countenance of one of these beauties was viewed in a reclining posture the lines of beauty were confused, and they presented a distortion that was simply repulsive."[20]

Along came Miss Hattie Green, of Oakland, California. She was on a tour of Europe and showed up one day in Rosenthal's studio hoping to meet the famous artist. When Rosenthal saw her patrician features, her fair skin, and her masses of golden hair, he thought his prayers had been answered. Miss Green was only too delighted to pose. The moment she lay down on the couch, her face collapsed into the same ugliness he had seen in all those other faces before her. To avoid offending his eager young model, Rosenthal finished the portrait, and Miss Green left Munich thinking she was indeed to be the living prototype for Rosenthal's "Elaine." Yet,

as soon as she was gone, Rosenthal erased her portrait in disgust. Thereafter, to test prospective models, he would drop his handkerchief in front of them. When bending down to pick it up, he could glimpse their faces from the desired angle. Each time he tried it, disappointment struck. Only a young relative of Piloty's was found "beautiful from every point of view." Piloty, however, forbade her to pose—at least in Germany, modeling was not a suitable occupation for a young lady of standing. In the end, Elaine was Rosenthal's own invention, idealized to cover up the imperfections of ordinary humankind.[21]

A year passed, and "Elaine" was still far from finished. Like Pygmalion in love with his own creation, Rosenthal kept working on the painting, which by now had grown to almost twice the size initially agreed. Rosenthal sent a letter to Parrott, in which he explained his predicament and raised the price from $1,000 to $2,200. Parrott refused to go along, at least according to Marcus Rosenthal, Toby's lawyer brother, who had words with Parrott back in San Francisco. Several months later, when Rosenthal was still waiting to hear from Parrott in person, Kate Johnson, another San Francisco art patron, walked into his studio. Mrs. Johnson had heard about "Elaine" through an English poet over dinner in Florence, and she now wanted to buy the painting. Rosenthal sold it to her for $3,500.

In San Francisco, tidings about the sale stirred up a heated debate, fueled and stoked by the city newspapers. Was Rosenthal guilty of a "flagrant breach of contract" by not delivering "Elaine" to Parrott at the price agreed upon?[22] Or, money being no object in the first place, should Parrott have given Rosenthal full artistic freedom and accepted the painting at whatever price the artist put on it? Marcus Rosenthal wrote letters to the editors, defending his brother's actions. Parrott himself kept out of the discussion, although Toby Rosenthal later accused him of having made anti-Semitic remarks which reflected his alleged belief that Rosenthal had tried to double-cross him.

Meanwhile, San Francisco fed on the attention "Elaine" was receiving

in Europe. Crown Prince Frederick William was said to have approached Mrs. Johnson, "through an agent," with "overtures" to buy the painting. Mrs. Johnson, in turn, "resisted all tenders."[23] The Berlin *Koenigliche Vossische Zeitung* printed "a long and flattering notice,"[24] the writer marveling at Rosenthal's "thorough artistic talent" and expressing surprise at never before having heard of him.[25] Both the London *Graphic* and the *Illustrated London Times* published engravings. By the time the painting arrived in San Francisco, the city was alive with anticipation. On the morning of April 30, 1875, hundreds of San Franciscans lined up outside the gallery of Snow & May at 21 Kearny Street, waiting to see "Elaine" at last. The doors opened at 10 o'clock; admission was 25 cents.

Before the day was over, more than a thousand people had seen the painting, which was set in a massive gold frame and draped with rich, red velvet. Some of the viewers reportedly broke into tears at the sight of the dead Elaine on the flower-strewn barge. In the grey light of dawn, dressed in white and partly covered by a cloth of gold, she lay under a canopy of crimson velvet which shaded her face and streaming blond hair. In her right hand, fallen by her side, she held a lily, in her left a letter to Lancelot. Her father's mute old servant, a dark figure in a hooded cloak, stood at the stern, steering the barge up the river (PLATE 10).

Local critics, however, were somewhat taken aback by the appearance of the "lily maid." Rosenthal's Elaine, unlike Tennyson's, was no frail young thing but rather "a large, fully developed woman," her legs "almost masculine."[26] While Tennyson's Elaine "lay asleep, and as though she smiled," Rosenthal's Elaine wore "that too common expression of death," one of suffering and pain.[27] Some expressed concerns about the barge: it seemed too stylish for King Arthur's era. Furthermore, draping it in red rather than black and mixing red flowers with white seemed "hardly in consonance with the funeral character of the subject."[28] All in all, though, Rosenthal had remained faithful to the poem, "only using such license as may be permitted to a true poet or a painter of good repute."[29] But there was one problem which some of the more conscientious critics found

harder to dismiss. Tennyson's barge was floating "upward with the flood"; the old servant did nothing to propel it forward but was merely "steering."[30] Rosenthal's servant was equally passive. Yet, the ripples at the bow of Rosenthal's barge clearly indicated some manner of propulsion. Who was pushing it? No one could come up with a good explanation. But only the pettifoggers seemed overly concerned.

While the city art critics were arguing over the finer points of physics, the approach of the city hoodlums was more hands-on. Thus, on the morning of May 2, the fourth exhibition day, Frank C. Snow of Snow & May found himself staring in disbelief at an empty frame and tiny strips of canvas on the floor beneath it. During the night someone had cut "Elaine" out of the frame and carried it away. The news of the abduction traveled like a prairie twister, drawing scores of curious to the gallery where the irreverent helped themselves to canvas strips for souvenirs. Mrs. Johnson announced that she would pay no ransom money, for fear it would set a bad precedent. Furthermore, she considered "ordinary punishment, like confinement in the penitentiary, too good for the thief.". He ought to "be hanged, drawn and quartered," she said, or at least "scourged at the whipping-post, after the manner of the baser criminals in Delaware."[31]

Wasting no time, Captain Lees of the San Francisco Police Department — "terror" to all "evil-doers"[32]— was hard at work examining evidence. Someone had spotted four men in spirited conversation across from the gallery on the evening of the crime. Judging by the description, one of them was Cut-face Donohue, a hoodlum well-known to the police and hard to miss with a huge scar across his face. Someone else had witnessed an unusually celebrative mood among a group of customers in a beer saloon on Third Street. The "Rogues Gallery" was brought out, descriptions were matched with photographs, and four more suspects were identified.

As it turned out, "Elaine" had been in more imminent danger than anyone even suspected. When the thieves found out that there would be no ransom money, their first impulse had been to destroy the painting before

it could link them to the crime. Only one, James O'Neill, opposed the idea. A "convict of a rather romantic turn of mind," he claimed he had conceived of a plan to sell "Elaine" and give the money to some charitable cause, possibly "the relief of the grasshopper sufferers in Nebraska." He grew vague and ill at ease when pressured by the interrogating officer about the details of his plan, but, as the *Chronicle* put it, "his intentions were none the less honorable."[33] Even so, it was hard to say how much longer O'Neill could have stalled his less philanthropic confederates. Most likely Captain Lees arrived at the last minute, before they carried out their sinister intentions.

Mrs. Johnson agreed to give the public one more opportunity to see "Elaine," and a few days later the painting was again on view at Snow & May, this time guarded by two policemen and hanging next to a large photograph of Captain Lees. By the time the exhibition closed, over 10,000 San Franciscans had come to see it. The net proceeds, amounting to $2,041, went to charity. A check for $141 was sent to Arriola's widow (Arriola had been lost at sea a few years earlier, on his way back to San Francisco from New York). The rest of the proceeds was divided among local hospitals, orphanages and old people's homes. Donohue and two of his accomplices were sentenced to San Quentin; the other two were set free. Toby Rosenthal would live out most of his life in Munich, where he married a wealthy banker's daughter and executed large commissions for both American and European patrons. In his posthumously published memoirs he wishfully referred to the Donohue gang as "art connoisseurs who had gradually assembled an entire gallery in a hidden cellar, and held it in high regard."[34]

Parrott, for his part, paid Domenico Tojetti a reputed $10,000 to paint a new, even larger "Elaine." When the second "Elaine" went on view at Messrs. Snow & May in the summer of 1876, it attracted almost as many spectators as the first. In the words of the *News Letter* it was "*the* subject of conversation in all circles where art talk is ever indulged in, and in many others where it never was before."[35] Even though Tojetti had been forced to read the poem in its Italian translation — initially a matter of concern

among the critics — he had treated it with greater "fidelity" than Rosenthal.[36] While Rosenthal's maid was said to be "unmistakably German in form and feature," Tojetti's Elaine had a "thoroughly English face, of exquisite beauty."[37] She looked dead, but not too dead: "the color of the face is that of fair complexion from which the warmth of life has departed, leaving that cold, marble-like appearance, without ghastliness, so rarely caught by artists."[38] The barge, a simple vessel of wood, also seemed more appropriate. The canopy was of black velvet; over the bow hung a large wreath of white roses; festooned along the gunwale was a profusion of heavy black crepe. And, most important, Tojetti had taken great care not to confuse the scientific-minded. The moment chosen was the barge leaving the shore near the castle. The servant stood in the prow, oar in hand, turning the barge in the current before steering it up the stream. The opposite oar hung loose in the oarlock. There could be no doubt in which direction the barge was heading, and every single ripple was accounted for.

The Ideal Bohemian Club.

PURSUING
LA VIE BOHÈME

ules Tavernier was trained in Paris, in the atelier of Felix Barrias. He sketched at Barbizon, Marlotte, Grèz, and the Vallée de Chevreuse, and he showed at the Paris Salon. During the Franco-Prussian War, he served as an artist-correspondent; his drawings of a besieged Paris were flown by balloon to London and reproduced in the newspapers. He also enlisted as a volunteer with the 84th Battalion of the Compagnie des Marche and fought in the Battle of Buzenville. In early 1871, shortly after the armistice, he left France, allegedly to avoid the impending Commune. He spent several months in London, working as an illustrator for the London *Graphic*.[1] By 1872 he was in New York, where his painting of Niagara Falls was reproduced on the cover of the *Aldine*. A huge boulder was starkly outlined against rushing waters and a dramatic sky. The magazine congratulated New York on its new arrival—"if he had painted no other picture than the one we have represented, we should have a just right to prophesy that he will eventually make a broad mark for himself in the history of American art."[2]

Jules Tavernier

After a year or so in New York, Tavernier was commissioned by *Harper's Weekly* to journey across the American continent and sketch frontier life along the way. Joining him was Paul Frenzeny, one of Tavernier's fellow students in Paris. Frenzeny's sketches of Mexico, where he rode with the French cavalry under Marshal Bazaine in the mid-sixties, had appeared in *Harper's* as early as 1868. In this new venture, Tavernier and Frenzeny were to be paid $75 for single-page illustrations and twice as much for double-pagers, largely thanks to Frenzeny, who, in the words of the *Sacramento Bee,* had "an eye as keen as a Boston aesthete for the vulgar dollar" and therefore was in charge of expedition finances.[3]

The artists left New York in late July or early August, 1873. It seems they crossed the Mississippi at Hannibal, rode the Missouri, Kansas and Texas Railway to Denison, Texas, then headed north again, probably joining a cattle drive to Wichita, Kansas. All along they kept sketching scenes which in time were to become the very archetypes of the Old West: settlers seeking shelter from a prairie windstorm; wolves prowling a deserted town; cowboys roping Texas longhorns; a hunter stripping a slain buffalo of its hide, leaving its carcass to rot. In the spring of 1874, after wintering in Denver, the artists arrived at the Red Cloud Agency in Nebraska. Earlier that year hostilities had increased between the Sioux and the white men at the agency. Order was restored with the arrival of General Smith from Fort Laramie, which made it possible for the artists to attend the annual Sun Dance held in June. Their sketch of the ritual self-torture, one of the earliest representations of the subject, showed young warriors suspended from a tall pole, on "stout cords" attached to pieces of wood hooked into their flesh. The pain, according to *Harper's*, was "borne not only without flinching, but with every manifestation of delight."[4]

In the summer of 1875, Tavernier and Frenzeny arrived in San

Francisco, where they joined the Bohemian Club, formed in 1872 by a group of hard-up writers, artists, actors, and musicians. Of late the club had been infiltrated by men of more lucrative professions, blessed with the wherewithal to keep the club out of debt. Everyone seemed to benefit from the arrangement, abiding by the motto "Weaving spiders come not here," which meant never doing business at the club, always keeping the nest of the owl — the owl being the club symbol — uncontaminated by sordid money-making schemes.[5]

Word was soon out that, in Tavernier, the club had gained a true Bohemian. Short and "peppery," fit and tan, Tavernier was "a nervous, excitable, explosive young man, careless about paying his debts, indifferent as to the morrow, a spendthrift, warmhearted, honorable in his own sight and exceedingly otherwise in that of his creditors."[6] The whole city probably heard about his run-in with William Ralston, financier and art patron. Ralston was not satisfied with Tavernier's representation of his Palace Hotel, at the time the largest hotel in the world, standing seven stories tall at the corner of Market and New Montgomery. Ralston felt that Tavernier ought to have bent the rules of perspective "and put the whole house in."[7] Tavernier took it personally, accusing Ralston of asking him to lie with his brush. What happened next no one seemed to know with certainty. Some said Tavernier attacked the canvas with a knife, others said he put his foot through it. In any event, the picture met with a violent end.

Another tale involved an anonymous "millionaire" who ordered a painting which he felt Tavernier was too slow to execute. Having paid part of the money in advance only worsened the situation. In Tavernier's mind, the man was no longer a patron but a creditor and thus to be avoided at all times. Writer Jerome Hart, a mutual friend, offered to help, demanding *carte blanche* from the "millionaire" in the matter of expenses. The next day three cases of fine red wine were delivered to Tavernier's studio from an anonymous sender. A couple of days later some beer arrived, followed by expensive Russian cigarettes, French cognac, and half a dozen bottles of "assorted liqueurs." Shortly thereafter Hart paid a visit to Tavernier's

studio. Though he claimed he had been sworn to secrecy, he nonetheless let slip that the mysterious benefactor was none other than their friend the "millionaire." Tavernier, apparently moved, finished the painting. A few days later, Hart paid a second visit to Tavernier's studio, where a small gathering of friends kept Tavernier company. Tavernier was in a dark mood. The mere mention of the millionaire's name made his mustache bristle, a known trouble sign. The man had done the unforgivable and ended up on Tavernier's permanent black list — when he paid for the painting he actually withheld the money Tavernier owed him.[8]

At the Bohemian Club, Tavernier soon became known as the *enfant terrible*, always on his guard against the Philistines, club members or not. His foremost weapon was his cartoons—drawings and paintings made expressly for the club, often done in connection with a "jinks" or entertainment. One cartoon, entitled "Ignorance," showed a grotesque brute, thinly disguised as a human, seated in a cesspool, oblivious of the Temple of Science, Literature and the Fine Arts, gloriously lit up behind him. Another depicted an owl in monocle and swallow-tails, protesting the club's new dress code. Both the ignorant brute and the dressed-up owl were hung on the walls of the club, unlike a third cartoon, which Tavernier one night secretly placed on an easel facing the members on their way to dinner. It showed the halls of Bohemia covered with spider webs, the members hawking their wares and services. This time Tavernier had gone too far. The "merchant princes" were furious, which pleased Tavernier no end.[9] He carefully rolled up the canvas and carried it out of the club. It was much too good for the *bourgeois*, he said, and it was not for them to keep, even if they begged him.

It was not long before Tavernier sought relief from the many constrictions of city life. He had found just the place: Monterey, a small town on the coast south of San Francisco, where a man could get by without his swallow-tails, and where the scenery had yet to be painted. At Jury's restaurant on Merchant Street, he had a long talk with Frenzeny, who finally agreed to go along. Shortly thereafter, on a foggy November evening,

the artists boarded the clipper steamer for Monterey. With them was Frenzeny's acquisition from the overland crossing — Judy, a pure-bred pointer, a hunting dog of great enthusiasm and no skill. "The goods and chattels of the partnership had been packed in a stave-bound flour-barrel, and I'm afraid that many a good picture was torn into shreds in the effort to fill that barrel's interior," recalled a friend, who came down to the wharf to see them off. The friend walked away the proud owner of a "precious fragment" which turned out to be the original sketch for the Sun Dance and no doubt would have ended up "in the dumps" had he not offered to save it.[10]

The following morning the steamer put in at the small harbor of Monterey. Once the proud capital of Mexico's Alta California, with bull and bear fights on Sunday afternoons, Monterey had lost most of its population at the cry of gold back in 1849. Even the soldiers at the Presidio deserted their posts to head for the Mother Lode. Now, with a population of around a thousand, Monterey had settled into peaceful neglect. On the hillside above the town stood an old fort and a lookout station for the whalers. The roof of the Spanish church of San Carlos was open to the sky, with grasses and wild mustard growing out of the crevices. Monterey itself consisted of muddy white adobe houses with iron balconies, red-tiled roofs, and courtyards surrounded by moss-covered walls. It had only five or six streets, all of them paved with sea sand. In the winter, torrents washed deep gulches down their middle, and the wooden sidewalks were in chronic disrepair. As the artists made their way towards the lodging house, they were not likely to detect very many signs of life. They might have seen some fishermen mending nets at the old Custom House, or spotted some activity around the card tables inside the saloons. Someone, somewhere, probably played the guitar (someone always did). A *vaquero* might have cantered by, in leather leggings and huge hand-wrought spurs, his mustang in silver-studded headstall. Geese, feeding in the gutters, may have hissed at Judy, who likely mistook them for canvasbacks in hunting season. Other than that, Monterey probably lived up to its reputation:

the sleepiest spot in the State.

Shortly after their arrival in Monterey, something went awry between Tavernier and Frenzeny, supposedly having to do with money. In the words of the *Examiner*, Frenzeny tore his hair and screamed at Tavernier. Tavernier, in turn, "raised his arms as high above his head as he could, wiggled his fingers and squealed," whereupon Frenzeny "pocketed the assets of the firm and departed." In the next several years, his sketches from Central America, London, and Siberia would appear in *Harper's Weekly*. By the late 1880s word reached California, again via the *Examiner*, that he had become "a long-haired, fiercely bearded 'cowboy artist' with Buffalo Bill's Wild West Show, a position for which his abilities just fit him."[11] What had happened to Judy seemed to be anybody's guess.

New friends soon gathered in Tavernier's studio. "How did a man kill time in those days?" wrote one of them, poet Charles Warren Stoddard. "There was a studio on Alvarado Street; it stood close to the post office, in what may be generously denominated as the busiest part of the town. The studio was the focus of life and hope and love; some work was also supposed to be done there." Here, among Indian trophies and paintings "in all colors under heaven," the studio intimates pursued the California version of *la vie bohème* — lounging on wolf skins and Oriental rugs, smoking the peace pipe, drinking beer, discussing art.[12]

Stoddard himself, a tall man with fine features, had made a name for himself through the publication of his *South-Sea Idyls*, inspired by his travels to Hawaii and Tahiti. Joe Strong, a young portrait painter, was newly back from Munich and studies under Karl von Piloty. Good-natured and quiet, with a "twisted yellow mustache and close-cropped hair,"[13] he was said to be "buoyant only under the most favorable circumstances."[14] Elizabeth, Strong's sister, had just turned twenty. A student at the California School of Design, she painted animals, chiefly dogs and sheep. Strong's other sister, the pretty Ninole, had no artistic aspirations whatsoever but spent her days sighing for San Francisco and its social life. Landscape painter Julian Rix — a large, handsome New Englander with

flowing blond side whiskers — was a confirmed bachelor well versed in "the art of making himself agreeable to the fair sex."[15] Carl von Perbandt, a blue-blooded Prussian, had studied under Friedrich Lessing in Düsseldorf and now specialized in California landscapes. His early claim to fame was his expertise at chess, inherited from a mother who played against one of Napoleon's generals and won. On all other matters concerning his family background, Von Perbandt maintained a sphinx-like silence, although it was rumored that somewhere in his recent past were a wife and two sons.

When not in Tavernier's studio, the Bohemians might be seen on their way to Jules Simoneau's restaurant, housed in the old jail, for some of Simoneau's famous *olla podrida*, a Mexican stew, "smoking hot and indescribably mixed."[16] Typically, Tavernier would be leading the pack, swinging around the corner, hands in his pockets, his drab felt hat cocked over his eye, pipe in his mouth. Strong, newly alert to the fact that dinner was about to be served, probably picked up the rear at a kind of running walk. Somewhere in the middle, in his Irish cap and long ulster, glided Stoddard, with an air of otherworldliness. At the restaurant, they ate and drank in the inner room — the *salle à manger* — with its commanding view of the jail yard and the well where frogs served time before the kitchen sent for them. As for the interior decor, it was limited to what Stoddard later would recall as "frescoes done in beer and shoeblacking by a brace of hungry Bohemians, who used to frequent the place and thus settle their bill."[17]

Bound to live long in the memory of those lucky enough to receive an invitation was the "Bohemian blowout" given one summer's night at the house of the Strong sisters.[18] The simple adobe chamber had been transformed into a resplendent banquet hall — part forest, with cypress branches, trailing Spanish moss, fern and flowers everywhere, and part cathedral, with sunlight filtering through windows stained by Strong and Tavernier "in the deepest and most splendid dyes." A giant *carte de menu* [sic] hung from the ceiling, reaching all the way down to the floor, "at every course a cartoon in color more appetizing than the town market."[19] Stoddard, in

toga and fez, received the guests at the door. Strong, in a chef's cap and apron, presided over the kitchen. Ninole, dressed as a Swiss milkmaid, assisted Von Perbandt, who, decked out as a French headwaiter with gold decorations and white kid gloves, was in charge of getting the food to the table, in the right order and with the right drinks. All in all, the guests enjoyed twelve different courses and seven kinds of wines and cordials: "mullet and salmon carp, snipe for game, entrées innumerable, roasts, relishes *ad lib*, champagne and Madeira and anisette, and French brandy and *café noir*."[20] Hired minstrels played in the adjoining room: "the guitar, the violin, and blending voices — a piping tenor and a soft Spanish falsetto."[21] Later the Monterey brass band showed up in front of the house. By the light of fireworks, the artists danced the *fandango* with the local *señoritas*, kicking up the dust in a rare display of single-mindedness and passion, while the rest of the town watched in wonder.

Despite all the diversions, as Stoddard pointed out, Tavernier kept busy at his easel. In fact, even the most casual observer — and most of them were very casual indeed — could not help but notice that Tavernier had to be a person of importance, at least by the standards of the outside world. Once a week the San Francisco steamer brought him canvases and packets of pigments, sometimes in exchange for a new painting, packed and padded and fussed over. Some of these paintings depicted Indian subjects, inspired by Tavernier's memories and sketches from the *Harper's* expedition. One showed a view of Red Cloud's camp somewhere near Crow Butte in the Wyoming Territory. In the foreground weeping squaws mourned their dead. Behind them teepees were scattered across the prairie; smoke from campfires rose towards the sky which glowed "with the last rosy tints of a dying day."[22] Another, called "Lying in Wait," depicted Indians about to ambush an emigrant wagon on the Overland Trail. As was often the case, Tavernier's true interest was in the landscape, the Indians and the wagon being a mere excuse for "some lovely effects of moonlight and soft, hazy atmosphere."[23] A third, "Dance in Digger Sweat House," was painted from sketches taken around Clear Lake north of San

Francisco. Ordered by Tiburcio Parrott, it measured six by four feet and contained nearly a hundred figures. Two Indians danced in the light filtering through an opening at the top of the sweat house. Surrounding the dancers were several squaws, who, in the words of the *Chronicle*, were "uniformly clad in semi-civilized apparel and seemingly gay and happy."[24] In the background, some white men were watching. The *Argonaut* identified one of them as Tiburcio Parrott and another as "a member of the firm of Rothschild," presumably the Baron himself, for whom the painting was intended as a gift.[25] Later Rothschild wrote Parrott from Paris that the painting had been received "with great favor, attracting a great deal of attention and comment at Goupil's, where it is now being framed for my private gallery."[26]

But most of the paintings taken away by the San Francisco steamer were views of local scenery: fresh out-of-door studies, sometimes foreshadowings of later studio work but often complete in themselves. Tavernier had no interest in grand scenery. Like the Barbizon painters, he preferred the intimate and the understated—ponds, forest clearings, clusters of trees, a muddy road after the rain, a hunter returning with his dog. Again like the Barbizon painters, he painted with a loaded brush, with broad and open detail. His colors were rich and subdued, dark browns and greens shot through with flecks of brilliant light. The *Monterey Californian* — it did not call itself "a live paper" for nothing — immediately picked up on the potential benefits to the community at large. "We, of Monterey, should feel proud of Jules Tavernier, who does so much to advertise our magnificent landscapes to the fashionable world, besides leading public taste to a higher appreciation of what is refined and beautiful, both in nature and art"[27] (PLATES 11, 12).

The San Francisco critics were less accepting. It was the old controversy about art versus nature all over again. Specifically, they took exception to Tavernier's tendency to experiment with strange lighting effects and distortion of form. "Storm," for example, showed water breaking and surging before a shoreline canyon. The beach in the foreground was covered

with pebbles, abalone shells, seaweed, driftwood, and giant ribs of whales. High above, sea gulls flew inland, away from the raging elements. The *Bulletin* praised the realism of the foreground: "even the small stones are figured with remarkable fidelity." However, the writer objected to the painterly quality of the surging water, which suggested "a ribbon well starched." In addition, the upper horizon gave the impression that "a pot of lamp black and umber has been struck by lightning, and that the contents are falling sheer down at an angle of about forty degrees."[28]

Another painting, "The Artist's Dream," showed an artist, alone in the forest, smoking his pipe by the campfire just before dark. The artist was seeing things he should not see, as ghostly forms emerged out of the shadows, part memories, part phantoms (either nature was playing tricks on him or there was more to that pipe than plain tobacco). The *News Letter* called the subject "purely imaginary" and dismissed the painting with a grunt.[29] The *Post* thought the details "admirable" but added that "a painting should make its meaning obvious at a glance": "The Artist's Dream" needed "too close study to ascertain its motive."[30] A third work, "Pillar Rocks," caused similar reactions. Here, as described by the *Alta*, Tavernier had "chosen the sunset hour, when the golden light of the departing day completely covers this peculiar geological formation, giving it the appearance of an old castle crumbling with age." Though assured by persons familiar with the location that the painting was "not in the least overdrawn," the writer remained apprehensive: "The picture is a peculiar one, and must be seen a number of times to be understood."[31] The *Chronicle* did not quarrel with its "truthfulness" but questioned the wisdom of copying nature at such extreme moments.[32] The *News Letter*, however, gave the painting a definite thumbs down: "In this picture the artist gives us an extravaganza in art, weird and poetical in the extreme, with just enough of nature in it to give it a name — a novel founded on facts, yet so embellished by the magic of fiction as to be beyond the recognition of [its] principal character."[33]

Tavernier's good relations with Monterey came to an end in the fall of

Alvarado Avenue, The Principal Street of Monterey

1878 when he illustrated an article about Monterey for the San Francisco *Argonaut*. The illustrations showed various points of interest, such as the old Carmel mission, the church of San Carlos, Chinatown, the fisheries, and the beach where the padres once had landed. But then there were other images, one of them entitled "Store in Monterey — Business Hour," a scene of perfect tranquillity, where most everyone was taking time out to nap in the sun. Another, "Strolling through the Sand," showed a street with figures wading rather than strolling through the loose, ankle-deep sand. In the background a carriage was stuck, the coachman cracking his whip to induce his horse to move. A third, called "Alvarado Avenue, the Principal Street of Monterey," showed Tavernier's studio, the post office, a saloon, a wagon shop, and J. Rodriguez Dry Goods store — the entire street a scene of utter desolation, a child and some dogs the only visible life. This time the citizens of Monterey were not pleased with the publicity: this was not how they wanted their town portrayed to the outside world. The town merchants, until then patiently extending credit to Tavernier, had a sudden change of heart, and almost overnight the air grew chill.

Like a flock of migrating birds, Tavernier and his fellow Bohemians took flight and headed back to San Francisco. "Tavernier has come to San Francisco to remain," announced the *Chronicle*, clearly pleased with the development. "He left Monterey because he found not only little encouragement there, but positive ingratitude. Not long since, thinking he was doing a favor to the place, he says, he furnished some illustrations of its

Store in Monterey-Business Hour

Strolling Through the Sand

quiet life for a paper of this city, which drew upon him a great deal of opprobrium, because they were a little too characteristic. Therefore he has decided to seek patronage in some livelier art center. The feeling regarding Monterey is shared by other local artists, who will hereafter make their rural studies elsewhere."[34]

By early 1879 the artists had established a new rookery in the old Supreme Court House long since abandoned by the legal profession. Von Perbandt was merely flitting through now and then, usually on his way to the redwoods, where he spent more and more of his time. Rix and Tavernier, however, acted as if they intended to stay for a while, setting up a shared studio, "a gathering point for wit, talent and *bonhomie*."[35] Down the hall, Elizabeth Strong was painting with more determination than ever, saving to go to Paris, while her patron Frank M. Pixley — man-about-town

and founder of the *Argonaut* — helped her with lucrative commissions for dog portraits from prominent local families. Nellie Hopps, "a type of refined ladyhood mingled with the strength of creative force," focused on forest scenes, somewhat in the manner of her mentor Thomas Hill.[36]

Charles Dormon Robinson, a former retoucher of photographs, painted landscapes and marines while befriending Rix and Tavernier and learning the tricks of the trade. Sharing Robinson's studio was Meyer Straus, once the head scene painter at the Grand Opera House but now scaling down his productions to easel paintings of Tamalpais and Yosemite. In a small studio all by himself, executing commissions for ships and seascapes using sketches of foreign coastlines to jog his memory, was William Coulter, a sailor turned full-time artist after a fall from a runaway buggy left him with a bad limp, unfit for life at sea. Two of the more illustrious occupants were Virgil Williams and his second wife, Dora Norton Williams, "a slim, straight-backed, decisive Yankee woman" who "fairly rattled with necklaces and bangles."[37] Virgil by now devoted himself almost exclusively to the School of Design, while Dora, who had been a promising watercolorist in Virgil's art class in Boston, specialized in flower painting. Another tenant of distinction was the elegant fresco painter Giuseppe Gariboldi. Dressed as a grand duke, Gariboldi drove around Nob Hill in a hired carriage, landing contracts to select art for the mansions and then hiring his friends to fill the orders.

While Rix soon joined Von Perbandt in the redwoods, "living a nomadic life in the tents and the shanties of lumbermen," Tavernier stayed behind working in his studio.[38] He was now a married man. His wife Lizzie was a striking young woman: tall, with a slightly curved nose, her shiny dark hair cut very short. She insisted that Tavernier keep steady hours and live up to his new responsibilities. Tavernier apparently tried to comply. Through Gariboldi, he had received a lucrative commission for the Hopkins mansion — six upright panels, about eight feet in height, meant to hang in the upper gallery of the great entrance hall. "Tavernier has on hand six large decorative tablets for Mrs. Hopkins' house, but even to his

most intimate friends he declines to show the sketches," wrote the *Alta*. "In a vague kind of way, he alleges that they will be of an oriental character, rich in coloring, and that he means to throw his whole soul into the work."[39] Panel number one was finished within a few months and installed in its new surroundings. It represented the courtyard of a Moorish palace, with a glimpse of a garden, a harem window with intricate lattice work, domes and minarets against a deep blue sky (Tavernier's Paris teacher, Felix Barrias, specialized in oriental subjects). Panel number two, reported to be a cathedral interior, was slower in coming. By now Tavernier was feeling very lonely. The *Chronicle* reporter stopped by the studio and found the artist on top of a stepladder, working away "with more or less listlessness," now and then relieving himself from the tedious task by turning his attention to smaller and less pretentious studies, such as a cloud effect in Nebraska or a picnic in the rain at Berkeley.[40]

Down the street from the old court house, at 7 Montgomery, Joe Strong was adjusting to married life as well. When Tavernier and the others left Monterey for San Francisco, Strong stayed behind to marry Isobel Osbourne, a young woman of dark complexion and an iron will (PLATE 13). At first their marriage met with disapproval from Fanny, Isobel's mother, whose plans for her daughter involved a wealthy Kentuckian rather than a poor California artist. Still, Fanny was hardly in a position to question the power of love. She herself was about to divorce Samuel Osbourne, her husband of eighteen years, to marry Scotsman Robert Louis Stevenson, a young and ailing writer, who had arrived in Monterey so gaunt and sorry-looking that even the local hostelries were reluctant to take him in (PLATE 14). All that was now behind them. Joe and Isobel had joined the Stevensons on their honeymoon in an abandoned miner's shack on the slopes of Mount St. Helena. At least in Stevenson's eyes, Joe had redeemed himself as "a most good-natured comrade and a capital hand at an omelette."[41] Back in San Francisco, they would all get together in Joe's studio, where the Taverniers were in the habit of dropping by after dinner, and where Stoddard would play the piano — softly, just for

background — as he watched Stevenson, in front of a small but captive audience, "literally *rise* to the occasion, and striding to and fro with Iconinc tread, toss back his lank locks and soliloquize with the fine frenzy of an Italian *improvisatore*."[42]

In 1881 the Strongs and the Taverniers took possession of the entire top floor of 728 Montgomery, claiming it for studio space as well as living quarters. Isobel, in her autobiography, *This Life I've Loved*, offered insights into Tavernier's domestic life at the time. On one occasion Tavernier was supposed to come home with a check for $500 in payment for a large Yosemite, which showed the valley "in a wide, all-embracing effect that Jules hated and despised." He had finished the painting under protest and only because Lizzie insisted. Before leaving, he told Lizzie to collect Stoddard and the Strongs; as soon as he was back he would take them all out for dinner. As everyone was waiting, Lizzie was leaning over the banister, ready to seize the money which would pay off their debts and buy her a new black silk dress. The moment she saw her husband coming up the stairs with two large parcels under his arms, her heart sank. As Tavernier unpacked a stuffed peacock and a pair of old dueling pistols (which he claimed were "genuine Louis XIV"), Stoddard discreetly slipped away. So too did the Strongs, who "had a sad little meal at a corner restaurant." When they returned, the Taverniers were still fighting, "Jules defending his priceless treasures, Lizzie reproaching, deriding, scolding, sobbing." In the morning, Tavernier slept late from sheer exhaustion. Lizzie brewed some perfect coffee and prepared an extra good breakfast—working in the kitchen always made her feel better, that is if she was lucky and not everything had been carted off to the pawn shop.[43]

However, most of the time life was good. The new studio, roomy enough for Tavernier and Strong to share, had a large skylight and gray plaster walls, the perfect background for their paintings. The hardwood floor, although a bit uneven, made an excellent dance floor when dusted with a bit of powdered wax. Tavernier took to inviting all his artist friends to evenings of life drawing. Every Tuesday and Friday about twenty of

them showed up, Tavernier providing the model. Lizzie, in the meantime, was ecstatic about her large new kitchen at the top of the stairs opposite the studio. Anyone who had a mind to was welcome to step in and help with the cooking. Rix, a frequent visitor, would don an apron and cook codfish and make Boston brown bread, while Strong flipped pancakes and mixed the salad dressing. Tavernier upstaged them both by dishing up, with considerable flourish, a *sole á la Marguery* or a *tripe á la mode de Caen*. "Our after-theatre suppers were impromptu," recalled Isobel. "Someone made a Welsh rarebit, while another would run down to the corner for a pitcher of beer; or if there were only a few of us, we'd sit round the stove baking oysters on a shovel, heating a poker at the same time to mull a jug of spiced claret."[44]

The party to top all parties was the one the artists threw for Oscar Wilde in the spring of 1882. The Englishman was in San Francisco to lecture on interior decorating, the English renaissance, and Irish poetry. Dressed up as Bunthorne, he appeared as his own caricature in the comic opera *Patience* which was playing at theaters around the country — a long-haired aesthete in a black velvet coat, knee breeches, black silk stockings and low-cut patent leather pumps, always with a sunflower or a lily in his buttonhole. Wilde, still in his late twenties, was not yet considered decadent, but was very much "the pure young man" Gilbert and Sullivan had envisioned. Echoing John Ruskin, his professor at Oxford, he talked about man's need to surround himself with beautiful carvings, stained glass, tapestries, carpets, wallpaper, chintzes, and furniture. He also took the opportunity to boost his then friend James McNeill Whistler, who had decorated a room in all the colors and tints of a peacock feather: "I regard Mr. Whistler's famous peacock room as the finest thing in color and art decoration which the world has known since Corregio painted that wonderful room in Italy where the little children are dancing on the walls."[45] All in all, Wilde appeared to be a man of highly refined sensibilities, jarred by his American experience. His tour of the United States, according to the *Chronicle*, had been "a succession of painful shocks, caused by his intro-

duction to ill-looking rooms in ill-built houses, furnished with blood-curdling evidence of barbarism in the shape of machine made rosewood furniture and black-leaded stoves."[46] The windows, he found, were much too large, the carpets too loud, the paintings hung too high. "Heah in California you have be-utiful marbles, but what do you do with them?" he asked in a drawling monotone, as quoted by the *Alta*. "Do you, like the ancient Greek and Roman Republics, fashion them into be-u-tiful forms? I fear not. I fear that you u-su-al-ly convert them into steps for your dwelling houses."[47]

At first, San Francisco society was at his feet. "[T]he gallery boxes were crowded with the aristocracy of Nob Hill and the glory of Van Ness Avenue," while "the Western Addition, from Pine to Post street, was spread over the closely packed chairs on the floor."[48] The men showed some restraint; only a few dared appear with "an aggravated lily" in their buttonholes. The women, on the other hand, went all out, arriving in bonnets covered with flowers, not just sunflowers and lilies but "dahlias, fuschias, daffodils, daisies, buttercups, primroses and all the horticultural products of nature."[49] However, as Wilde's lectures began sounding more like criticism than entertainment, San Francisco society had second thoughts. They had come to see the caricature. Instead they got the real thing—"a badly proportioned six-foot mountebank" who was not only boring but insulting as well.[50] The artists, though, sympathized with the aesthete. Here, finally, was someone who dared speak the truth, someone who spoke about beauty as a necessary part of life—in art, in architecture, in dress, even in conduct — and yet he was sadly misunderstood by his audiences and abused by the newspapers. "In short," Virgil Williams told his students, "he seems a kind of apostle or missionary, and he will no doubt meet with about the same encouragement that our Christian missionaries generally have among the heathen."[51]

At the Bohemian Club, Wilde's popularity soared. Over lunch, according to a gleeful account by club member Dan O'Connell, Wilde commented that he had never seen "so many well-dressed, well-fed business-like

looking Bohemians." After lunch, Wilde "lay back in his chair, entranced at the many evidences about him of the lucrativeness of literature and art in our city. 'Of what branch of letters, or art, are these men mostly the devotees?' he asked of a sleek old Bohemian next to him, whose diamond solitaire glistened as he shifted his four-bit cigar to answer: 'Business letters, I guess, and the art of double entry.'"[52] Later Wilde gained everyone's respect by drinking several of the club members under the table. As a result he was asked to sit for a portrait for the club, painted by young Theodore Wores. Afterwards Wores could attest that Wilde was most assuredly "no spidery weakling," but a real man with a passion for Western outlaws, particularly Jesse James, who had just been shot in the back by members of his own band.[53]

Convinced that Wilde was indeed a kindred spirit, Tavernier and Strong invited him to their studio for tea. The news of the invitation caused anxiety at home.[54] The notion of a tea party had actually been Stoddard's idea. After all, Wilde was English, and the English always drank tea in the afternoon. So tea it was, even though Strong, just to play it safe, insisted on brewing some of his famous rum punch as well, convinced that none of it would go to waste. Then there was the question as to what would be the proper edibles to go with the tea. Someone mentioned fried oysters. Someone else suggested scones, but no one really seemed to know what they were. Finally Stoddard, with the authority that came with his role as the group's chief of protocol, reassured everybody that "thin slices of bread and butter and pound cake were the correct and only things to serve."

On the day of the party everything was ready for the distinguished guest. Tavernier had painted the skylight full of roses. Sing Lee, the artists' Chinese helper, had brewed the tea and brought the tea cups. The guests were all lined up — artists, writers, actors, a handful of token society girls. Lizzie glowed "in her black silk dress with its slim waist and long train sweeping the floor, touched at the neck and sleeves with white lace." Sing Lee wore a mandarin hat and a richly brocaded gown, his queue braided

The Modern Messiah. Oscar Wilde in San Francisco

with strands of scarlet silk. Wilde arrived late (for effect), swept through the studio door, threw off his cape, raised one eyebrow, and took in the room and its contents in one long and cold aesthetic stare: the decorated skylight, the bowing Chinese next to the tea service, Strong's portrait of his friend Frank Duveneck over the rear door, the leering Japanese idols, the porcelain bric-a-brac, the shells, the beaded moccasins, the peacock, and the skulls of Texas longhorns. "This is where I belong!" he cried out. "This is my atmosphere! I didn't know such a place existed in the whole United States."

The tea party was a resounding success. At one point, Wilde almost stumbled over Miss Piffle, Strong's lay figure, dressed in Lizzie's clothes and looking very lifelike in the light dimmed by Tavernier's roses. He then started a conversation with the dummy, according to Isobel "a marvel of impromptu humor": "He told her his opinion of San Francisco, and inci-

dentally of the United States and its inhabitants; he replied to imaginary remarks of hers with surprise or approval so cleverly that it sounded as though Miss Piffle were actually talking to him. It was a superb performance, a masterpiece of sparkling wit and gaiety." Before the party was over, Wilde had charmed everyone, including Strong, who had been only too pleased to serve him a second glass of punch.

Yet the good life was taking its toll. "There is among the majority of San Francisco artists an assiduously cultivated Bohemianism, that is paralyzing to the faculties of those who remain too long among us," the *Californian* had warned in the fall of 1881.[55] Strong, for one, was finding too many excuses to brew his legendary punch and too little time to paint. Fortunately, John Spreckels commissioned Strong to paint pictures for his Honolulu office, and in 1882 Isobel and Joe sailed for Hawaii, where Stoddard was already waiting for them. Of the rest of the original Montereyans, Elizabeth Strong was now studying art in Paris, and Von Perbandt had gone to live in the redwoods. Later, Rix was to leave as well — he went to New York, where he "gained immensely in manner and polish" and his paintings took on "an expensive, European look."[56] In 1884, Tavernier would join Strong in Hawaii, where in the spring of 1889 he drank himself to an early death (Isobel said there was a bullet hole through his heart). For the time being, however, he remained in San Francisco. Soon he would rally his colleagues in a memorable attack on the San Francisco Art Association, where Philistine rule was making artist life close to unbearable.

DRIVING
THE LAST SPIKE

ince his "Merchant of Venice" had taken first prize at the California Art Union in 1865, Thomas Hill had sketched at Fontainebleau and studied under Paul Meyerheim in Paris. Per the Boston papers, he also showed at the 1867 Paris Exposition, where Thomas Couture was said to have praised his work. After Hill's return to San Francisco in 1871, his client list ran like a roll call of the richest men in the West. Friends described him as "liberal to an extreme" though "red hot after money."[1] His enemies said he conducted his affairs in ways "not entirely legitimate." On the whole, however, such allegations found few believers, as Hill was in no need of "extraneous help" to enhance the value of his paintings.[2] Referring to one of Hill's large Yosemites, the influential critic S.G.W. Benjamin ranked him as one of the leading painters of grand mountain scenery. "Some of the qualities we have learned to look for in vain in the canvases of Bierstadt, we find represented or emphasized in the paintings of Thomas Hill," Benjamin wrote in "Fifty Years of American Art," published by *Harper's* in 1879. "In his great painting of the Yosemite he seems to have been inspired by a reverential

spirit; he has taken no liberties with his subject, but has endeavored with admirable art to convey a correct impression of the scene."[3]

Among Hill's San Francisco patrons was William Ralston, founder of the Bank of California and one of the leading developers of the Comstock silver mines. On one occasion the strapping financier — Ralston was six feet tall and kept in shape through daily swims in the bay — appeared at Hill's studio wanting to know how much he wanted for "the lot."[4] Hill, never shy about such matters, named his price. The next day the paintings were shipped to Belmont, Ralston's country estate south of San Francisco, famous for its sprawling white mansion which slept 120 guests and was almost always filled to capacity.

Ralston used Belmont — and Hill's paintings — in a grand promotional scheme to entice visitors to make California their permanent home and to invest their money in its future. In his elegant *charabanc* pulled by four black stallions, he would whisk his intended converts from hotels and ferry station, racing the trains down to Belmont. For a week or so he entertained them with sightseeing tours to the geysers and the giant redwoods (Ralston was the first to drive a four-in-hand through Yosemite), and a round of social calls to the Athertons, the Lathams, the Donahues, and other wealthy neighbors willing to show off their mansions and aristocratic life style. In the evenings, while Ralston's horses rested in stables of carved mahogany, their monogrammed harnesses hung on pegs of solid silver, his guests sat through 21-course dinners and danced under crystal chandeliers to the tune of a mechanical piano cranked by Ralston himself. Only later, much later, were they allowed to retire, exhausted and incredulous.

Hill's work also hung at the Palace Hotel, another showpiece in Ralston's selling of California. Lined with fireproof brick, the hotel was most celebrated for its circular carriage court of white marble, surrounded by tiers of balconies rising to a vaulted glass roof and kept warm by huge braziers of polished brass filled with glowing charcoal. Other touches included Irish linen, Bavarian china, French porcelain, and five elevators or

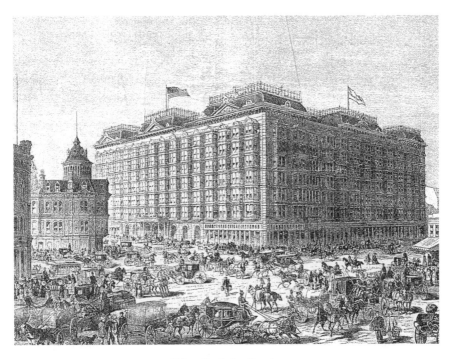

Palace Hotel, San Francisco

"rising rooms," furnished with couches, mirrors, and chairs. After Jules Tavernier refused to paint the Palace in accordance with Ralston's instructions, Ralston handed over the commission to Hill, who obligingly broadened Market Street so that he could fit in the entire hotel. Shortly thereafter, Ralston's reign came to an end. In August, 1875, the Bank of California collapsed because of excessive speculative financing on Ralston's part. On "Black Friday," August 26, nervous depositors made a run on the bank. Throughout the run, a pale but calm Ralston stayed with the clerks and the tellers. The next day he drowned while swimming in the bay, whether by design or not, no one could say.

Another of Hill's patrons was Elias Jackson "Lucky" Baldwin, a cocksure character with a pointed beard, wearing a Stetson hat and packing a pearl-handled pistol. Baldwin had gained his nickname "Lucky" when in

1872 he sold his Ophir stock to Ralston for $1,800 a share after having paid only $2 a share a couple of years earlier. He also developed the Santa Anita Rancho in southern California which had the largest racing stable in the country. Supposedly he was also the last ever to pay his bills, and then only if accompanied by a court judgment. Less lucky in love, Baldwin married four times. He was repeatedly sued for seduction and breach of promise, and shot twice by women he had wronged, one "a fair young cousin who charged him with her ruin."[5] In his defense he argued that his reputation as a womanizer was so solid that the ladies ought to be well forewarned and only had themselves to blame. None of this, however, was held against him when in 1875 he paid a reported $10,000 for Hill's "The Heart of the Sierra" (Hill said he received most of the money but not all). Measuring eight by twelve feet, the painting purported to be a scene of Lake Tenaya against a background of snowcapped mountains. Though composed of sketches from different locations, it was said to be "realistic in the strictest sense of the term."[6] The San Francisco papers were full of congratulations; after striking one bonanza in mining, Baldwin now had struck another in art. The *Overland Monthly* even held him up as a paragon, saying it was "glad that a wealthy Californian has shown his taste and judgment in purchasing [the painting] for a liberal sum, and thereby setting an example worthy of imitation by the rich *parvenus* who have hitherto been afraid to purchase any but foreign pictures."[7]

Also buying Hill's work was Leland Stanford, ex-governor and president of the Central Pacific (PLATE 15). Stanford's art gallery, in a mansion on top of Nob Hill, was finished in soft gray and gold in the style of Louis XVI and furnished with crimson plush sofas and ottomans. Here paintings by Bierstadt, Tavernier, and Hill hung alongside those by William-Adolphe Bouguereau, Jean-Léon Gérôme, Pierre Charles Comte, Auguste Leloir, Eugéne Verboeckhoven, and Meyer von Bremen. A portrait of Mrs. Stanford was executed by Léon Bonnat, one of Stanford Junior by Carolus Duran. Stanford himself had sat for Jean-Louis-Ernest Meissonier. Incorporated into the portrait was *The Horse in Motion*, an album of

photographs by Eadweard Muybridge, commissioned by Stanford to prove his theory that a horse, at a trot or at a gallop, momentarily has all four feet off the ground. Allegedly, Stanford first met Meissonier through the album. In his efforts to paint realistic images of horses mid-stride, Meissonier had conducted a few experiments of his own, one of which involved building a special trolley in which he could travel next to the running horse while observing it at close range.

Around 1874 Stanford had summoned Hill to his office. He received him from behind a massive desk piled with letters and reports, which he continued to peruse while simultaneously addressing the artist. An imposing man with a large chest, big nostrils, and sharp eyes, Stanford had the reputation of being a man who "clings to his friend with hooks of steel, but who will trample on his enemy as he would on a toad."[8] Opposite Hill, he spoke the way he usually spoke—slowly, as if with great effort, now and then looking up to note the effect of his words. He wanted to discuss a commission to paint Donner Lake, showing one of his trains making its way through the pass (Bierstadt, it will be remembered, had painted the same subject for Collis Huntington). He also wanted Hill to paint "a grand historical painting" of the ceremonies marking the 1869 completion of the transcontinental railroad, certainly one of Stanford's greatest moments.[9]

The building of the railroad had always been controversial. At first people scoffed at the notion of running a railroad across the mountains, saying it could not be done. Nonetheless, four Sacramento shopkeepers— Leland Stanford, Collis Huntington, Mark Hopkins, and Charles Crocker — persevered: their efforts, in time, would make them some of the wealthiest men in America. Their company, the Central Pacific, began construction eastward from Sacramento in January 1863. Their Eastern counterpart, the Union Pacific, began building westward from Omaha in July 1865. Work proceeded, despite blizzards and avalanches, and thanks to raw muscle, iron hand drills, black powder, and homemade nitroglycerin. Throughout, officials of both companies were accused of stretching the truth as well as the road when applying for land grants and government

bonds, which ranged from $16,000 to $48,000 per mile of track built. Other accusations involved accepting bribes to run the lines through certain towns, and risking the lives of their workers. In April 1869 the two construction gangs engaged in a spectacular last race across the desert in Utah. The Union Pacific crews broke a record by laying eight miles of track in two days. The Central Pacific crews, made up of mostly Chinese, answered by laying the final 10 miles in only one day, as Charles Crocker, in his own words, roared up and down the line "like a mad bull," all 265 pounds of him, "raising Old Nick with the boys that were not up to time."[10]

When the rails finally met, hundreds of people — railroad laborers, surveyors, engineers, soldiers, journalists, Indians, and Mormon farmers — gathered to celebrate at Promontory Point, a sage-strewn plateau some fifty miles northwest of Ogden, Utah. The day was sunny with a few clouds and a slight breeze. "Twenty or thirty prominent newspapers are here," wrote an eyewitness. "Everybody who is sober enough is scribbling; some are cheering, some laughing and throwing up their hats and it is a festive scene."[11] The Central Pacific contingent — the Big Four and their distinguished guests—had come prepared with costly ceremonial spikes, the engine of their train covered with flags and ribbons. The Union Pacific group, on the other hand, arrived "unprepared for celebrating except by a collation, and a little unpremeditated eloquence."[12] The journey had been trying. Unpaid railroad workers had held them hostage in Wyoming for two days, demanding five months' back pay. Thomas Durant, the ranking Union Pacific official, had nursed a headache ever since. After some last-minute arguing about who would drive which ceremonial spike, Stanford and Durant took turns tapping four spikes of gold and silver into a polished tie of California laurel. Next they tackled the real thing — the last iron spike. Connected to a telegraph wire, it would, when driven, flash the word "Done" to a waiting nation. Stanford lifted the heavy sledge hammer, swung — and missed. The crowd cheered. The military band, which by now "had taken too much ardent spirit," kept playing, not well but steadfastly.[13] Then Durant had a go at the spike. He, too, missed. A worker came to the rescue. After some

forty years in coming, the great Pacific Railroad was finally a reality. Champagne was poured on the tracks as Central Pacific's engine *Jupiter* and Union Pacific's *No. 119* slowly moved up, head to head, cowcatchers touching, steam whistles blowing. "Never since history commenced her record of human events," gushed the speechmaker, "has she been called upon to note the completion of a work so magnificent in conception and so marvelous in execution."[14]

This was the event Stanford wanted Hill to paint. "After a great deal of talk, in which the whole scene was laid out graphically before me, even to the minor details and the naming of most of the characters to be represented, it was agreed that I should paint the picture under his direction," Hill recalled in a privately printed pamphlet a few years later. Although Hill couldn't quite "form an idea what such a task would be worth," he promised Stanford it would not exceed $25,000. In any case, he agreed to leave that matter to his patron, "having every confidence in his good judgment and generosity."[15] Next Hill was off to Promontory — on a railroad pass furnished by Stanford — to sketch the scenery for the background of the painting. As recalled by the *News Letter*, he left "with a great flourish of trumpets," joined by two friends to "guard him from the Indians, who, it was feared, would molest the great artist in his undertaking to perpetrate and hand down to future generations the scene which was the signal of the red man's utter defeat and humiliation."[16] The danger of an Indian attack was probably exaggerated. It was the year before Little Big Horn and Custer's last stand, and the old ways of native Americans were ending. By now they too rode the trains, on railroad passes furnished by Crocker, permitting chieftains to ride the passenger cars and tribesmen of lesser rank to ride the freight cars.

However, about a year later the *News Letter* announced, based on "the best authority," that the painting was not to be painted after all, that "no such commission has ever been given, or will be given, by Mr. Stanford — had in fact been refused."[17] Hill, in his pamphlet, also referred to some sort of changed understanding. Stanford, at the time, had commissioned

William W. Story, the renowned American sculptor, to create a monument in honor of Stanford's many achievements. Story provided drawings for a curious piece of allegorical work, which showed Stanford, in the words of Hill, as "coming out of the clouds on a locomotive, and in many other god-like attitudes figurative of the life and doings of the governor." Stanford showed Hill the drawings and asked for his opinion. Hill, rather at a loss for words, "spoke in praise of their execution, but thought, as any sensible person would, that they were in bad taste." Stanford, again according to Hill, was then advised by a friend to drop not only the statuary but Hill's painting as well. Thus, one day when Hill met Stanford in the street, Stanford approached him "in the friendliest manner," telling him that he would have to "countermand the order for the Spike picture, as he feared that his friends and the public would think him egotistical if he had anything to do with such a work." Hill told Stanford he would finish the painting anyway. It was an historic picture, he said, and, if "truthful," bound to find a purchaser. Stanford agreed and asked to be the first to see the painting when it was completed. Supposedly the two men left it at that.[18]

During the next few years, Stanford continued to patronize Hill. In 1876 he bought a large Yosemite, a sweeping view of the Merced River, Bridal Veil Falls, El Capitan, Half Dome, North Dome, Cathedral Rocks, the Royal Arches, and the Sentinels (PLATE 16). The painting was controversial from the start. The ever vigilant *News Letter* claimed that, aside from a slightly different foreground featuring tourists on horseback rather than Indians by a wigwam, the painting was to all intents and purposes a duplicate of an earlier Yosemite, the "Great Canyon of the Sierra," finished in Boston in 1871. After the "Great Canyon" won the bronze medal at the Palette Club in New York, it had been purchased by Judge Edwin B. Crocker of Sacramento for either $5,000 or $10,000, depending on which source one chose to believe. In any case, reasoned the *News Letter*, the judge had paid enough to own the subject as well as the canvas. In a letter to the *News Letter*, a "friend" came to Hill's rescue. The letter stated that while the new Yosemite was indeed painted from sketches taken at the

actual scene, the "Great Canyon" had been painted from a photograph by Carleton Watkins. The letter, of course, only confused matters and damaged Hill's reputation. Shortly thereafter, an article appeared in the *Bulletin*, profusely extolling the virtues of the new Yosemite. Disgusted, the *News Letter* called the article nothing but a puffed-up ad parading as a legitimate piece of criticism, and placed in the paper either by Hill himself or by his helpful "friend."[19]

When reports were published that Stanford had paid $10,000 for the new Yosemite, tempers flared anew. The *News Letter* claimed the painting had brought much less, condemning the practice of hyping an artist's work by reporting false prices to the press, a practice indulged in not only by Hill but by other artists as well. By now, even the *Bulletin* was losing patience. "A vicious habit is obtaining ground here of reporting the prices at which pictures sold much higher than the facts warrant," it growled. "We have in our mind an instance where the reported price of a picture sold was $10,000, and it was so certified to us in writing. We happen to know that the picture brought only about half that sum. Art does not need to be bolstered up by falsehoods. Hereafter when the price which a picture has brought is reported falsely, we shall correct the mistake in a way which will be much more satisfactory to us than to the party who attempts to mislead us and the public."[20] None of the quibbling, however, seemed to hurt the painting, which went on to win "Best in Landscape" at the Philadelphia Centennial, in competition with works by Thomas Cole, John F. Kensett, Asher B. Durand, Sanford R. Gifford, Worthington Whittredge, Thomas Moran, and Albert Bierstadt. In the *Official Report of the American Centennial Exhibition*, John Ferguson Weir called it "superior to anything of the kind in the Exhibition in the way of attractive and realistic representation of scenery strikingly grand in its own elements."[21]

Meanwhile, despite frequent interruptions, Hill continued work on "The Driving of the Last Spike." Although Stanford had withdrawn his open patronage, Hill claimed that Stanford continued to supervise and direct Hill's work, providing him with photographs and sending over

sitters. At times Hill's studio was besieged by Central Pacific railroad officials carrying notes from headquarters requesting Hill to find a place for them. Stanford, again according to Hill, kept rearranging the painting, ordering personal foes cut out and friends' faces added to their decapitated bodies. When Stanford discovered that Hill had placed Durant next to Stanford, both men holding hammers, he objected "in expressive language."[22] Nobody except Stanford was to have a hammer, and Hill was told to find a less noticeable position for Durant. Frederick MacCrellish, editor of the *Alta*, was ordered out altogether. The banishment was hardly surprising. Throughout the construction of the railroad, MacCrellish and his paper had ridiculed and criticized the Big Four; Judge Edwin B. Crocker, legal counsel to the Central Pacific, supposedly had two of his clerks employed full time merely pasting clippings into scrapbooks, "under different heads."[23]

In January 1881 Hill gave a private showing of "The Driving of the Last Spike" to friends, patrons and critics at the San Francisco Art Association (PLATE 17). In the Great Picture tradition, spectators were given a printed lettersheet (copyright Thomas Hill) which explained the painting at some length. The mammoth canvas, measuring eight by twelve feet, showed a dignified group of railroad, financial and political luminaries, men in flowing coattails and mutton-chop whiskers, baring their heads. It represented, according to the lettersheet, "the assiduous labor of nearly four years — four years of determined effort to make the absolute and commonplace yield to the principles of art." Of some four hundred figures, seventy were actual portraits, "placed in positions pre-arranged, and not easily varied": "It was essential that they should be grouped according to official prominence, and rules of subordination, based on their relative importance to the enterprise." Indians, soldiers, a poker game on a barrelhead, a wagon train, and a mustang race were added "to give variety of detail, to enrich and harmonize the colors, and to relieve the more formal groupings."[24] The moment chosen was just before the actual spike-driving, with most everyone's attention focused on the clergyman offering up his

invocation. In the center was Stanford, hammer in hand, with the electrician kneeling at his feet, adjusting the wire leading off to the telegraph pole on the right. To the side, behind two women with elaborate hats, were Charles and Edwin Crocker. Next to the Crocker brothers, towards the front, was chief engineer Theodore Judah, who looked amazingly lifelike considering the fact that he had died six years before the ceremony. Farther back was Mark Hopkins, soft-spoken and studious, with an extraordinary fondness for account books and expense tallies. Huntington—the mastermind of the Big Four, shrewd lobbyist in Washington, "scrupulously dishonest" and "ruthless as a crocodile"[25]— had been placed behind Stanford and James Harvey Strobridge, Crocker's chief construction boss. Strobridge, in turn, had replaced Durant, now standing a few feet away from Stanford, looking rather meek without his hammer.

The critics were of varying opinions. "When people came, at last, to behold a group of gentlemen, standing with that stiff awkwardness inherent in the male sex upon a railroad track in the midst of a desert, there was an inevitable sense of disappointment," wrote the *Californian*. "Large groups of gentlemen, all arrayed in the modern stiff black suit, are not even graceful. There is no appeal to any of the higher passions. There is no action. It is simply a canvas crowded with black coats and pants."[26] The *Chronicle*, on the other hand, felt that all was "ease, grace and naturalness where we might reasonably have expected hardness of line and repellant formality,"[27] while the *Alta*, despite the exclusion of editor MacCrellish, called the painting "a rare combination of strong faces and manly forms."[28]

Stanford, at least according to Hill, "seemed delighted with the work, and spoke of it as 'giving him more pleasure than any picture he ever saw.'" Hill, however, needed more than verbal recompense. Emboldened by Stanford's praise, he asked for an advance of $5,000 to tide him over for the time being. Stanford readily agreed, told Hill to pick up the money at his office, and left. Next Charles Crocker walked through the door. "What d—d nonsense is that?" he exploded when he laid eyes on the painting. Hill, courteous as always, tried to deflect the onrush of invectives by

offering to perfect Crocker's likeness, if Crocker would only be good enough to come to his studio for a sitting. "He was too mad a man at something to even give me a civil answer," Hill recalled. "He asked if Mr. Stanford ordered it. I told him he did, and had directed its general arrangement from the beginning. He evidently was greatly offended at something and left me with malice in his eyes."[29]

When Hill called at Stanford's office the next morning, Stanford would not see him. After returning for several consecutive days, never getting beyond Stanford's waiting room, Hill finally received word through one of Stanford's "pampered menials" that Stanford "did not wish to buy any more pictures." Next, there was Stanford's sudden departure for Europe. "There are not many men situated as I was who could have escaped the asylum in Stockton," wrote Hill. "Though I was $10,000 in debt on account of the picture, this I could have got over, but to be left like a cur dog by my 'friend,' as I supposed, was incomprehensible and humiliating. If I could have known the cause! What had I done? His treatment so preyed upon my mind that my friends had grave fears for me."[30]

Meanwhile, down at the SFAA, the Spike picture had a close call too. "One day last week," wrote the *News Letter*, "the reflector escaped from its mooring near the ceiling, and swooped toward the canvas like a huge hawk, or bat, or eagle, bent on destruction. First it seemed to bode malicious mischief to Governor Stanford; then hovering on the right, it threatened Charles Crocker's capacious brain, afterward approaching his more capacious stomach, like the sword of a Japanese official about to commit harakiri. After this, taking a turn to the left, it attempted to behead the ... clergyman, and finally ended its alarming gyrations by penetrating the skull of the Indian cigar-seller, and clipping off the nose of the gambler standing near her. Mr. Hill, who is not unskilled in surgery of this kind, quietly repaired the damages, and the public will be no wiser."[31]

In the end, what truly happened between Stanford and Hill can only be a matter of conjecture. Stanford died in 1893, leaving behind large debts brought on by a life style so extravagant that even the railroad failed to sup-

port it. To the very last, he denied ever having commissioned "The Driving of the Last Spike." George T. Clark, Stanford's biographer, would back him up. "Mr. Hill's original composition seems to have grown and developed until it transcended the realm of actualities," wrote Clark in 1931. What "most offended Stanford's sense of historical accuracy was the introduction of some seventy portraits of men prominently identified with the Union and Central Pacific railroads, very few of whom were really present when the last spike was driven."[32]

Hill also stuck to his version. In 1895 he placed a claim against the Leland Stanford estate for payment of the controversial painting. The claim was rejected. In 1905, after Mrs. Stanford's death, he corresponded with Henry C. Petersen, curator of the Leland Stanford, Jr. Museum. Petersen tried to find a donor who would buy the painting for the Stanford collection, but failed. According to Hill, the son of a certain East Coast railroad official offered to buy the painting and place it in New York, "where it would be fully appreciated." First, though, he requested that Hill make a few more "alterations," no doubt having to do with giving his father more of the limelight. Hill declined, claiming to be "too loyal to the old cause."[33] Hubert H. Bancroft, the historian, sided with Hill (he himself had had some problems dealing with Stanford). "The Driving of the Last Spike," wrote Bancroft in 1912, was painted "at the instigation of Leland Stanford." However, Stanford soon realized that the "associate magnates" resented the conspicuous position given him by Hill. "So in order to show indifference to fame, and smooth the ruffled plumage of the others, he repudiated his obligation to Hill, and left the huge painting, the work of several years, on the artist's hands."[34]

It is certain, however, that Hill and Stanford were not the only ones feeling the squeeze of hard times. By the early 1880s, the depression already hurting the rest of the country had caught up with California as well. The railroad had failed to bring about the expected surge in prosperity: rather than creating opportunities for California merchants and manufacturers, it had made them vulnerable to competition from the East. Land values

declined, new construction tapered off, unemployment rose. Denis Kearney organized the Workingmen's party, which campaigned against the Big Four as well as the Chinese, imported by boatloads to help build the railroad, but now stranded in San Francisco, where they worked for low wages. Additionally, the bottom fell out of the Comstock. Like the railroad, the stock gambling craze had enriched a few and impoverished thousands. The aggregate value of "Consolidated Virginia" had fallen from $75,000,000 in 1875 to less than one million in 1881. "Sierra Nevada," during the same period, fell from $27,000,000 to $825,000; "California" from $84,000,000 to $351,000.[35] Outside the San Francisco Stock Exchange, where brokers usually made their way through crowds of would-be investors, all was quiet. "Men, aye and women, too," stumbled along the city sidewalks, looking downward and talking to themselves.[36] The bonanza was over, and the morning after had dawned. Art, too, went begging.

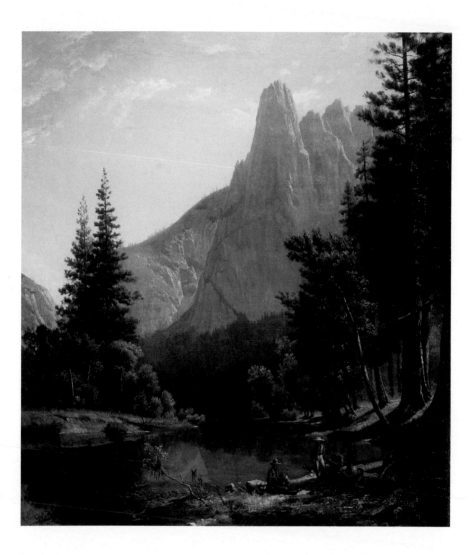

PLATE 1
Virgil Macey Williams (1830–1886)
Along the Mariposa Trail, 1863

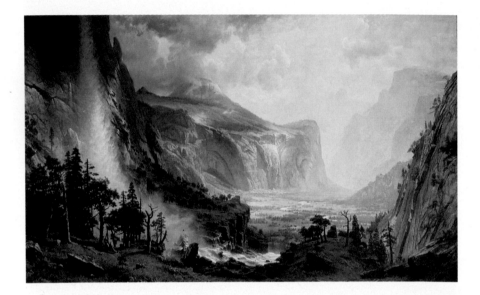

PLATE 2
ALBERT BIERSTADT (1830–1902)
Domes of Yosemite, 1867

PLATE 3
Art Gallery, Woodward Gardens
San Francisco Public Library

PLATE 4
SAMUEL MARSDEN BROOKES (1816–1892)
Sacramento River Fish, 1872

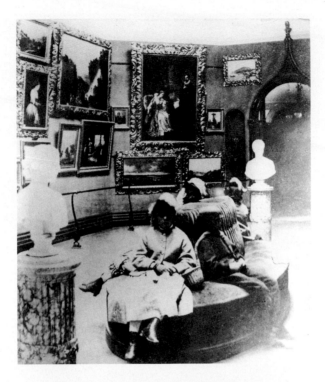

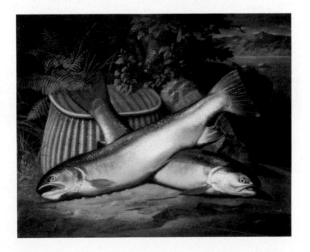

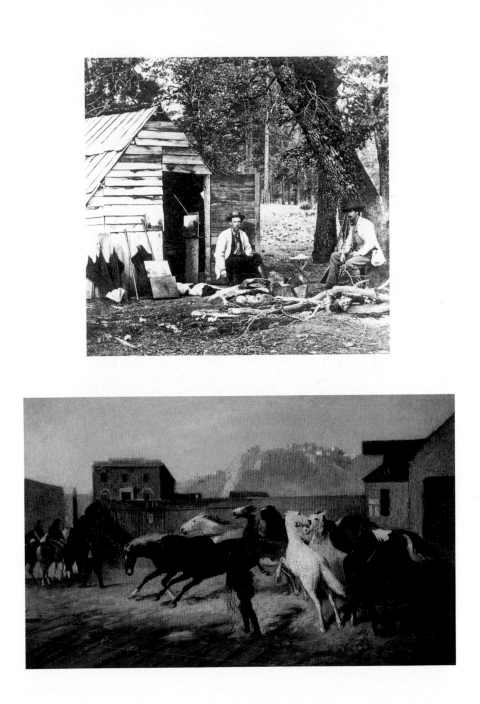

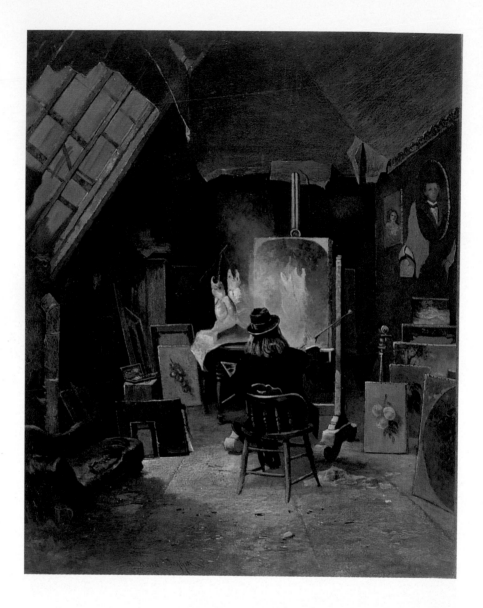

PLATE 8

EDWIN DEAKIN (1838–1923)
Samuel Marsden Brookes in His Studio, 1876

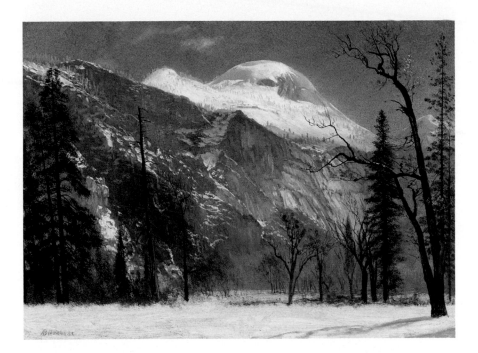

PLATE 9
ALBERT BIERSTADT (1830–1902)
Winter in Yosemite Valley, 1872

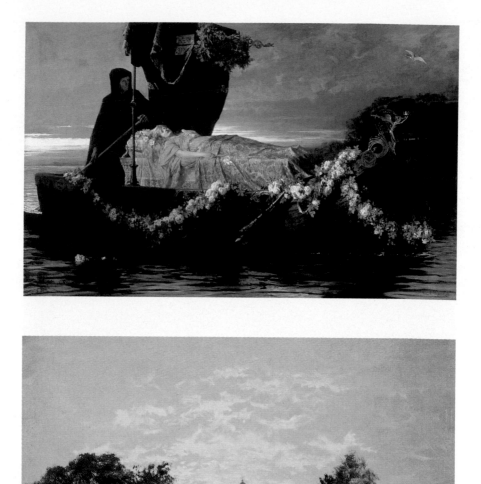

PLATE 12
JULES TAVERNIER (1844–1889)
In the Forest, n.d.

PLATE 13
Joseph Dwight Strong (1852–1899)
Isobel at Monterey, 1879

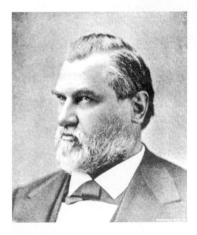

PLATE 14
Robert Louis Stevenson

PLATE 15
Leland Stanford

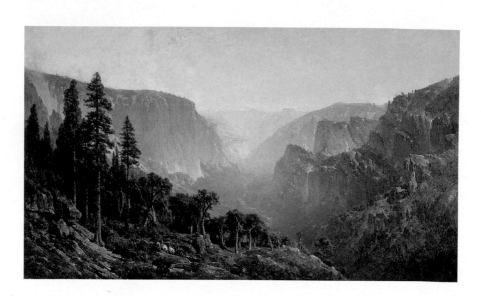

PLATE 16
THOMAS HILL (1829–1908)
Yosemite Valley, 1876

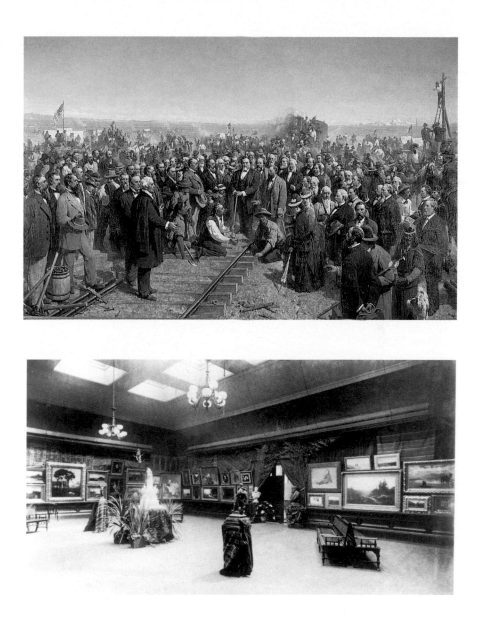

PLATE 17

THOMAS HILL (1829–1908)

The Driving of the Last Spike, c. 1881

PLATE 18

*Exhibition of Paintings at the San Francisco Art
Association on Pine Street, c. 1880*

PLATE 19

EDWIN DEAKIN (1838–1923)

Notre Dame, Paris, 1888

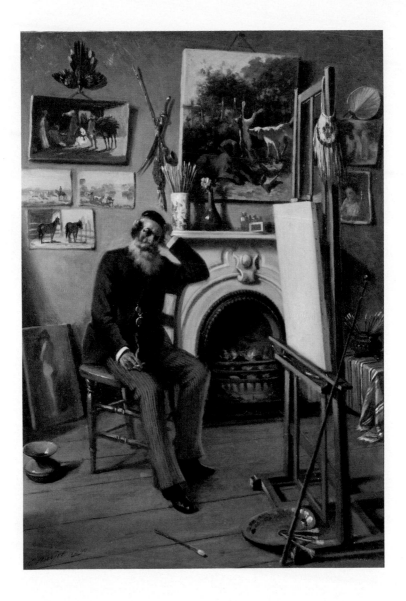

PLATE 20

ERNEST NARJOT (1826–1898)

Self-portrait in the Artist's Studio, 1890

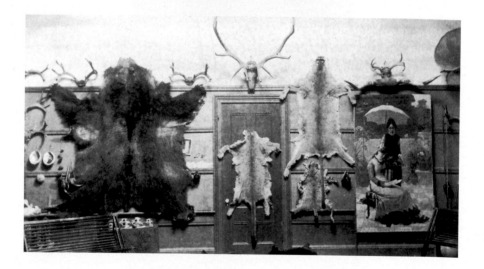

PLATE 24
Thomas Hill

PLATE 25
Interior Thomas Hill's Yosemite Studio

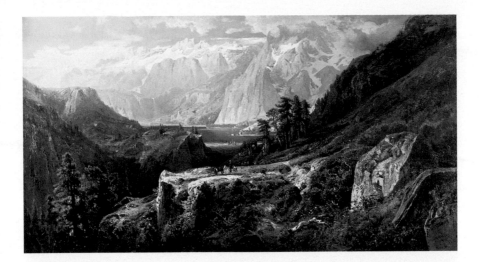

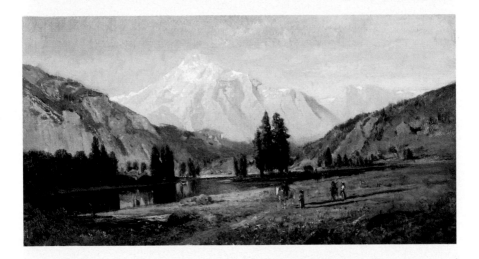

PLATE 26
WILLIAM KEITH (1838–1911)
California Alpine Grandeur, c. 1878

PLATE 27
WILLIAM KEITH (1838–1911)
*Glacial Meadow and Lake, High Sierra
(Tuolomne Meadows)*, c. 1870–79

PLATE 28
GEORGE INNESS (1825–1894)
California, 1894

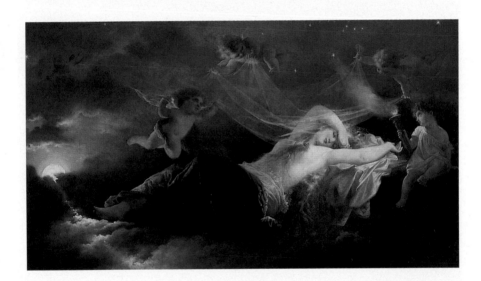

PLATE 31
GRACE CARPENTER HUDSON (1865–1937)
Little Mendocino, 1892

PLATE 32
Grace Hudson, the Crack Shot

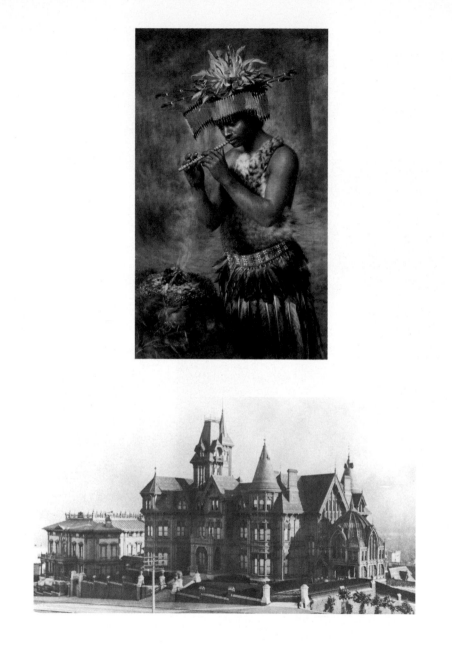

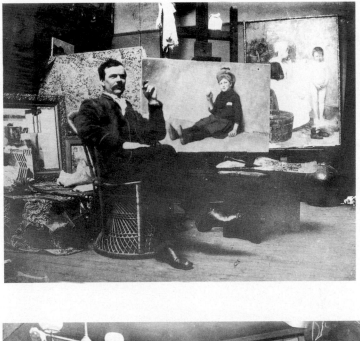

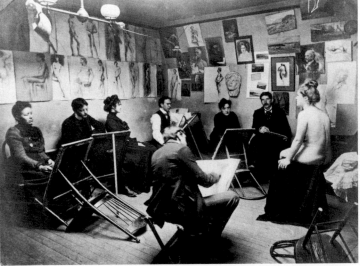

PLATE 35
Arthur Mathews in His Studio

PLATE 36
Life Class at Mark Hopkins Institute of Art,
c. 1898

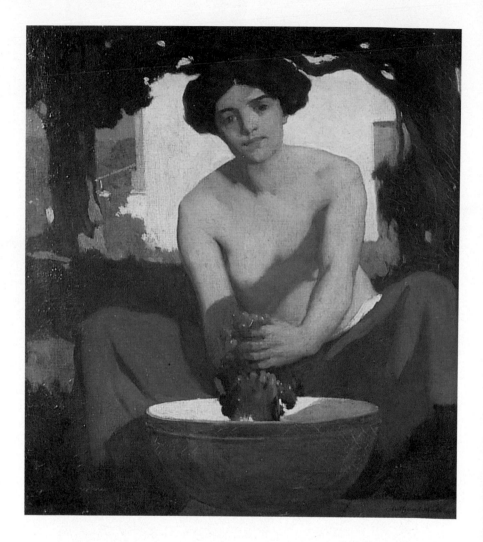

PLATE 37
ARTHUR FRANK MATHEWS (1860–1945)
The Grape (The Wine Maker), c.1906

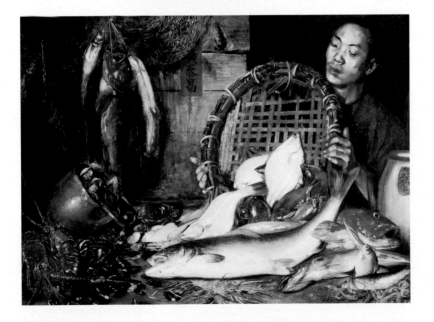

PLATE 38
Theodore Wores

PLATE 39
THEODORE WORES (1859–1939)
Chinese Fishmonger, 1881

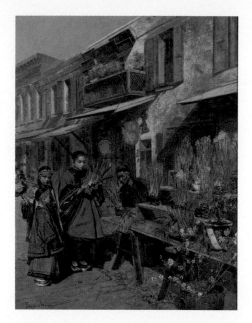

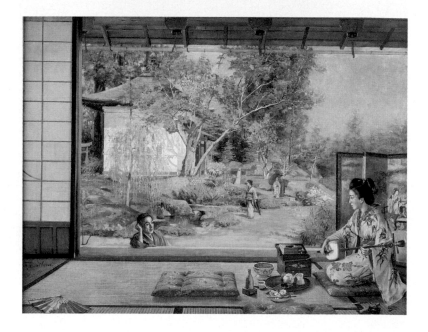

PLATE 42
CHARLES ROLLO PETERS (1862–1928)
Nocturnal Street Scene, n.d.

PLATE 43
WILLIAM KEITH (1838–1911)
Evening, n.d.

PLATE 44
GOTTARDO PIAZZONI (1872–1945)
Reflection, 1904

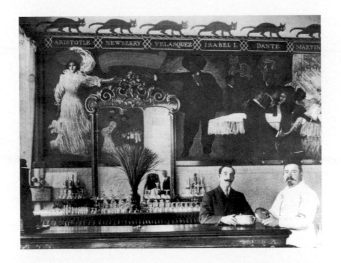

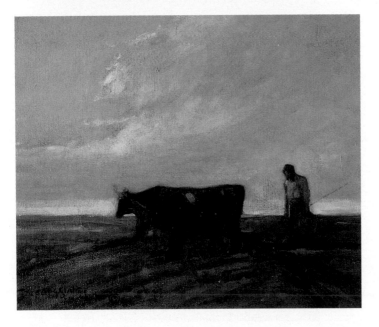

PLATE 45

Coppa's Restaurant

PLATE 46

XAVIER MARTINEZ (1869–1943)

Oxen Plowing, n.d

PLATE 47
WILLIAM ALEXANDER COULTER
(1849–1936)
San Francisco Fire, 1906

PLATE 48
THEODORE WORES (1859–1939)
*Ruins of City Hall after the Great Earthquake
and Fire, San Francisco*, 1906

BUCKEYES AND POTBOILERS

n early 1879 the *New York Times* printed scathing reports on the state of art in America. American art was suffering from "discouragement" and "neglect." A "general sense of poverty," brought on by the depression, was in part to blame. More to the point, though, American art buyers showed "a perverted preference for foreign products."[1] This, added to an unwillingness to study and learn, made them an easy target for unscrupulous dealers both abroad and at home. In hotel lobbies all over Europe, "cappers" were waiting to steer ignorant Americans to picture dealers who paid a handsome commission for each new customer.[2] In America, the scam continued. "It is a well-known fact that the rubbish left in foreign shops, after the best works have been carried off, is almost invariably shipped to this country, and makes up a large part of the stock of our dealers."[3] These dealers "have assiduously disparaged native artists and undermined their interests, resorting to the most unworthy tricks to win away their patrons and influence opinion against them."[4]

Thus, in 1881, visitors to the San Francisco Mechanics' Fair were sur-
prised, though not as surprised as they ought to have been, by the appear-
ance of the J.W. Shaw Collection of Old Masters, scheduled to be sold at
auction immediately following the exhibition. Lit by rows of gas jets, the
collection featured some sixty paintings, including Lebrun's "Day of
Judgment," Veronese's "Adoration of the Magi," Dürer's "Holy Family,"
Murillo's "Immaculate Birth of Christ," plus one Van Dyck, one
Tintoretto, two Teniers, and no fewer than four Titians. These were very
old masters indeed, "genuine originals," normally not obtainable for any
amount of money. Shaw, in fact, had purchased them in Spain during the
late Civil War, at a most opportune time "when many such works were hur-
ried into market in Madrid, or sent across the border into France."
According to the catalogue, the people of New York had declined the
opportunity to buy Shaw's treasures, partly because of "the most illfound-
ed prejudice which exists there against 'religious paintings.'" Thus provi-
dence had brought them to San Francisco, where the people were blissful-
ly free from religious restraints.[5]

By the sound of it, the paintings were the typical collection of forg-
eries. Some of them may have been entirely new productions: copies black-
ened by smoke, the paint made to crack through heat or varnishes, a few
"fly spots" discreetly added through judicious sprinkling of the right color
paint. The most common type of forgery, however, was not the newly
painted picture, but the one painted on top of an old one, the existing sig-
nature replaced by a more impressive one. The advantages were obvious.
The back of the panel or the canvas showed all the right signs of age (noth-
ing like a few worm holes to reassure the suspicious). Often, the forger
would repaint only certain parts, then proceed to destroy and restore his
own work, so as to dispel all doubts as to its authenticity.

The San Francisco press blew the whistle. "Poor galleries of Madrid
and Seville! poor Louvre! poor Pitti Patti!," mocked the *News Letter*.
"Your Murillos, your Titians, your Tintorettos, are mere copies or shams.
The true originals are here at the Mechanics' Pavilion. Dispel your delu-

sions — be quick, they are for sale — the whole of Europe is coming to buy them."[6] The *Chronicle*, too, had grave doubts regarding the authenticity of the collection: "True, Mr. Shaw acknowledges that 'most of the paintings are not first-class works,' but even a third-class Titian, whatever that may be, does not go floating around waiting for chance buyers." It was, concluded the writer, "very evident that there has been a big mistake somewhere, and that someone has been betrayed into a shady transaction." Whether this "someone" was the "distressed Spanish Government," Shaw's European "advisers," or Shaw himself was open to speculation. The best possibility was Shaw himself, because, if not, he was nothing but a ruthless swindler trying to "dispose of a lot of wretched daubs at a fictitious value."[7]

If the trade in "old masters" was losing credibility, the trafficking in "buckeyes" was as brisk as ever. Buckeyes were paintings mass-produced at "picture factories," the largest of which was located in New York. The owner, Phillip Levy, bragged of a capacity to fill an order for a hundred

MISS PRESIDIO DE HYTE (a local art connoisseur and patron of deserving paint shops) — Oh, Mr. Joullong, do tell us what you think of this lovely chromo which Paw bought at the Jabez Swan sale the other day for eight dollars and fifteen cents. It's guaranteed a genuine Jackart. MR. JOULLONG (one of those envious local artists) — Great heavens, what a colossal swindle! Where's the cart?

Another Disputed Art Treasure

paintings on only a few hours' notice. Although Levy was known to cut even more corners than some of his competitors, his operation was still typical of the business.

House and carriage painters laid in the groundwork on cheap cotton canvas, using stencil plates, broad brushes, and ready-mixed paint. The canvases were then passed on to more accomplished artists, who, assembly-line style, contributed their particular specialties, one working up the sky and distant effects ("such light that never was on sea or land"), another following with the foreground, a third filling in the middle distance, a fourth throwing in some prize cattle or a pair of swooning lovers — whatever the setting called for. The signatures were either pure inventions — preferably foreign-sounding, such as Waterbin, Jardinier, or Schinzel — or closely resembled, perhaps slightly changed in spelling, those of well-known artists, such as Gifforde for Gifford, Sontag for Sonntag, or Shryer for Schreyer. Finally, to hide some of their most glaring faults, the buckeyes were coated with thick layers of varnish and placed in frames covered with a composition known as "Vienna metal," a cheap imitation of gilt which invariably cracked and tarnished after a month or so.

Thus they arrived by carloads in San Francisco, where they were put up for auction, advertised as "genuine oil paintings in real gold frames." Painting after painting was placed on a brilliantly lit easel and sold off by a glib auctioneer. The bidding was spirited, typically kindled and rekindled through bogus bids placed by secret "confederates" hired expressly for that purpose.[8] The collection was usually knocked down at prices ranging from $50 to $250, while Levy himself stood at the front of the auction room, wringing his hands in despair over the "ruinous sacrifice."[9]

Eventually, San Francisco artists grew tired of watching their own work gather dust, while sales of inferior pictures were booming down at the corner auction house. Some lost heart and began painting pot-boilers, which were auctioned off at the so-called artists' combination sales, held at the San Francisco Art Association following the exhibitions. Dashed off for easy cash, these potboilers were typically short on drawing

and long on paint, not entirely without merit but clearly catering to popular taste. Many buyers were all too easily taken in. And, because everything was offered with the implied endorsement of the SFAA, they thought themselves on safe ground, bidding wildly on the paintings of their choice, mostly those tending towards mawkish sentiment and gaudy color. As a result, good work was slaughtered while bad work fetched prices far above actual value.

The practice soon made everyone look bad. Elsewhere, as the *News Letter* pointed out, auctions might be "perfectly legitimate and quite the thing."[10] In San Francisco, however, they meant that either the artist or the buyer was almost invariably taken. In the case of auctions held by individual artists, it was usually the artist. William Keith's sale in 1874 was characterized by the *Call* as "a sale memorable for the high quality of the pictures, and for the miserable, indiscriminate prices realized."[11] The result of William Hahn's auction in 1876 was just as discouraging. In the words of the *News Letter*, the paintings brought "ridiculously low prices": "There seems to be no buyers who know, or care, for the difference between manufactured pictures, duplicates, or even copies, and such real, honest work as that put out by Mr. Hahn."[12] The following year it was Thomas Hill's turn. While he had indeed held a successful auction in 1874, he too was about to experience failure. According to the *Examiner*, the auction was "well attended" but the bidding "apathetic."[13] A scene of a bear hunt brought the highest price and went to E.J. Baldwin for $1,100. The *Alta* commented that "hardly a single painting went for its intrinsic value": "the prices obtained were only so-so at best, and in several instances, the painting was passed and withdrawn, because nobody would start it at the artist's price."[14]

Shortly after the Hill sale, the SFAA directors committed an obvious and disastrous blunder. They announced that some one hundred twenty European paintings, owned by a C. Highwood of Munich, were to be hung at the SFAA and later sold at auction. The idea was to "still further popularize" the SFAA, which had recently moved to new quarters next to the Bohemian Club, above the California Market at 430 Pine Street.[15]

According to the SFAA Secretary, the collection comprised "the most *magnificent collection* of foreign pictures" ever brought to San Francisco, "being selections from the *ateliers* of most of the celebrated artists of Europe, including Gérôme, Toulmouche, Goupil, Hue, Caraud, Andreas Achenbach, Madou and others."[16]

However, once hung, the collection failed to deliver. According to the *News Letter*, it was "greeted by metaphorical catcalls at the hands of the press and a well-nigh unanimous verdict of 'Trash' on the part of artists and connoisseurs."[17] The *Bulletin*, somewhat cautiously, ranked most of the paintings "good enough for the auction room, but not good enough to be exhibited under the patronage of the SFAA."[18] The *Chronicle* maintained that not one of ten was "a genuine work of the artist whose name it bears." In fact, the paintings were simply the property of "a professional picture-peddler, who has brought them from New York, stopping at intermediate cities and winnowing out nearly all that was worth having at successive auctions and leaving the refuse for the San Francisco market."[19] The SFAA, rather shamefaced, had no choice but to cut its losses and withdraw the collection from public view.

In 1879 word leaked out that certain San Francisco artists were themselves on contract with the firm of Dampf & Childs, an itinerant peddler of potboilers, with headquarters in San Francisco. The *News Letter* critic wasted no time looking up the firm at its prestigious 638 Market Street address, across from the Palace Hotel. A careful inspection of the paintings disclosed that they did indeed carry the signatures of various noted San Francisco artists, and, although executed in a hurried manner, they were indeed the products of these artists' brushes. Dampf himself was roped in for an interview, where he confirmed that he represented several artists of "acknowledged ability," such as Jules Tavernier, Julian Rix, Gideon Jacques Denny, Charles Dormon Robinson, and Domenico Tojetti.[20] The artists, he said, received from $4 to $20 per painting, with Dampf furnishing the canvas and the paint, which meant a saving to the artists of $2 to $5. Not offered for sale in San Francisco, the paintings were shipped to

"interior towns," where they sold at prices ranging from $25 to $80, depending on the size of the canvas — quality and subject being of no importance.[21] The gold frames were included in the price, and, as Dampf so eloquently put it, "varranted to vash long after you is tead."[22]

Dampf also claimed that he could add to his list just about any other local artist he desired, even though some of them preferred not to have their names mentioned. However, after some clever questioning, the reporter felt reasonably reassured that the majority of the San Francisco artists did not have the pleasure of Dampf's acquaintance — at least not yet. Meanwhile, the artists already named observed an ominous silence. Even when the *News Letter* threatened to publish catalogues and lists of prices realized at various locations, the only response it got was the assurance, which came "from good authority," that the artists were digging in their heels and intended to continue their potboiling as long as they deemed it necessary. By way of apology, it was asserted that "all the noted artists of this country and Europe are doing likewise."[23]

Apparently, this was not too far from the truth. In 1881, the New York *Evening Post* reported that potboilers by "well known" local artists were for sale at "some of the better auction houses," consigned by dealers "well acquainted with the sources of supply, and with the worth of ready money for the impecunious artist."[24] In Europe, Courbet had set up his own picture factory, after he was arrested and fined some 400,000 francs in connection with the demolition of the Vendôme column during the 1871 Commune.

According to the *New York Times*, others had succumbed as well. "Occasionally a man of world-wide reputation accepts an American order, but he cannot divest himself of the feeling that his work is to be expatriated and to go where it will be appreciated, not for its excellence, but for the fact that his name is upon it and it cost a large sum of money. Consequently, he sends out a pretentious but careless and slovenly piece of work. It is hardly in the nature of things that a great European artist should want his best works to come here, where they would no longer be seen by

those on whose judgment his reputation and success mainly depend, or be closely associated with his career. Besides, it is certain that the best works of these men are secured by the munificent buyers of their own countries."[25]

Not unexpectedly, more voices began to be heard in defense of the potboiler. In an anonymous letter to the *Chronicle*, the writer argued that art should not be for the wealthy alone. The masses had had their fill of engravings and chromolithographs — artists who painted "cheap and respectable oil paintings" gave them a chance to own the real thing and ought to be commended for it. The demand for potboilers signaled a primal longing for genuine art, a desire which — in time — would refine itself and only grow stronger as America itself came of age. Whoever tried to deny this "might as well stand on the bank of the river and bewail its onward flow to the ocean."[26] Thus, the potboilers being unavoidable — in fact the whole country would sooner or later be flooded with them — why not encourage home industry and buy the works of local artists rather than those offered by transient hucksters from New York?

The issue was also addressed from the artist's point of view. "No man — not even a great painter — can live on exalted inspiration," commented Noah S. Brooks in the *Overland Monthly*. "If he cannot sell his best work for a thousand or five thousand dollars, and can sell his worst for a hundred or fifty, or even less, then he must paint pot-boilers, at least to sustain him while he is doing something better."[27] New York artist Will Low, on the other hand, was against potboilers on principle, as set forth in "A Letter to a Young Gentleman Who Proposes to Embrace the Career of Art," published by *Scribner's* (young women entertaining similar notions were ignored). The artist, in Low's opinion, must be financially independent of his art. To pay his way he must find other work, such as magazine illustration or teaching. "You can draw honest illustrations where the subject and even the manner of treatment is imposed upon you. You can teach honestly. But you cannot paint honest pictures if in their production you relent for a moment from an unflinching effort to do your best."[28]

Robert Louis Stevenson, advising the same young "gentleman,"

seemed to come at it from two directions. On the one hand, he warned against laziness: "the artist who says '*It will do*,' is on the downward path; three or four pot-boilers are enough at times (above all at wrong times) to falsify a talent." However, having said this, he also warned against that other tendency, a tendency to be inflexible, too intent on following your own bent. The end of all art, he wrote, was to please. "To give the public what they do not want, and yet expect to be supported: we have here a strange pretension, and yet not uncommon, above all with painters. The first duty in this world is for a man to pay his way; when that is quite accomplished, he may plunge into what eccentricity he likes; but emphatically not until then; till then, he must pay assiduous court to the bourgeois who carries the purse; and if in the course of these capitulations he shall falsify his talent it can never have been a strong one, and he will have preserved a better thing than talent — character."[29]

Justified or not, the potboiler did not go away. By the early 1880s thousands of San Francisco potboilers were reputedly in circulation, reaching Chicago, St. Louis, Cincinnati, and Kansas City. Judging by reports from the studios of San Francisco the practice was as prevalent as ever. Tojetti, wrote the *Chronicle*, "has his parlors crowded with his brilliant-plumed angels and golden-haired goddesses, and his studio lighted up with still more brilliant portraits undeniably good as likenesses, but as gaudy as a new chromo."[30] Denny, according to the same source, "storms and frets over the public's inappreciation of his sea pieces, and dashes in the blues and the greens as if his own blueness were at the end of each brush, and savagely works up a thunder-cloud as if to fill the sky with his own gloom. Out of his black humor he has evoked a castle perched on a rocky shore. A drifting bark, plunging heavily through a tumbling sea, is also in progress, and a half-dozen pot-boilers are to be turned off for the Chicago market."[31]

The only good news came from the studio of Samuel Marsden Brookes, where Brookes had been hard at work, waiting patiently for better times. His paintings, of which he by now had a large number, were stacked all around the studio, with good prices affixed to them (once

Brookes put a price on a canvas, not even Satan himself could make him reduce it). One portrayed a life-size peacock, posed on a balustrade before a palatial country house. The painting had been languishing in Brookes' studio for quite some time, waiting for a buyer. The longer the bird remained on his hands, the higher Brookes jacked up the price. He had started at $750, a figure already pronounced much too high by his dealer. Out of sheer spite Brookes immediately raised it to $1,000. Thereafter, the price of the peacock had steadily escalated. From $1,000 it went to $1,200, then $1,500, then $1,700. By the time Timothy Hopkins, adopted son of the late Mark Hopkins, came to see the painting, the price had soared to $2,000. A few days later, when Timothy returned with Mark Hopkins' widow for a second look, Brookes promptly raised the price to $2,500, announcing that, while he did not have any money he did have the picture, "and here it stays until I get my price."[32] In the face of such rapid developments, Mrs. Hopkins surrendered on the spot, adding two still lifes, one with apples, one with fish, for a total of $3,000. The idea of the solitary artist brandishing his mahlstick on the ramparts of High Art, willing to die, yet prevailing in the end, was inspiring. However, it was merely the exception confirming the rule. By the early 1880's, the prospects of art were decidedly bleak.

INSURRECTION

ne evening, in the spring of 1881, the artists at the San Francisco Art Association gave a press conference. All over America a war had begun "between men who desire and endeavor to do good work and the tricksters who palm off upon the public meretricious and valueless rubbish."[1] In San Francisco, the battlefield would be very close to home. For the first time, the SFAA exhibitions were to be vetted by the artists alone. Gone were "the loose days when anything offered was hung on the walls." There would be no room for daubs and potboilers; permission to exhibit would in itself be "a valuable certificate of merit." The announcement was celebrated through the "unlimited enjoyment" of "exalting liquids" and "soothing cigars." No women were present, even though, as one critic took care to point out, not all artists in the city were male, "nor all the best of them."[2]

For the upcoming spring exhibition, Julian Rix and Samuel Marsden Brookes were appointed members of the Hanging Committee. Theirs was the power to decide which paintings were to hang "on the line" (at or close to eye level) and which were to be "skied" (hung higher up where they were more difficult to see). Rix and Brookes in turn appointed a Rejection

THE HANGING COMMITTEE.

Committee, with the power to decide which paintings were to be admitted in the first place. "It has been remarked that the names of the gentlemen composing the latter committee would never be known, that all knowing those names would go to the grave with the secret locked in their bosoms," wrote the *Argonaut*.[3] It had also been remarked, added the *Argonaut*, that their names were Jules Tavernier, Edwin Deakin, and Max Tauble (the latter largely unknown by the press but apparently trusted by the artists themselves).

The spring exhibition opened with about a hundred paintings and some three hundred sketches and drawings scattered throughout the main exhibition room, the library, the small salon, and the hallways (PLATE 18). The Hanging Committee, it was generally felt, had "discharged its delicate and onerous task with impartiality and rare good judgment," and each picture was placed in such a way that it could be viewed "to the very best advantage."[4] The Rejection Committee also had performed "without fear and without favor,"[5] with the possible exception of "a somewhat polite adherence to the canon of *place aux dames*, and a perhaps praiseworthy wish to help a promising pupil or two."[6] All three committee members had unanimously agreed to reject twenty-two submissions. Four more hopefuls had been discussed for "some time" with the result that three of the four could stay.[7] "In the survival of the fittest but few have survived," wrote the *Chronicle*, "and the walls of the main salon have never looked so bare or shown so many pictures worthy of something more than handsome frames."[8]

Facing each other on the east and west walls of the main room were two large canvases. One was Tavernier's "In the Redwoods," the height of the trees "very powerfully suggested."[9] The other was Rix's "Pollard Willows," the foreground a "wealth of color," the distance "tinged with the rays of the level sun." In "Notre Dame," Deakins had reproduced the "airy boldness of the flying buttresses" with "absolute truth" (PLATE 19). Brookes' "Grandpa's Pet" showed a laughing, brown-eyed boy playing with his grandfather's spectacles. Thomas Hill's "In the Birchwood, Autumn"

hung on the line on the north wall and depicted rows of tall birches, "as one might gaze down the aisle of some old cathedral."[10]

Grouped around Hill's large painting were four small landscapes by William Keith, "all of them gems."[11] Virgil Williams, still drawing on "his stock of Italian memories," showed a Roman girl standing by a well, two young man eyeing her at a distance.[12] To the left of the door leading to the students' room was Gideon Jacques Denny's "The Smugglers," a contraband schooner at moonlight, commendable for "the general handling of the difficult night effects."[13] Raymond Dabb Yelland, Williams' assistant at the school, showed "Twilight" and "Carmel Bay" (the following year his view of Point Bonita would be given "a prominent position" at the National Academy of Design in New York).[14] Old-timer Ernest Narjot (PLATE 20) was responsible for two girls discussing sweethearts, a "delightful" and "spirited" piece of genre.[15]

Back from Paris and fired by new ideas, Ransom Gillet Holdredge was represented by "Morning, Little Lake Valley," said to be full of the artist's own "peculiar mannerisms," including "a liberal use of the palette knife in lieu of brush."[16] Henry Raschen, recently returned from Munich, showed a head of an old soldier, praised for its natural flesh tints, the kind "not often seen in the pinkdom of local portraits." Beneath, on the line, was a picture of a calf, said to be most "calf-like" in both conception and presentation.[17] It was sent in by Matilda Lotz, another School of Design graduate, now studying art in Paris, and in no need of special consideration because of her gender.

However, as some of the rejected paintings showed up at various galleries around town, the "small but savage tribe of the rejected" soon found its own advocates.[18] Norton Bush, an exhibitor at the SFAA long before some of the present exhibitors "knew a brush from a broom stick," had had one of his "tropicals" turned down.[19] Representative of his usual line of work, "suggestive of dreamless ease and lazy contentment," it featured a motionless lagoon, birds asleep on lily leaves, and trees too languid to fight off the vines.[20] According to the *News Letter*, it was "as good a picture as

Gem of Keith

he ever painted, and as such did not merit the treatment it received."[21] Stephen W. Shaw, a former director and teacher at the Boston Athenaeum, had also been snubbed, allegedly without fair cause. The *Bulletin* called the rejection of his portrait of Keith "an egregious blunder."[22] The portrait was supposedly one of the best the veteran artist had ever painted; according to the *News Letter*, it would have been accepted at any exhibition in the East or even in Europe, "and should be seen by all who take an interest in art matters."[23]

Meyer Straus, who had just finished a row of Assyrian bulls guarding a heaven over at the Grand Opera House (he still resorted to scene painting when hard up for money), had been dealt "a double thrust" and was said to be in the curious position of having had his worst piece accepted and his best piece turned down.[24] While the former, "South Prairie Creek," received but faint praise at the SFAA gallery, the latter, a large view of Mount Rainier, drew crowds at Schwab & Breece's, mostly because of its size and "bright colors."[25]

Almeigh Woodleigh took up his own defense in a long "anonymous" letter to the *Post*. A relative newcomer to the San Francisco art scene, he claimed he had won distinction long before landing in California, taking "the highest point of merit" when competing with at least a hundred distinguished European artists, one of them a high-paid director of a "flourishing academy of arts" in England. Surely "the balance of educated and traveled humanity" would agree that his rejected paintings were as good as any of those now on view over at the SFAA, including those painted by the committee members themselves.[26] Indeed, before it was over, it was all too clear that "'Hell hath no fury like a painter scorned,' and never one so wretchedly inefficient that he could not prove himself in endless newspaper columns a veritable Michael Angelo and the victim of envy and jealousy."[27]

As a result, the procedure of painters judging painters was abandoned. The hanging and rejection of paintings was to be entrusted to responsible laymen with unquestionable motives; it most certainly should not be left to artists who saw a chance to do away with the competition. However, finding the right laymen — men who were as knowledgeable about art as they were unbiased in their judgment — proved close to impossible. Most of San Francisco's business men were hardly up to the task of refereeing paintings. Typically, the committee members would meet at the last minute. Some might not show up at all. While one man would stay behind, the others left to track down the missing, who would be out for lunch or had not been notified. The one remaining member would send for a boy and ladder and start hanging the pictures by size, if only to get them off the floor. When his colleagues returned, they would begin by finding fault with the arrangement. However, since by then it would be close to dinner time, they might decide they liked it after all, wipe the sweat from their foreheads, and congratulate each other on a job well done.[28]

Meanwhile the artists, having lost all faith in the selection and hanging process, were sending their best work to the city art stores and relegating their old "studio gods" to the SFAA exhibitions, where they showed up minus the cobwebs, retouched, with new dates and titles. Just to fill the

walls, the SFAA was back as a free-for-all, accepting pictures by amateurs and professionals alike, even opening up its rooms for more auction sales of dubious character. In 1883 it seems the offering was viler than ever. "The San Francisco Art Association is a delusive title," wrote the *Wasp*. "Rambling through their rooms last week one would have noticed such a badly-arranged, queer lot of pictures, that the display looked like the nightmare of a billsticker, or like the decoration of a lunatic asylum by its patients. There were contusions in black-and-blue, and ravings in yellow ochre; tropical horrors and dropsical Niagaras; several degrees of poisoned pup and some freaks in cattle. There were some paint which resembled flowers, and some still-life which resembled paint; some convalescent landscape, and some hopelessly incurable architecture."[29]

The rebellion came in early 1884. The artists were rather summarily called to a meeting held in the main exhibition room at the SFAA. Again, it was apparently an all-male gathering. As they entered the room, they found Tavernier presiding at the head of the table. Charles Dormon Robinson—Tavernier's new cohort now that Rix had moved to New York—was seated next to him, glaring at the latecomers from under bushy eyebrows, now and then taking a quick bite at his fingernails.[30] Having called the meeting to order, Tavernier announced the organization of the California Palette Club, with Tavernier as president and Robinson as secretary. From now on, the Palette Club was to be in charge of appointing hanging and rejection committees for the annual SFAA exhibitions.

Norton Bush, in waxed mustache, balked on the spot. "If the club is to be antagonistic to the Art Association," he protested, "then I am opposed to it." Tavernier assured Bush that artists were welcome to maintain memberships in both organizations, and that all exhibitions were to be held at the SFAA as usual. Deakin, not about to rush into anything — and not convinced that the California Palette Club was setting up a friendly takeover — wanted to know the exact nature of the "existing objection."[31] Tavernier listed the grievances as having to do with auction sales, incompetent committee members, and lack of concern for artists' needs. By now

he spoke "with great volubility and consequent indistinctness," rapidly approaching 300 words a minute and switching into French.[32] Virgil Williams, in his black skull cap, pointed out that the SFAA had always been run in the interest of the artists, but this view went down in the barrage that followed. Samuel Brookes, who so far had stayed aloof, sided with Williams. Throughout the rest of the evening, the debate went back and forth, more agitated than productive, with Robinson and Williams dueling on the side, one-to-one. The meeting ended with Robinson reading out loud the constitution and bylaws of the new organization. The next day the *Call* published a list of some twenty artists who had signed up as members. Williams, Deakin, Brookes, and Bush were not among them.

In the next few months hostilities grew, as the SFAA refused to recognize the Palette Club. The Palette Club rented rooms of its own — for "study and recreation"— at 417 Kearny Street.[33] Here, above the floor occupied by the Democratic County Committee, the members held stormy meetings, the "uproar" often causing pedestrians outside to wonder which of the groups was in session.[34] One meeting in late April was particularly animated. Again Tavernier was presiding, with Robinson at his side. Brookes and Deakin were on hand to represent the SFAA. The purpose of the meeting was to discuss plans entertained by the Palette Club to give its own separate show, in protest against a recent decision by the SFAA to solicit fifty paintings by East Coast artists for its upcoming spring exhibition.

The previous year Rix had used his influence to persuade several New York artists to show at the SFAA. According to Rix, all the San Francisco artists welcomed the opportunity to exhibit alongside their East Coast colleagues. This time, however, showing outside work was seen as an affront. Not only had the SFAA directors contacted the East Coast artists without first consulting the Palette Club, they had also offered to reimburse them for framing, insurance, and freight costs. They had even agreed to pay 20% of the price put on any unsold paintings. Freight costs alone being what they were, the proposition threatened to become costly. The *San Franciscan*

testily suggested that it might be cheaper for the SFAA simply to charter its own "excursion train" and go to New York and view the pictures there.[35]

Both Brookes and Deakin tried hard to bridge the differences. Brookes argued that the SFAA, deserted by the Palette Club, had no choice but to secure paintings elsewhere. Deakin pointed out that, while he would not oppose a separate exhibition held by the Palette Club, he would much rather see the club join forces with the SFAA, which of course it was still welcome to do. Not about to be appeased, Robinson wanted to know how the SFAA, having never had enough funds to aid its own artists, could all of a sudden afford to import these Eastern pictures at such expense.

Amidst angry endorsements from the seething ranks, Robinson also took aim at the School of Design, accusing its directors of nepotism and mismanagement of funds. Someone took a few pot shots at the absent Virgil Williams, having to do with dictatorial tendencies and too-long vacations. Dissatisfaction with the school had festered for a long time. Many felt it was still more a finishing school for young ladies than a serious art academy. Williams' insistence on carrying most of the teaching load himself deprived his colleagues of added income, needed during the current hard times. With more instructors, the school would benefit as well: "there would be better work, larger attendance, less complaining and a better financial showing."[36] Shortly, the meeting lost semblance of a civilized affair. Verbal missiles crisscrossed the room, hissing at each other midair. After two or three unsuccessful attempts to get the discussion back on track, Brookes and Deakin left. A while later, after an adjournment of sorts, the other artists spilled out on to the sidewalk, venting their frustration in mostly purple language interspersed with loud fragments of French.

The SFAA exhibition, which opened first, in 1884, drew only average attendance. Granted, a number of out-of-town visitors did find their way to Pine Street — squeezing past carts loaded with produce outside the California Market, defying whiffs of horse dung and fish guts, and pushing through the din of crowing roosters—before they reached the stairs to the SFAA and the exhibition on the second floor. Even some of the locals

came, but most were friends of the artists and in no position to boost sales.

The borrowed East Coast paintings left the critics indifferent. Some, according to the *San Franciscan*, even had "the honor of being much worse than anything we can produce at home." The same paper also lambasted the Hanging Committee for exhibiting "an originality that passes description," with a dreamy autumn scene by Jervis McEntee, said to be "the delight of the New York critics," skied in the small room, and J. Well Champney's "Hide and Seek," a picture of children playing in a barn, virtually hidden behind the door. Skied out of sight in the large room was Alexander H. Wyant's "Evening," one of the artist's "tenderest bits," while a painting by Peter F. Rothermel, "a hideous crowd of pink putty bacchantes," was hung on the line. Also hanging on the line was "Near Morilia," a Mexican landscape by Thomas Moran, described by the *San Franciscan* as "a red and yellow sunset which looks like an unsalable freak of composition that has been a long time in the studio."[37]

Competing with Moran was Albert Bierstadt, whose style of painting was now considered hopelessly old-fashioned. His "Forest of Mr. Washington" was supposedly named after an intended patron who apparently neglected to take the bait, because the painting was now in San Francisco carrying a price tag of $1,000. The *San Franciscan* called it "about as unsatisfactory a substitute for a picture as dough would be for bread" and claimed the only reason for its presence in the show was the fact that it carried Bierstadt's signature.[38] "Poor old Bierstadt probably thinks the fact of his signing a picture makes it valuable," echoed the *Wasp*. "As an autograph it is very good; as a landscape it is very bad."[39]

Only a few days after the start of the SFAA exhibition, the Palette Club responded with its own show. On opening night the rooms were "packed to suffocation," the gathering "as elegant socially as it was strong numerically." Emblazoned on the wall was a quote from Horace: "Blend a little folly with thy worldly plans; it is delightful to give loose on a proper occasion" (the only real "folly," noted the *San Franciscan*, was leaving the SFAA in the first place). Thanks to Lizzie Tavernier's "excellent taste" and

"unremitting energy," flowers were everywhere, around the doors and windows, and in the small side room where the ladies put their wraps.[40] From the center of the ceiling of the main gallery hung a huge Japanese umbrella, decorated with smilax and more flowers, shielding the guests from the glare of the electric light which flooded the walls and the paintings.

All in all about eighty works were exhibited, most of them oils, the remainder watercolors, crayons, and etchings. The center of attraction was Oscar Kunath's large and ambitious "Luck of Roaring Camp," based on Bret Harte's story about a child born in a mining camp. Kunath, who swore he had never actually seen a miner's cabin, had done convincing work, the picture containing about a dozen miners greeting a baby in a candle box, while the mother, "Cherokee Sal," lay dead on one of the bunks. Henry Alexander, recently back from Munich, showed a humorous picture of two monks playing cards, initially meant for the SFAA exhibition but switched to the Palette Club at the last moment. A close friend of Bush, Alexander was walking both sides of the firing line, keeping a second painting, "Morning Prayer," over at Pine Street. Theodore Wores showed a painting of fish, much looser in treatment than Brookes' representations of the same subject. Also carrying his signature was a portrait of an aging knight in steel cuirass, painted during Wores' stay in Munich.

Still more portraits with a marked European air to them were shown by Frederick Yates, a tall and somber Englishman who had studied in Paris under Léon Bonnat and Jules Lefèbvre. Tavernier himself contributed eight paintings, both in oil and watercolor. One in particular, "The Old Antiquarian," was widely praised although not quite finished. The subject was an old man with a gray beard and massive head, seated in the light streaming through a window, smoking a long German pipe and studying an ancient scroll through a magnifying glass. Robinson showed only one painting, a Yosemite which the *News Letter* called "crude and amateurish in the extreme."[41] The *Wasp* was equally unimpressed. Robinson, it snickered, "seems so absorbed in the importance of his official position in the Palette Club as to forget to exhibit anything worth mentioning."[42]

Despite Robinson, the Palette Club proved a strong contender. The newspapers did not mention anything about sales, but judging by the chest beating that could be heard over at Kearny Street, something must have gone right. Triumphant, the club was promising more exhibitions in the future and counting among its members most of the local artists, some thirty in all, and over one hundred patrons. The SFAA, on the other hand, was looking weary, numbering some five hundred members, the same as the year before. Sales had failed to pick up. By June, when the spring exhibition closed, quite a few of the Eastern paintings were still on the walls, "among them several of the best."[43] In the end the SFAA was forced to pay over five hundred dollars — the agreed-upon 20% — in addition to freight, framing, and insurance costs.

The next confrontation took place in connection with the 1884 Mechanics' Fair. The paintings shown at the fair had always been a mishmash, with works by professional artists hanging next to amateur paintings of the worst possible kind. The Palette Club refused to mingle with company such as this, even though the SFAA had long since learned to live with it. The Palette Club demanded its own exhibition space, set apart from that of the SFAA and the amateurs, an action seen as clearly antagonistic to the SFAA (never mind the amateurs). After fair management turned down the request, the Palette Club withdrew over a hundred intended entries. Several of its more "reasonable" members decided not to go along with the boycott and sent in their paintings anyway.[44]

Many of the paintings at that year's fair had already been shown at the SFAA, including a number of the imported Eastern paintings, notably "Little Sunshine" by George C. Lambdin, "Tuning Up" by Walter Shirlaw, "The Broken Pitcher" by George H. Storey, "Grandfather's Slippers" by E. Wood Perry, "Spring on the Hillside" by Hamilton Hamilton, and "The Hunters" by George Inness. Among the local artists, Deakin showed no fewer than 29 pictures, most of them the usual "picturesque" views of old European churches, castles, towns, and streets. Complementing these were his popular grape pictures, juicy clusters of "Flaming Tokays,"

"Cornshons" and "Sweet Water Grapes," typically placed against a background of crumbling brick. Judging by the sheer number and variety of Deakin's entries, the *Post* concluded that the artist "desired a monopoly in all branches of art."[45]

Midas, of the *San Franciscan*, had his own musings on the topic, suggesting that Deakin "was so terribly afraid that the Palette Club's display would be ahead of the Association's, in point of merit and numbers, that he thought it his plain duty to stick all his unsold pictures up before the gaze of the fair visitors." In fact, Midas was quite worried about Deakin's mental state: "We sat vis-à-vis in the same street-car the other day, and I must say that his wild, careworn appearance quite alarmed me. Can it be that the rotary exhibition scheme has 'rotated' his brain like an egg-beater? He got off a block too late, after having failed to recognize his best friend, and went wandering back down the street, with his eyes turned starward and the bottom of his trousers' leg up over his shoe-top. Rotation is a dangerous thing for any one to consider for a great length of time; and I fear the worst in Deakin's case."[46]

The fact that several members had defied the official decision of the Palette Club to boycott the fair was one of the first signs that the club was about to self-destruct. The situation worsened when Tavernier skipped town to join Joe Strong in Hawaii, leaving a frustrated sheriff with nothing but an old iron stove and "the remnants of a light breakfast."[47] Following Tavernier's departure, discord within the club grew stronger, with four or five factions jockeying for power and Yates, the new president, unsuccessfully trying to present a united front. The show given by the Palette Club in the spring of 1885 was weak. Several members were not represented at all, others but poorly. Many exhibited at the SFAA as well, although "a few of the old war-horses repudiated with scorn the insinuation that they had been won over."[48] By May, according to the *Argonaut*, it was clear that "dissensions have arisen among the members of the Palette Club, and that the organization will soon disband."[49] That same month the club dissolved. "The Palette Club is whizzing along the down grade," wrote the *San*

Franciscan. "Bang! over she goes, and that's the end of it. Peace to its memory! We know it had war enough when living."[50]

The return of the artists to the SFAA coincided with a general sense of "settling-down-to-common-sense" which pervaded San Francisco at the time.[51] California was finally recovering from the depression. However, gone were the days when men could expect "sudden wealth without toil." Life, from now on, would depend on commerce and manufacturing, not on "spasmodic 'finds' of treasure."[52] More than ever, a "properly maintained" art association was paramount to San Francisco's reputation as a truly first-rate city.[53] The rise and fall of the Palette Club had certainly brought about some badly needed changes: lines had been drawn and more exacting standards had been set.

But, from now on, the SFAA would be back in charge. It had always done nobly and would no doubt continue to do so. "From a Bohemian standpoint [the artists] are excellent companions," wrote the *Post*, "but as business men there are few of them practical enough to control even themselves, much less an important society."[54] The *Chronicle* emphatically agreed: "The fact is, that when there is anything to be done, artists are of very little use. They are vague, emotional, excitable and vacillating, with seldom a mouthpiece, and still more seldom, a headpiece, among them. They rave among themselves over their misfortunes, and lack the business sense to take certain very simple and obvious steps which would improve their affairs."[55]

In late 1885, taking almost everyone by surprise, a new exhibition opened at the SFAA, mounted by the women artists of San Francisco, among them several graduates of the California School of Design. From France, Elizabeth Strong sent a portrait of a fiendish-looking Persian cat. Matilda Lotz sent a painting of two hunting dogs, "soft, shaggy, sad-eyed creatures resting in the wet marsh of field under the gray sky of hunting weather."[56] Among the women working in San Francisco, Mrs. Frank Pixley showed a sketch of Chinatown, in which she achieved "an extremely realistic effect," relying on "a slant of light falling on the soft gray effect

of wood and stone."[57] Mme. de L'Aubinière contributed "strong-armed, vigorous peasant women" under "yellow harvest skies," the whole suffused with "quiet, subdued pathos."[58] Marian Weeks' portrait of an English farm girl, "taken from life," was "delicious with a dewy sort of youth and fresh-ness which holds and fascinates the eyes."[59] In the flower department, by far the largest, Alice Chittenden's chrysanthemums asserted themselves "in a great glowing mass against some tawny matting,"[60] while Dora Williams' mossy greenhouse pots were "artistically grouped and broadly painted, somewhat after the impressionist school."[61]

All in all, however, the press treated the whole undertaking more as a social affair than an art event. Column after column was devoted to descriptions of the invitation cards ("beautifully engraved by Miss Ingalsbe"), the envelopes ("small and unobtrusive, but so artistic!"); the entertainment (Arditi's "Kellogg Waltz" and Soldermann's "Swedish Wedding Chorus" by female voices).[62] About the paintings themselves, the little that was written was often condescending, though disguised as praise. The *Chronicle* referred to the "natural tendency of the feminine mind toward flower painting": "There is a certain, delicate satisfaction to be gathered from this not too difficult phase of art. An honest effort in this direction, guided by talent, is apt to be encouraged by a swift success."[63]

The *Chronicle* also seemed anxious to justify the existence of a "Ladies' Exhibition" in the first place. The women behind it had "none of the fierce, aggressive spirit of woman's rights women." On the contrary, they were "refined" and "rather retiring." As if against their will, and cer-tainly against their nature, they had been forced to look after themselves while the male artists were too busy fighting. "One thing led to another, and the exhibition grew into shape of its own accord, being from the begin-ning fostered and encouraged by the public-spirited gentlemen of the Art Association and aided in no small degree by the liberal and kindly voice of the press."[64] Even Mrs. M.B. Unger, alias Fingal Buchanan, art critic for the *San Franciscan* and one of the driving forces behind the exhibition, was conciliatory, almost apologetic. "The Ladies' Exhibition should not be

regarded as a declaration of woman's rights or a sign of permanent seces-sion," she wrote. "It is merely an ambitious and energetic trial of strength, the forerunner, let us hope, of days of peace—days when the lion and the lamb shall lie down together and the interests now separate shall be per-manently joined under one harmonious rule."[65]

DIRECT
TO NATURE

n 1874, one critic called the work of Impressionist Claude Monet "wallpaper in its embryonic state."[1] Three years later, when Whistler exhibited his "Nocturne in Black and Gold" at London's Grosvenor Gallery, John Ruskin accused him of "flinging a pot of paint in the public's face." Whistler sued for libel and won one farthing for damages.[2]

That same year work by Munich-trained American artists — among them Frank Duveneck, William Merritt Chase, Walter Shirlaw, Frank Currier, and other members of the Leibl Kreis — hung on the line at the National Academy of Design in New York. Dark monochromatic browns were laid on with slashes, jabs, and twists, the entire surface a *tour de force* of crusty pigment, shadows, and light. Again, much of the reception was hostile. "No borrowed or eccentric nomenclature will compel a sensible public to accept splashes of paint, however labeled, as works of art," wrote the *New York Times*. The public would continue to insist "that the true function of art is to reproduce nature with fidelity, and that for its performance something more is needed than a wild dream and a frantic effort to dash it upon canvas at a single stroke."[3]

At the California School of Design, the old order still prevailed, as Virgil Williams paced along rows of students working on lapboards or at easels. The floor around him was littered with charcoal-blackened bits of French bread used for erasers; now and then a rat would pop out of its hole and collect a few pieces for purposes of its own. In the center of the room, under a skylight, were the great plaster casts on their pedestals. On the still-life tables were vegetables and dead game, garnered from the California Market below (one student insisted on having her bird smothered so there would be no blood on its spotless white plumage).

Williams kept his students on a short leash, encouraging a broad yet thorough style. "Art is to a great extent mechanical," he said. "No matter how high, delicate or refined your impressions of nature you cannot express them without great command of your materials." Of the French artists, Williams admired the work of Jean-François Millet, although he never quite warmed up to the Frenchman's peasants, finding them "too Calvinistic" with all their "woes, sufferings and sorrows." His own Italian peasant girls lived a different life, forever fair, romantic, and indolent, gazing out of windows or leaning against garden walls, waiting for their lovers (a custom which, Williams assured his students, was considered perfectly proper in those southern climes).[4]

Williams' gospel was the gospel of drawing. Students first drew from objects with flat surfaces, such as a cube or a pyramid. Next they were introduced to rounded surfaces, perhaps a ball or a vase. When sufficiently proficient in these exercises, they drew from a cast of a foot or a hand, gradually progressing to the full-length figure. Some of Williams' younger colleagues argued that drawing from casts was a waste of time. The students, they said, should draw from live models, thus beginning to "look around," observing the characteristics and peculiarities of real people. "I say I don't want the very beginner to look around," countered Williams, rubbing his nose the way he usually did when irritated. Only later, after the student had learned "certain canons of beauty and proportion," was it time to "look around." Still, the attacks became more and more frequent, even

vicious. Williams complained about being "tired to death." He talked about leaving San Francisco and going back to Rome.[5] In December, 1886, after a day of hunting and sketching in the woods around his ranch on Mount St. Helena, he died of a heart attack.

Emil Carlsen

The following year Emil Carlsen, a Danish-bred painter, was persuaded to leave New York to take charge of the school. In his early thirties, Carlsen was short, rather thin, with red whiskers and kind, appraising eyes. At the San Francisco School of Design, he lectured on Hippolyte Taine, who saw the evolution of art as Darwin saw the evolution of nature, subject to the same laws of heredity and environment. Carlsen also introduced his students to the work of his New York friends Augustus Saint-Gaudens, J. Alden Weir, Thomas Dewing, John La Farge, and Kenyon Cox, artists who, like Carlsen, viewed their art as a legacy from the past as well as to the future. The underlying message was important. In the great scheme of evolution, art knew no country — America might well be the place where it would prosper next.

Carlsen himself painted still lifes in the tradition of Jean Baptiste Simeon Chardin, in turn inspired by the 17th-century Hollanders. Like his predecessors, Carlsen painted humble, everyday objects — brass bowls, copper kettles, black earthenware jugs, a basket, perhaps a white towel. He worked with craftsmanlike precision, using methods that would mystify generations of artists—scraping, painting, then scraping again, building impastoes compared to "finely woven tapestry."[6] His colors were soft and

subdued, here and there with a brilliance like glowing embers; his outlines were blurred, his shapes half hidden; his backgrounds were dark and seemed to go on for ever. A painting, he told his students, should not be judged by what it depicted but *how*. Above all, it was a surface with paint on it. Its content was purely aesthetic; its only language was color, masses, contours, and rhythms of line.[7] This, indeed, was the clarion call of modern art. Resounding with the *"l'art pour l'art"* ideas of Théophile Gautier and the brothers Goncourt, his teaching heralded a kind of art yet to come: abstract arrangements, absolute in themselves, existing for no other reason than their own power and beauty.

Despite his profound influence, Carlsen's time in San Francisco was difficult. He chafed at the long teaching hours, arguing that no artist of standing should be asked to spend all his time teaching. In early 1889 he resigned in disgust. After a few months in the East, he returned to San Francisco. This time he agreed to teach at the Art Students' League, where the students hired their own teachers and shared the expenses; the teaching was shared by several artists, a system which the School of Design would adopt as well.

In 1892 he left San Francisco for good. "After two years," he said, "I find it unpleasant to be a pioneer in a place where the wealthier people get their pictures from Europe and the East, and the class of people that might like to purchase local paintings cannot well afford it."[8] Back in New York he taught at the National Academy, sold his work to major museums, and was repeatedly referred to as the best American still-life painter of his time (PLATE 21).

Meanwhile, that other still-life painter, Samuel Marsden Brookes, was now in his seventies and still holding forth in his Clay Street studio, a popular haunt for the city art crowd. Art, to Brookes, meant "a correct representation of nature," warts and all.[9] Aided by a magnifying glass, he labored with infinite patience, carefully covering his tracks, erasing all trace of brush marks. "For my part, what it takes anyone else a day to do, takes me a week," he said with a proud flourish of his brush, indicating a series

of still lifes with fish lining the wall in front of him. "I don't make sketches! can't make sketches! haven't got such a thing as a sketch! Whatever I do is finished as I go along."[10] If one of his models began to rot, he had to buy a new one and begin again. In one case, while working on two life-sized river salmon weighing in at 18 and 36 pounds respectively, he used up a total of 160 pounds before he was wholly satisfied.

Like New York artist William Harnett and other *trompe l'oeil* painters, Brookes often chose a flat, shallow background. One of his studio props was a plaster cast made from a brick wall. Time and dust had made it a silvery gray, but under his brush it became "pink, green or yellow according to the color of the fish, flowers or fruit."[11] Brookes was so attached to his *faux* wall that some critics begged him to change the scenery once in a while. Occasionally he succumbed to their wishes — putting in a river bank, a blue sky, some holly oak and flowering thimble berry — but more often than not he posed his still-life models against that old plaster cast.

The effect was striking: shimmering salmon strung up by their gills as if separate and independent of the canvas; great clusters of honey-heart cherries shown off in bold relief; pigeons hung by their throats with their feet thrust outwards; branches of green apples reaching towards the spectator, "so hard and juicy-looking that the mere sight of them would be enough to give any half-grown boy a spasm of anticipatory misery."[12] These paintings always drew crowds of admirers at exhibitions. Brookes complained that they came back to his studio "nearly ruined" because those same admirers kept running their hands over them to make sure they were nothing but paint[13] (PLATES 22, 23).

But Brookes was more than an illusionist. His emphasis on facts was very much in keeping with trends of the times. Through his interest in a scientifically observed and reproduced reality he actually had much in common with the French Impressionists. Both Brookes and the Impressionists claimed they painted only what they saw. They asked the same questions but their answers were vastly different: Brookes' work was simply one aspect of nature, the work of the Impressionists another.

111

The connection was not lost on at least one San Francisco critic, who quoted a "Paris correspondent" on the emergence of "a new school of painting": "Its aim is absolute truth — utter *naiveté* — and its followers go direct to nature, allowing no preconceived idea, no conventionality of any sort to come between them and what they see. The idea is to allow of no technical trick, no symbolism, nothing but the absolute painting of what they see in all completeness. The school in fact aims only at absolute realism." The critic saw Brookes as an American exponent of that very same development. "Where other local artists, who might be named, seek to sentimentalize their subjects by the introduction of poetic auxiliaries, Brookes looks upon nature as perfect in herself, and regards art as the medium through which that perfection should be shown in its entirety. This view of the matter agrees thoroughly with the ideas and aims of the realist school, which is now receiving so much attention in the metropolis of France."[14]

In 1883, Brookes' quest for "absolute realism" found its ultimate expression in a painting of his left hand holding a white cloth. At the San Francisco Art Association, a large magnifying glass hung next to the work, encouraging the viewers to examine it closely. The *Call*, noting the "novelty of the subject," referred to the painting as "probably the most remarkable piece of flesh painting ever seen in San Francisco."[15] The *Examiner* called it "frightfully realistic": "It bears the search of the microscope. The tissue of the skin is nature itself. As it presses against the soft foreground, we see the delicate wrinkles that come with the approaches of age, and actual blood and vitality seem coursing through every pore."[16] The *Golden Era*, however, was skeptic: "As a perfect imitation of a hand, it is, perhaps, a success, but whether it can be considered as a work of art, is quite another matter." The writer felt it needed some form of context to make it more palatable. "Now, that hand suggests no connection with an arm, it looks as if it were something uncanny and weird. A man would not like to strike a light, two o'clock in the morning, right beside it. It is too gruesome. But if it were a pickpocket's hand, just poising to creep into a coat pocket, there would be something exceedingly human, and even a little humorous, in

it. There would be a story told which would alter the whole aspect of the case."[17]

In landscape, Thomas Hill also followed his own bent (PLATE 24). His comings and goings always made for good newspaper copy, catering to San Francisco's paranoia about losing him to some other city. In 1885 he traveled to the World's Fair in New Orleans, where he exhibited "The Driving of the Last Spike" and also served on the Hanging Committee. On his way back he made a stop in Boston, causing the usual anxiety at home, this time heightened by runaway rumors that he had purchased a plantation in Mississippi and started a tannery for dressing alligator hides.

Back in California, still "perfectly alive to the moneymaking side of his work," Hill returned to his true *métier* — painting for the Yosemite tourist trade.[18] In his cottage studio next to the Wawona Hotel at the entrance to the valley, he took advantage of his "immense technical dexterity"[19] and staged a virtual production line of Yosemites, taken "chiefly from one point of view."[20] The fact that his daughter had married the hotel proprietor gave sales an added boost. Each night after dinner the guests were gently but firmly ushered over to Hill's place, where he entertained them "most generously," played billiards "with the expertness of a professional player," and answered questions about his work, his Indian baskets, his heads of deer and mountain lion, and his five-foot rattlesnake, "stuffed with grain and thrown carelessly over an antler"[21] (PLATE 25).

From the start, and even more so after his stay in France, Hill's work had been sketchy and vigorous, with a hearty disdain for "accuracy" and detail. The more literal-minded, of course, criticized his attitude. One such occasion had to do with a scene on the coast near Pescadero north of Santa Cruz, painted in 1877. Several years later the *Chronicle* referred to it as his famous "penguin picture," which in itself was a curious turn of events, since the painting was of pelicans, not penguins (the sight of even *one* penguin in this particular location would be perplexing enough).

According to the writer, who in turn heard the story from a "brother artist," the finished painting, true to the sketch on which it was based,

showed the beach almost covered with seagulls and the aforesaid penguins, "looking pensively out to sea and standing in all sorts of quaint attitudes": "Hill viewed it critically and decided that the public would be incredulous as to the number of birds depicted. He painted out a score or so; still he was uneasy. He thinned them out in other places, slaughtering with an unsparing hand. His friends, anxious to see Hill's reputation for veracity preserved at all hazards, advised still further extinction of feathered life. Satisfied at length that he had fulfilled his entire duty, the artist placed the picture on exhibition, only to find it greeted with skeptical shrugs and scathing remarks upon the extravagant array of penguins."[22]

In a similar vein, Hill's "Rescue of the Innocents" provoked a nasty review by the *News Letter* when exhibited at the SFAA in 1877. The painting showed a dog attacking an eagle as a flock of sheep fled up the hill. To begin with, Hill's sheep had their mouths open "in full bleat," and, according to the well-informed critic, sheep do not bleat and run at the same time.

Worse, however, was Hill's representation of the eagle. Its body was drawn "tolerably true to nature," but the head showed a shocking ignorance of (rather, indifference to) ornithology. Not only were there problems with the beak—something about missing membranes and a faulty shape of the lower bill—but the tongue was all wrong, smooth rather than bifid, and without the barb always so prominent in a real eagle.[23] The *Post*, nonetheless, referred to the painting as Hill's finest work to date. "In the hurry of preparation for a given day's exposure, some parts have been left unfinished, but to think these slighted would simply be in ignorance of artistic methods."[24] Even so, Hill later remedied some of the more glaring "errors" while the *News Letter* took all the credit.

As new ideas took hold, Hill was attacked more because of his subject matter than his technique. Although he also painted small and intimate canvases, the public saw him mainly as a painter of large Yosemites: mountain vistas of great space and airiness, hazy chasms, perpendicular granite cliffs, tree-fringed rivers, their sandy banks filled with driftwood—a world of silence where only now and then one could almost hear the distant crash

of a waterfall, the rush of the wind blowing through Sequoias and sugar pines, or the blast of a hunter's shotgun.

However, in keeping with the modern trend towards the intimate and the understated, grand views were no longer considered suitable for the painter's brush. More and more, artists looked for fragments of nature rather than the whole. "In the expression of great distances and certain atmospheric effects, Hill's pictures have been a guide to Yosemite painting for all who have come after him," wrote the *Chronicle* in 1885, as if already formulating the epitaph on the artist's tomb. "As far as it is possible to express the inexpressible, to embody the incorporeal, to measure the infinite with a tape measure, Hill has covered the ground." Yet, what "was good in its season is ill at a later day The use and at the same time the misery of civilization is that it teaches man his limitations."[25]

Hill defended his position in rather forceful language. "Mr. Hill sticks to his usual style of work," reported the *Call*. "He feels that he can paint mountains better than anything else, and paints them as he sees them, regardless of what anyone else thinks of his work."[26] Hill also felt that he deserved recognition for being original rather than "receiving condemnation for not following in the footsteps of a clique."[27]

In 1893, after a visit to the Chicago World's Fair, he stated his opinion in no uncertain terms. To begin with, he found the American paintings more Frenchified than the French. "I must say that the American exhibit in the art palace was the poorest attempt on the part of a civilized country I have ever seen. The painful comparison between our American side and that of Europe was decidedly conspicuous. I heard on every side such severe criticisms from connoisseurs of art, which so coincided with my views, that I fairly felt ashamed to admit my nativity."[28]

Of the European paintings, judging by rather summary notes in his notebook, he much preferred the German paintings, particularly two examples of sheep and cattle, "with the most beautiful of landscape work."[29] By comparison, the daring new innovations by Claude Monet, Camille Pissarro, Alfred Sisley, and Auguste Renoir, shown in a much

talked-about loan exhibition entitled "Foreign Masterpieces Owned by Americans," appeared to offend him. The Germans, he noted in his diary, "are conscientious workers who try to paint nature as we see it." The French, on the other hand, "merely give you a suggestion, an impression of the Thing which the observer must complete according to his own taste. This they call poetic Art. I call it Rott [sic]."[30]

In retrospect, it seems he did protest too much. Clearly, Hill had much in common with the "moderns." His bold manner of painting, at first confined to the foreground, would soon expand throughout the entire canvas. "It is not necessary to work the cattle up," he told his son, a novice painter, "they are only for effect — dabs of color [will do]." He also advised him to stay away from small brushes. "Accidental effects can only be gotten with a big brush," he said. "I depend entirely on accident — you have no idea how much is produced that way."[31] His use of color, in the words of artist Bruce Porter, showed that he "had an eye open to the light" and "solved certain problems" long before most American painters were even aware of them.[32]

Case in point was a large Yosemite shown at the Chicago World's Fair. "Nature herself does not employ such tints in the landscape which Hill has depicted," wrote the San Francisco *Call*. "The foreground, for instance, consists principally of pine trees. To depict these Hill has used all shades of ocher, raw sienna, vermilion and India red. These tints are not true to nature; they would not be found in a pine forest. But it is not carelessness or ignorance that made the artist employ them. On the contrary, he threw vermilion tints on the canvas with a deep object in view."[33] Indeed, when Hill was at his best, Yosemite became more a *motif* than a place — his interest in topography gave way to his interest in paint itself, laid on in swirls and ridges, representing foliage and rock, yet powerfully asserting its own nature as nothing but pigment and oil.[34]

While Hill reached artistic maturity fairly early in his career, the art of William Keith evolved more slowly. In the early 1870s, Keith had been beset by the same passion for mountains as Hill and Bierstadt. He forged

what was to be a lifelong friendship with naturalist John Muir, who took him on daring expeditions into unexplored parts of the Sierra, where the two of them scrambled down icy mountain sides, lost their provisions to bears, and returned to camp "half dead with hunger and fatigue."[35] Keith endured it all for the sake of his art, always looking for higher mountains and more distant vistas. Those were the days when he tackled, broadside, the entire valley of Yosemite, trying to fit it all in (PLATE 26). Later he was to apologize for his presumptuousness, promising never to try it again. Muir, on the other hand, claimed that Keith was "painting better than he knows, observing a devout faithfulness to nature, yet removing veils of detail, and laying bare the very hearts and souls of the landscape"[36] (PLATE 27).

William Keith

Around 1880 Keith found another friend and supporter in Joseph Worcester, pastor of the Swedenborgian Church in San Francisco. Under Worcester's influence, a more mystic side of Keith began to emerge. Increasingly he came to doubt the value of presenting facts as mere facts. Sunsets were one of his favorite themes, painted against the light, softening the edges of his landscapes. Critics accused him of being careless or even lazy. The *Alta* urged him to paint his pictures in broad daylight, as practiced by Virgil Williams and Thomas Hill: "It is a great mistake in Mr. Keith to suppose that the public taste will be satisfied with landscapes in which there is a yellow sunset, with distant mountains, middle ground and foreground so vaguely painted that nothing can be seen distinctly save the sky. No amount of skill in grouping the brilliant colors of the horizon at the close of the day is sufficient. Such work does injustice to his capacity."[37] Muir, too, was disgusted. "Why in the deuce don't you imitate nature?" he grumbled,

declaring his friend artistically dead.[38]

Keith pushed on, knowing he was on to something. In 1883, when he was in his mid-forties, his explorations took him to Munich, where, after Duveneck's departure, Frank Currier had become the leading American painter. On one occasion, Currier stopped by Keith's studio and offered to help him out with weekly criticisms. In return, he suggested that Keith buy one of his sketches for $200. Because Currier probably took no more than four hours to finish a sketch, and the regular rate for "a very good professor" was only $7.50 a month, Keith decided that Currier was asking for more than his fair share and did not take him up on it. Besides, Keith preferred working on his own. "I don't believe much is to be got out of a regular teacher," he wrote to Worcester. "I find that the criticisms I get are what I see clearly enough myself. It would be different if I were a young man without experience."[39]

Nonetheless, Keith was intrigued by Currier's methods, particularly his habit of painting outdoors to capture fleeting effects of light and atmosphere. However, in Keith's opinion, Currier's canvases were too large. No matter how rapidly he painted, the light would change and the moment would be lost before he could cover the entire surface. Keith, instead, tried the experiment on a smaller scale. The result, he told Worcester, was astonishing — "a blotch of color will stand for a tree — no drawing." In the end, however, his old work ethic prevailed. "Impressions are dangerous to the artist when carried too far. I mean when patience and industry are given the go-by for the sake of being artistic. It's just like a tramp compared to a good workman, and I think Currier is suffering in his nature from just this."[40]

Except for exhilarating visits to the Pinakothek with its collection of old masters and occasional breakthroughs in his work, Keith's stay in Munich was unhappy. The city, he wrote, seemed "like a big factory for making painters." He preferred to stay home with his wife rather than participate in café and club life, so he had little contact with his fellow Americans. He suffered headaches from smoking too much, complained

about rheumatism in his shoulder, hated the wet weather, and disliked the Germans.[41] He kept questioning his own abilities. "I'm improving a good deal in drawing, but ... my color is fearful," he wrote in a letter to San Francisco artist Theodore Wores. "So hard and wooden. Just like a board."[42]

He even questioned the very purpose of art itself. "Take all the religious pictures of Rubens, Van Dyck, etc. They seem to me to be simply painted from the pictorial sense, not from any religious feeling, at least in me there is nothing of that sentiment aroused when looking at them and I doubt whether the painter had any of that feeling. Rubens is only an enjoyment of sensuous color, dramatic in design. Van Dyck the same only in a fainter way. I don't see that the art of painting elevates either the painter or the spectator. It is a *simple intellectual pleasure*, not of the heart at all."[43]

In 1885 Keith returned to San Francisco. He set up a studio at 417 Montgomery Street, where he surrounded himself with adoring female students (he did not accept men since he felt they were "too inquisitive").[44] His confidence appeared restored. No longer "a literal, practical painter," he had become a "poet of the brush," painting to evoke a mood, not a place.[45] His main language was pure masses of color laid in side by side: tawny yellow, olive, and brown, next to dark red and orange, with notes of deep green and blue. The *Chronicle* critic wrote, after seeing Keith's most recent paintings, "They are, briefly, the expression of sentiments or emotions by color values independent, or nearly so, of form. That does not mean that drawing is neglected; far from it.[46]

In spite of critical acclaim, Keith was still unsatisfied. His sense of inadequacy would now and then resurface, bringing on spells of depression and raising recurring doubts about the meaning of art. Nonetheless, he kept pressing on. In a lecture given at the University of California in Berkeley in 1888, he talked about the three states of an artist's development. In the first state — the one Keith called "childhood" — the artist was all about feeling but did not know how to express it. In the second state — "youth" — he worked hard to learn the "facts" of nature, so hard that in

the process he lost some of his feeling. Keith confessed that he himself, like most artists, had never moved beyond the second state. For quite some time he had struggled to cross into the third state, which he called "manhood." Here the artist regained the full force of his feeling and also had the knowledge to express it.[47]

In 1891, a two-month visit by George Inness helped push Keith into full-blown artistic "manhood." Inness, 16 years Keith's senior, had lived in Italy and France, steeping himself in Claude, Poussin, Delacroix, and the Barbizon painters. According to the *Wave*, his modesty had by no means "kept pace with his merits," and hence "the little sharp-nosed artist" was in San Francisco to show the world how Yosemite and its two-thousand-foot waterfalls ought to be painted.[48] Inness and Keith left for the valley. The day after their arrival, Inness, well equipped for the day, set out "to commit the scenic wonders to canvas." Keith stayed behind at the hotel, waiting for "the inevitable." Within a few hours Inness was back, spitting profanities and throwing his paint box to the ground. "It can't be done," he shouted. Keith reportedly smiled and said nothing.[49]

Inness spent most of his time in California painting with Keith in Keith's San Francisco studio (PLATE 28). What exactly went on in that studio has never been thoroughly documented. It seems the two artists argued the subject of art from every possible angle. They had much in common: both were trained as wood engravers. As painters, both started out with large, literal landscapes, before turning to the subjective and intimate. Both were influenced by mysticism and Swedenborgian theories; both saw nature as a manifestation of the divine, the touch of spirit upon matter.

Their working methods, however, were quite different. Keith was intrigued by Inness' constant "going over" of his canvases, reflecting Inness' belief that a painting, before completion, had to go through a set number of stages and treatments. Inness, on the other hand, was impressed — as much as he was capable — with Keith's ability to catch the essence of a scene right away. "Not one of us," he said, "can carry a picture so far by the first intention, except perhaps Rousseau."[50] On one occasion,

when frustrated with one of his canvases, Keith held it up to Inness. It was a somber scene, crowded with dark California live oak. "What's wrong with it?" Keith asked. Inness reportedly grabbed Keith's brush and with a few strokes brought out a sunlit vista and a glimpse of bright blue sky. Perhaps it was indeed at this moment that Keith broke through the limitations of his "bodily" eye and learned to "see into the very heart of things."[51] From then on, his work grew bolder and even more introspective, often compressed into two simple components, a broad light and a broad shadow. "I no longer want to die," he told Worcester. "I have been feeling for a long time that I was just hanging around waiting. Now I want to work."[52] San Francisco was poised to watch.

A Local Candidate No. 12

A Local Candidate No. 15

Miss Mary M. James, the Third Candidate

Miss Marian Nolan, the Fifth Local Contestant

ARTISTIC ANATOMY

hroughout the 19th century both Europe and America remained ambivalent towards the nude. To be acceptable or justified, the nude must embody high moral principles and be cloaked in allegory, mythology, or history. In depiction, it must be so void of all blemish, so removed from "life," that no one could possibly mistake it for being human. Thus, elevated to the hallowed sphere of the ideal, the nude complied with time-honored rules set forth in the late 1700s by Sir Joshua Reynolds, President of the London Royal Academy. Beauty in art, wrote Sir Joshua, "is general and intellectual; it is an idea that subsists only in the mind; the sight never beheld it, nor has the hand expressed it; it is an idea residing in the breast of the artist, which he is always labouring to impart...."[1]

San Franciscans had long since become accustomed to nudes depicting writhing Bacchantes, struggling Sabines, sleeping nymphs, and wrestling Amazons. No one seemed to object to Domenico Tojetti's "Night," a woman asleep on a cloud, even though "the ruddy glow" on her bare breasts gave her "a heartily human look" and might quite possibly set unwary minds wandering[2] (PLATE 29).

Art lovers were equally willing to suspend disbelief before Tojetti's "Venus and Cupid," which showed Venus, life-size and nude, lying on a couch covered with blue satin, her golden hair streaming down her back. In the words of the *News Letter*, the color of her skin looked "generally natural." Yet, it was "so brilliant and beautiful that to render it upon any figure but a veritable goddess would be to overdo."[3] The *Alta* concurred: "The molding of the limbs; the voluptuous swell and graceful lines of the bosom and hips; the lovely expression of the eyes, and fascinating face, make altogether the most charming picture of a woman possible to imagine — a great artist's conception of the Goddess of Love."[4]

Then morality struck at the 1880 Mechanics' Fair, stamping as obscene one particular nude, painted by French artist Gabriel Guay and exhibited at the Paris Salon of 1875. "The Awakening" showed a nude woman, life-size, lying on her side and just waking up. The figure was gracefully posed, the drawing faultless, the flesh tones soft and lucid. In short, wrote the *Californian*, it was "a splendid study of the female form."[5] Even so, the moralists had reservations. It was Manet's "Olympia" all over again, only fifteen years later. The nude in "The Awakening" was too realistic, "the work of a Zola."[6] She was too contemporary, a modern-day woman, "the very embodiment of flesh, blood and passion," portrayed after what some said was surely a night of debauchery. There was nothing instructive about her. The painting had no redeeming sentiment, no narrative context, no Cupid! It was merely a tasteless depiction of a commonplace subject, likely to inspire but one kind of thought, which had nothing to do with art. No "art cant" in the world, said the moralists, could change that. "The Awakening" was too much for San Francisco and ought to have been too much for France as well.[7]

Alarmed, the fair managers hung an unsightly red drapery over the offending nude as they tried to decide what to do next. This, of course, only made matters worse. Gallery visitors, young and old, took to peeping behind the drapery "in anticipation of the promised and prurient treat."[8] The drapery kept falling down, so a policeman was posted next to the

painting to ensure public safety until the fate of the nude had been sealed. That was to happen the following Saturday, when a vote would be taken among gallery visitors to determine whether "The Awakening" should stay or go.

On the day of the vote, the art gallery was crowded. The policeman had been reinforced with a civilian, who presided over the ballot boxes with an air of impartiality. Visitors stood in clusters around the periphery of the room, eyeing the controversial nude, unveiled at last. Some of the male voters took the occasion to examine the painting at close range—very close range—while young women kept circling it, casting sidelong glances over the shoulders of their escorts. Conversation was subdued but animated, punctuated by the clucking of tongues, squeals of delight, and the occasional guffaw. As the votes were being counted, it soon became obvious that "The Awakening" had more admirers than adversaries. The painting could stay. "Speaking in a general way," wrote the *Chronicle* the next day, "all the good-natured, sleek and healthy people appeared to be in favor of allowing the picture to remain and all the dyspeptic and melancholy ones determined to have it removed."[9]

At the Mechanics' Fair of 1893 there were eight more of these modern-day nudes, all by local artists — and all turned against the wall, resolutely separated from the "regular art proper." A reporter from the *Call* arrived on the scene to find out why. He first cornered Norton Bush, seasoned superintendent of the fair gallery. In a rather vague way, Bush told the reporter that "when a painting of the nude by its spirit and surroundings directed the mind away from the element of artistic beauty it became vulgar." The rejected pictures, he said, all fell into that category. Other than that, Bush had no comment, nor would he reveal who the artists were. He was merely the superintendent. It was not his place to pass judgment on the paintings. That was up to the institute directors.[10]

Not much wiser, the reporter went looking for the three jury members ultimately responsible for the decision to ban the nudes. As it turned out. A.S. Hallidie had been far too preoccupied with his cable car business to

Venus de Milo Under the Tapeline

have much time for art matters. M.A. Dorn had been too busy with his law office. Hence A.W. Stott, the jeweler, had shouldered most of the responsibility. Stott also was evasive and appeared well rehearsed. He said he had nothing against nudes on principle, as long as he could take his mother or sister to see them. However, he added, rolling his eyes, "a painting of an ordinary woman, such as you see in the street every day, standing without clothing and with her hair down before a bath, is not of that kind." That was about as much as he would say. No doubt there would be some painters airing their grievances, but the decision had been made. The artists, still unidentified, had been notified to call around with express wagons during office hours to pick up their pictures. The sooner they did so the better, said Stott. Clearly, concluded the reporter, "California artists will have to study art a while longer before they can paint Venuses that will come up to the Mechanics' Institute standard of merit."[11]

That same year society matron Frona Eunice Wait announced a contest to find a "California Venus." Whoever came closest to matching the proportions of the Venus de Milo would be immortalized in marble by sculptor Rupert Schmid and exhibited at the World's Fair in Chicago as the most perfect type of physical beauty California could offer. Candidates — only "good" and "honorable" ones need bother — were asked to submit their measurements along with photographs of their artistically but scantily draped figures.[12]

The next day the studios of artists and photographers were overrun by starry-eyed young women. Mrs. Wait, interviewed by the *Examiner*, had

given the matter a great deal of thought. "Well, if I were to pose for the contest myself," she said, "I should use silk underclothing—tights and a sleeveless undershirt, of course. The underwear would be white, either a union garment or in separate pieces. Then I should take a piece of white crepe and wind it around the body, draping [it] slightly and enough to make it graceful and easy, so that it would show the form and yet conceal the body.... The only other articles worn would be sandals."[13]

A photographer representing the prestigious Taber studio advocated the use of dampened cheesecloth. Referring to a successful photo session he had just finished, he explained: "First, the drapery was entirely saturated with water. Then the cloth was stretched out to its full length, and was wrung from each end until nearly dry. That, as may be understood, made it cling to the form as desired, and caused all the folds to run one way. Besides, it gives an effect of stone chiseling, which makes the photograph look like the picture of a statue, and so heightens the artistic appearance."[14]

Schmid himself offered advice on the taking of measurements. "Any woman can put on a gauze costume of Greek drapery and have her picture taken, but to measure her own proportions is not so easy. In fact, a woman should not attempt to do the work herself, but should stand erect, like a soldier, while some competent assistant takes the measurements. That is the only way of being accurate, and any slight variation from the real proportions would be detrimental in the contest."[15]

Most San Francisco artists showed little enthusiasm. Mary Curtis Richardson called the proposed beauty contest "very unpleasant." She found "the idea of woman's beauty being thus displayed before the public ... particularly distasteful." When asked if she thought that the old Greek statue was offensive as well, she snapped: "Oh, the old Greek statue is a very different matter. It is not a portrait, not a model of any woman, but a conception of the sculptor."[16]

Arthur Mathews felt it would be impossible to create a California Venus, not for lack of beautiful models, but for lack of the right sculptor. "The sculptor needed for the interpretation of the Californian beauty is not

with us, nor among us, nor of us," he said. "When I say 'Californian sculptor' I mean an artist who is born with us and educated with us, who knows California beauty and knows no other. That is the kind of sculptor that might and will make a Californian Venus."[17]

Willis Polk, dapper young architect with a reputation for stirring things up, was even less optimistic. Granting that he was not "an expert on modern Venuses," never "having made the personal acquaintance of one," he was nevertheless willing to wager that artistic drapery alone would not make a winner. More drastic measures might be called for. "Perhaps it may be necessary," he suggested ever so blithely, "notwithstanding the decided discomfort of such an ordeal, for our prize California girl to submit to the amputation of her arms in order to secure the success of the statue she shall be required to pose for."[18]

Despite reservations, applications started pouring in as stores were running out of tapelines and gauzy fabrics. Scores of pictures of aspiring candidates appeared in the newspapers. However, the truly perfect body was nowhere to be found. Hips were too wide and legs too muscular, the unfortunate result of climbing all those hills. Other common afflictions were protruding stomachs, constrained waists, and swaybacks, all of which made it painfully clear that Venus de Milo, with her large artistic waist and perfectly rounded back, "never wore corsets even when she was fully dressed and had arms."[19] Feet posed another problem. According to a society chiropodist, at least three-fourths of the fashionable women of San Francisco suffered from corns and calluses, only because they insisted on wearing dainty shoes with pointed toes, at least one size too small. As compared to the real Venus, San Francisco women also tended to grow large heads — which was actually taken as a good sign, indicating that female intelligence was on the rise.

In the face of all these imperfections, there was talk about turning the "California Venus" into a composite. The press launched into an animated debate as to which young lady should be allowed to contribute which body part, envisioning titles such as "The Misses Mary Brown, Gertrude de

Jones, Miss Evelyn Rich et al."[20] The solution was not that preposterous: indeed, it was in harmony with the basic premise of ideal art, which held that perfection as such did not exist in the real world, and only the sum of perfect parts could begin to add up to a perfect whole. Even so, nearly every society for moral purification was up in arms. The "greatest beauty contest the world has ever known" was called off.[21] Not least distraught was Mrs. Wait. "Had I dreamed that it would have occasioned such an indecent exposure of the mentality of the male writers and some of the prominent members of the Young Women's Christian Association and the Native Daughters of the Golden West, I should have hesitated long before bringing about such a misfortune."[22]

However, an almost perfect Venus had actually been found, and in all secrecy Schmid began modeling her. She was Miss Marian Nolan, pronounced by the sculptor to be a splendid specimen of womanhood. Although slightly on the short side—she was only 5 1/2 feet tall—Miss Nolan displayed almost ideal proportions: waist 23 1/2 inches (26 inches would have been more like it); bust 32 1/2 inches (32 inches would have been just right); hips 38 1/2 inches (32 inches was wishful thinking); neck 13 inches (divine!). About a year or so later, a plaster cast appeared at the San Francisco Art Association, half hidden behind palms and ferns, under the alias of "California Poppy." The press hardly noticed it. The cast never made it to Chicago. Nevertheless, it was very much the outcome of the aborted beauty contest. Shortly thereafter Schmid took it to Italy to have it cut in Carrara marble.

Whereas San Francisco women fell short of the ideal, Eugene Sandow was indeed the perfect man. Bodybuilder and showman, he was in San Francisco for the 1894 Midwinter Fair, where he juggled dumbbells and lifted horses in front of gaping audiences (his only serious competition was Little Egypt, the dancer). He had already conquered Boston, where Mrs. Jack Gardner openly declared that Sandow was more worthy of admiration than "Japanese pugs" and "Kentucky thoroughbreds." New York society at first "sniffed its nose in fine scorn" but before long muscle was

Sandow, "the Perfect Man"

king even there, as men in dress suits and women in opera cloaks gathered in Sandow's reception room and took turns pinching his biceps.[23]

While in San Francisco, Sandow was also called upon by artist Solly Walter, portrait painter and illustrator, to serve as model for Walter's lecture on "The Relation of Muscle to Art." Thus, under the auspices of the Sketch Club, and in front of a stylish female audience, Sandow stepped into the spotlight at Stockwell's Theater, naked except for a strip of white silk, which some said was no larger than a handkerchief. Small and dark-skinned, Walter darted around his model like a nervous sparring partner, pointing and poking at the blond athlete, as Sandow systematically brought each individual muscle into play. The audience was asked to pay particular attention to the lights and shades of bone and tissue, the projection of strength, the slender ankle, the bulk of the leg itself. Sandow, observed the *Chronicle*, was "absolutely expressionless of face, except when he exhibited some slight interest in himself and looked down at his own muscles as their long Latin names were pronounced."[24]

The main drift of Walter's lecture was that the human body had deteriorated through neglect and easy living, resulting in a degeneration of modern art. Confronted with inferior models, artists were often content with reproducing "the nasty, the ugly, and the imperfect."[25] They called it "realism," thereby implying that perfect beauty did not exist in the real world. Not so, argued Walter. Venus de Milo, the Farnesan Hercules, and

other famous ancients were not idealized versions of second-rate models but copies of flawless human beings such as existed before the decline of the race.

Sandow was living proof that the same physical perfection was still possible through wholesome habits and gymnastic exercises. "Mr. Sandow would make as splendid a model as any Michael Angelo ever had for his saints and sinners," explained Walter, picking up speed, "for no matter how holy or remorseful Michael Angelo's figures were, they were always superbly developed."[26] A murmur of "Aaaah!" arose from the audience as Sandow transformed himself into "Ajax Defying the Lightning." Walter, equally inspired, took to quoting Goethe, something about how "beneath the clothes there is the naked man."[27] A gentle but insistent "patter of gloved hands" brought on an encore.[28] It was a most dignified affair. There was neither false modesty nor giggles. The spirit of the sleek and healthy prevailed once more.

Soon "living statues" were quite the thing. At the SFAA the directors sat in the very front row, not missing a curve as models in tight fleshings struck their classic poses. Artist Perham Nahl took the human statuaries one step further when he covered his models with a thick bronze paint, thereby achieving "a fidelity hitherto unapproached."[29] Seeking a broader audience, he tested his "act" at a local church benefit, with the most encouraging results. Next he hired a business manager, Giles Bradley, and took his "living bronzes" to New York, where director Rudolph Aronson agreed to try them out for his vaudeville show at the Casino.

Nahl and Bradley engaged a number of models, both male and female, the star being Miss Bertha Diensbach, known in theatrical circles as Bertie Bache. While the orchestra played the Star-Spangled Banner, and red, white, and blue lights flashed around the room, Bertie posed as the statue of Liberty in "Liberty Enlightening The World." The audience was luke-warm, their sense of patriotism obviously at a low.

Bertie wore too much clothing. One naked foot in a sandal was not enough to raise anybody's temperature. Bradley, more astute than Nahl in

Applying the Liquid Bronze

these matters, decided to do away with draping altogether. The next evening, the models wore nothing but paint and tiny rubber trunks. Bertie Bache supposedly protested. According to her own version, she was given "a little rag of drapery," which Bradley tore off just as the curtain lifted. This time the audience perked up. New York newspapers ran headlines such as "Clad Only in Paint" and "Almost for the 'Altogether.'" And as the bronze paint grew thinner and thinner, the lines outside the theater grew longer and longer.[30]

One night a squad of policemen in civilian clothing filed into the theater, armed with opera glasses. After the show the whole company, from the director down to the models, was arrested. In an interview with the *New York Times*, Director Aronson gave an impressive performance as the unlucky target of ignorance and wrongful persecution. "This is supposed to be a free country, but there is not near so much freedom here as in France and England," he wailed. "We seem to be in the hands of a pack of fanatics. There is no more beautiful object on earth than a handsome

Draping One of the Living Bronzes

woman in tights, and my bronze statues are admitted by artists to be the most artistic exhibitions ever seen in this country. They are classical, and yet objection is made to them. We try to educate the people to appreciate art, and we get arrested for it."[31]

At the ensuing examination and trial, held in the Jefferson Market Police Court, Nahl produced a "decided sensation" in the court room when telling Justice Simms that his "living bronzes" had been shown as a church entertainment at the Christ Episcopal Church in Alameda, California. Both Bradley and Nahl maintained that the exhibition, both at the church and at the Casino, had been "artistic pure and simple." Furthermore, they claimed that at no point had any of their models been entirely nude, even though Titus, one of the arresting officers, swore they sure looked that way to him.[32] Called in as an expert witness was William Merritt Chase, President of the Society of American Artists and a man of distinction — even in the eyes of Justice Simms. "There is nothing immoral about the human frame," said Chase. Immorality, he added, "only exists in the mind,

and that, I think, can be educated."[33] In the end it was decided that the "living bronzes," however shocking they appeared to the unartistic eye, were not nude in the strict sense of the law, and Justice Simms dismissed the case.

On the whole, however, the verdict did little to advance the status of the nude in America. While drawing from live nude models became wholly accepted as part of the training of future artists, the nude as a subject for finished art, painted for "its own beauty as men paint flowers and landscapes," remained controversial.[34] When asked to concentrate on paint rather than subject, to put aside all other considerations, whatever they might be, the American public refused to cooperate. As late as 1905, art historian Samuel Isham would conclude that the nude was only "imperfectly acclimated" in America. When exhibited, paintings of the nude were typically "small in scale" and "treated decoratively rather than realistically." By comparison, the "carefully finished life-size study such as crowds the walls of the French and German salons is practically unknown."[35]

In 1907, in his *Story of American Painting*, Charles Caffin voiced similar regrets. He blamed the situation on "two centuries of Puritanical tradition and prejudice," which "had engendered a prudishness that even today, while not quite so virulent, is still prevalent and hidebound." Even so, Caffin was not altogether disappointed. The rejection of the nude, he noted, had its "compensations." It forced American painters to stop imitating the Europeans, in subject as well as in methods. It helped them focus on the "expression of native sentiment," on the "distinctly American," which lay not in figure but in landscape.[36]

THE NEW WOMAN

y the early 1890s, American women were no longer content to wait for the lion to lie down with the lamb. Calling themselves "new women," they insisted on their rights, in art as well as in other areas. All over the land women artists were setting up studios, burning candles in front of smudgy casts of "*La Femme Inconnue*," and reading thumb-marked copies of the diary of Marie Bashkirtseff, kept by the young Russian while studying art in Paris. Magazines featured articles about the girl Bohemian and her daring new lifestyle — "she smokes, she drinks, and softly — now! she swears."[1] In the Woman's Building at the Chicago World's Fair, Mary Cassat's mural "Modern Woman" caused mostly negative reactions. Some of them had to do with the "impudent" and "garish" colors.[2] The content was just as suspect. One of the side panels showed three young women pursuing Fame, a flying female nude. No man was within sight. The central panel was even more unsettling. It showed twelve women picking fruit, no doubt of the forbidden kind. Here indeed was modern woman, quite "apart from her relations to man."[3]

Female Art Students

Elizabeth Strong

"It cannot mean very much; the results are so very meager, this overwhelming studying of art by almost every tenth woman in the country," wrote Emil Carlsen in a letter to the *Examiner*. Compared with his male students, Carlsen found that the typical female did not take well to criticism. "To keep a girl at her work begin the correction with a pleasant little compliment, otherwise she will either burst out crying, sulk or put on her sealskin and march off!" Half the time she did not come to class in the first place. Either she had nothing to wear and "must stay at home for weeks to superintend the making of dresses." Or there was an invitation to spend a month in the country, which had to be accepted because Mama insisted.

The ultimate obstacle appeared to be a pervasive lack of self-confidence. "The young man," wrote Carlsen, "is always anxious to try his ability; commences large work early." By contrast, the typical woman "studies under one master, then under another; goes from one school to another; she fears to branch out; she has learned some drawing; her color is good; she is bright, clever and has ideas; why don't she try something! Why this eternal taking lessons!" All in all, it was a monumental waste of energy and money. "To a great extent it is a fad, seldom a serious undertaking. Those that are poor turn teachers, eke out some sort of existence; others get married, drop the profession altogether, speak learnedly of work they do not understand, and copy chromos for a pastime."[4]

Despite the gloomy prognosis, San Francisco did produce some excellent women artists, the kind that even Emil Carlsen tipped his hat to. Among the pioneers were Matilda Lotz and Elizabeth Strong. Both studied under Virgil Williams at the California School of Design; both continued their studies in Paris in the early 1880s. Lotz received generous support from Dan Cook, a San Francisco patron, who paid her a monthly stipend of $100 for four years. Strong, in the shadow of brother Joe, "was dependent entirely upon her own efforts, paid her way through the art school, and has relied upon herself ever since."[5]

At the time opportunities for women artists in Paris were limited. The

Académie Julian was open to women, as were several private studios. However, in almost every instance where both men and women were accepted, women were charged higher tuition than men. The official reason: many of the female students "are not studying professionally and consequently instruction as a luxury is put at a higher price."[6] Additionally, the instruction received by women was often inferior; many of the professors did not visit the women's classes as frequently as they did the men's. Studying at *L'École des Beaux Arts*, operated by the state, was not even an option. While the school accepted male students tuition-free, without regard to nationality, no women were admitted until the late 1890s, when separate life classes for men and women were established. That the classes should be mixed was out of the question, not to spare the women "the supposed embarrassment," but because their presence would limit "freedom of conversation" among the men, stifling the latter in their "artistic development".[7]

Both Lotz and Strong studied in the private atelier of Émile van Marcke, a well known animal painter. "Not altogether rosy the fate of a California painter away from home," wrote the *Wave*. "Miss Lotz, for instance, has had somber intervals during which the fate of her next dinner hung in uncertainty."[8] For Strong it was no easier. According to the San Franciscan, she "made her mark in spite of oppression, injustice, and difficulties of all kind."[9] The *Golden Era* intimated that her "struggles and final success" had been "almost heroic in character."[10]

By 1883, Lotz had rented a house in Senlisse, a village close to Cernay-la-Ville, some twenty miles outside Paris. Adjacent to the house was a stable, where, according to the San Francisco *Chronicle*, she could "keep her four-footed subjects and study the traits of their various quadrupedal characteristics at the most perfect convenience."[11] Strong had taken up residence nearby, surrounding herself with a collie and four sheep as live-in models. The hunt, "thirty strong, all in scarlet," met near her house, hounds and horses providing spirited material for her brushes.[12] More models materialized as she introduced herself to the owners of the neighboring

estates; gatekeepers soon knew her by name and dogs were let out of the kennels at her request.

According to the Paris *Morning News*, by 1885 both Lotz and Strong showed regularly at the Paris Salons. Lotz' salon painting that year was "*Premier Déjeuner*," which represented a number of street dogs feasting on the contents of an overturned garbage can. Strong showed "Waiting for the Master," a painting of her black and tan collie and a white greyhound by an iron-barred gate.

Meanwhile, in San Francisco, a rivalry was building between those who liked Lotz and those who preferred Strong. It turned particularly vocal whenever a new painting arrived from France and was in no way toned down by the intelligence, from the Paris *Morning News*, that the two women themselves were "the warmest friends."[13] The Lotz fans warmly applauded two spaniel pups, with soft brown eyes full of "rakish wisdom."[14] The Strong camp answered with a painting of another canine, full of "deep doggy, expressive beauty, of steadfast faith and marvelous, dumb patience."[15] When the Lotz fans proclaimed one of her sheep paintings infinitely better than anything Strong had ever done, the Strong camp countered with a delicate little meadow scene featuring a child among wildflowers. "She can not only go far ahead of Miss Lotz in animal painting," they said, "but she is bound by no narrow limitations, and is equally strong in landscape."[16]

By the mid-1890s both women had clearly "arrived." In 1895 news reached San Francisco that Count Miklos Esterhazy had invited Lotz to spend the summer at Tata, his Hungarian estate, which served as horse farm and artists' retreat in one. While a guest at Tata, Lotz met the Duke and Duchess of Portland. They in turn invited her to Welbeck Abbey, their seat in England, where she painted portraits of St. Simon and Donovan, the Duke's famous horses. A few months later she traveled to North Africa, executing some "charming bits" around Cairo, the best of which was also purchased by the Duke, the artist "fixing her own price."[17] Strong, in the meantime, returned to San Francisco, where she gave an interview for one

of the papers. In her early forties, hair tied in the emblematic artistic knot, wearing a high-neck dress and tiny wire-frame eyeglasses, she talked of her recent show at the St. Botolph Club in Boston. Although she said she was quite busy with commissions from her East Coast patrons, she had finally given in to her desire to revisit the city of her youth. Now she planned to stay awhile, devoting herself to "distinctively Californian subjects."[18]

More than anything, though, she talked about her time in France, how she and Lotz "visited all the time in a pleasant unceremonious way at the different castles."[19] The usually reserved Strong — according to the Paris *Morning News*, her greatest "defect" was her modesty[20]— poured it on rather thick. "We used to see a great deal of the Duchess de Luynes, who is about the richest and noblest lady in France," she said, no doubt producing much the desired effect among impressionable readers. She also mentioned frequent dinners with the Baroness de Meneval, whose husband, a former aide-de-camp to Napoleon, "used to paint a great deal, oh! very badly, but he enjoyed getting us to criticize his pictures."[21]

Another graduate of the California School of Design, Evelyn Almond Withrow, left for Munich in the early 1880s, accompanied by her sister and mother. Upon her arrival, William Keith offered her the use of his studio without charge. Keith thrived on female companionship, but in Withrow's case he may also have been motivated by a sense of fairness since, in his own words, Munich was known for its "deeply rooted 'Bavarian' prejudice against 'emancipated' womanhood."[22]

The homesick Keith was going through one of his creative lows, while Withrow, at least in the eyes of Keith, perceived herself as a budding genius, singing and whistling shamelessly at her easel. Withrow's spirits soared even higher, when the great Frank Currier became her "master" (Keith, it will be remembered, had turned him down). Currier's willingness to take her on was indeed cause for celebration, since he was notoriously suspicious of women students, having seen too many examples of their "pretended worship at the shrine of the goddess of art."[23] Though her stay in Munich lasted only four years, her friendship with Currier would be

lifelong. His letters to her, written from 1885 to his death in 1909, are one of the chief sources of information about this elusive but important American artist.

In the late 1880s, after a year's "rambling" through Italy and two more years in Paris, Withrow returned to San Francisco where she soon became the darling of the local press.[24] Reporters insisted on calling her "unassuming," a quality considered most feminine and therefore applied to virtually every successful woman artist of the period. Her Pine Street studio was known as one of the "prettiest" in town. The mantel, covered by a "gorgeous" material in olive, gold, and Persian-blue, held pieces of Japanese bronze, pewter tankards, and beer-mugs gathered during summer sketching trips around Bavaria. In one corner was her portrait of Currier. In another stood a 15th century cabinet from Verona, on top of it "a quaint Jewish candelabrum, a spoil from Prague." Portières from Tunis draped the wall, and throughout the rest of the room were scattered "odd pieces of furniture of such different origin, that in looking them over one becomes queerly jumbled as to centuries and localities."[25]

Her copies of paintings by Rubens, Rembrandt, Reynolds, Murillo, and Gainsborough — "in original size" — elicited much enthusiasm, as did her sketches of "old Rottenburg [sic] church interiors, bits of shrines, delicious dashes of spring blossoms and greens, curious street views, odd faces, old and young, dear little German babies, quaint and solemn."[26] William Vickery, the San Francisco dealer, claimed she could not paint "fast enough" for him. "I have been so very successful with Miss Withrow's violets this year, that I send you some on sale, hoping they will be of use to you," he wrote to William Macbeth in New York in 1892.[27] Macbeth had just opened the first New York gallery to show exclusively the work of American artists. Though many doubted his chances to compete with galleries specializing in European art, his timing was right, and Withrow, along with Lotz and Strong, became part of his success.

By the late 1890s, when Withrow took a studio in London, she was well prepared for her role as the consummate woman artist. According to the

Chronicle, she walked right into the so-called Ultra-Bohemia, "a very swagger section that admits lords and ladies of high degree into terms of equality with successful artists and singers." Tantalized San Franciscans read about her afternoon teas — veritable "crushes" — where supposedly "everybody, from royalty down, went and enjoyed the music, bread and butter, cake and tea".[28] Withrow herself wrote effusively about her visit with the aging George F. Watts, R.A., who received her in a "long, loose gray dressing gown, a deep red necktie and little maroon velvet cap."[29]

Demand for her paintings apparently increased when she changed her signature from "Eva Withrow" to "E.A. Withrow," proving, as the San Francisco *Call* put it, that "in benighted England a masculine signature to a picture is as sterling on silver to us."[30] Her "Antiquarian" was accepted and hung at the Royal Academy. The painting, in line with Tavernier's treatment of the same subject, showed an old scholar reading a book, surrounded by various objects indicative of his calling. It had been shown and "loudly" admired in San Francisco but had not yet found a purchaser.[31] In London, one of the leading art dealers, Henry Graves & Company, bought the work "for a high price" and reproduced it in etchings, supposedly making Withrow a household name in "many artistic homes throughout the world."[32] Violet, Countess of Rosslyn, rumored to be the most beautiful woman in London, became one of her "most devoted adherents and patrons," and the Marquess of Dufferin and Ava was said to be greatly taken with her work and sending her "any number of orders."[33] Baron Otto von Schleinitz commissioned her to paint a portrait of artist Walter Crane for his *Life of William Morris*, which proved she had "arrived," even in the most discriminating circles (PLATE 30).

While Withrow was in Munich, Julie Heyneman was still a young art student in San Francisco. In letters to her sister, she wrote about her work at the Art Students' League. Her dedication to her studies — and her stalwart and outspoken manner — made for constant friction with some family members. "We had very heated arguments during the week as to whether I had any right to devote so much time to the League," she wrote.

Julie Heyneman

"I had given as my reason that I wished to be independent and everyone had condemned that desire."[34] At night she lay awake, absorbed by thoughts of art, feeling lonely in a house full of people. "I have come to the conclusion, one which has caused me not a little pain. I am out of sympathy with my surroundings and the sooner I realize that I must live in this part of my life for myself alone, that I must be the one to enter into the lives of others and not expect the return interest in mine — the sooner I will arrive at that peace of mind which is more necessary to me than the food I eat."[35]

Her drawing from the nude only aggravated matters. Although more and more American art schools were now offering life classes for women, many parents did not allow their daughters to attend, fearing that such exposure might violate their "natural womanhood" and stir up passions best left dormant. In 1882, in a letter to the Pennsylvania Academy, the writer warned of such insidious threats to public morality: "There is not a

young woman who has been a member of the life class for any length of time, but has become more or less coarse in manner and word."[36] Initially, even Heyneman herself was apprehensive. The first few days were indeed disagreeable, but gradually the awkwardness wore off, as the model ceased to be of flesh and blood, becoming just another "study" and taxing her powers to the utmost. "For six months I have been in the class and I have not only conquered my feelings, but I have none other than when I copy from the cast of a Venus or Apollo," she wrote. "I draw with no other sensation than one of absolute absorption in the beauty of line and curve."[37] At home, however, her brother was still objecting. Heyneman, as usual, stood her ground.[38]

On her arrival in London in 1892, Heyneman shocked her English relatives by calling on John Singer Sargent at his studio on Tite Street in Chelsea — without a chaperone. The studio, with its dark wainscoting and Florentine mantelpiece, was already crowded with visitors, a formidable gathering of haughty necks and lofty eyebrows, among them Henry James and Sarah Bernhardt. Sargent, the most sought-after portraitist of his day, turned Heyneman over to the rather forbidding Miss Anstruther-Thomson, who took pity on the young American and provided her with tea and "a few conversational openings."[39]

A day or so later Sargent called at Heyneman's "apartments," which she shared with her sister, asking to see her work. Heyneman spread her sketches on the floor. Sargent sat down next to them, and began his critique "with so kindly a smile that it took the sting out of the verdict." He warned against "easy solutions," saying she was "still too ignorant to be so clever."[40] Yet he saw promise. At his suggestion, Heyneman spent the next few weeks copying heads by Frans Hals at the National Gallery, while Sargent paid regular visits to check her progress. He would teach her to paint with "good thick brushes that will hold the paint and that will resist in a sense the stroke on the canvas."[41] He also emphasized how each brush stroke must have significance, how she must never use a stroke just to fill an empty space, how she must "paint thicker — paint all the half tones and

general passages quite thick — and always paint one thing into another and not side by side until they touch."[42]

Socially, Heyneman was less successful. "One is more than usually hedged in, here in London," she wrote to Arthur Mathews in San Francisco after an encounter with a particular crowd of Philistines. "If now and then I grow impatient and let myself go, conversationally speaking, either my statements are regarded as daring jokes or as more than ordinarily rampant Americanisms." For her own part, Heyneman was only mildly impressed by what the British themselves had to say: "They are so odiously well informed, they are 'up to everything,' they discuss with vigor and decision, with a freshness that speaks of excellent articles in the sixpenny papers, read with a certain superficial understanding and a wonderful aptitude for catching the phrases." But London had its redeeming side. "Seeing that I have come direct from John Sargent's studio, that I had tea there in the charming, mellow light, with the big simple artist, and a very quiet Englishman, and a bright, very deferential young American, seeing that I have driven through Hyde Park, with the evening bloom in the trees, and the long quiet stretches of grass under a luminous sky, I do not see exactly the occasion of my tirade against the conventionality of being well informed."[43]

Like Withrow, Heyneman would in time establish herself as a competent and successful painter, with studios in both San Francisco and London. In San Francisco, she taught at the Art Students' League and found time to write a biography of Arthur Putnam, a young sculptor who became her protégé. In London, she continued to paint under Sargent and remained very much part of his circle, "clever people with famous names who liked her brew of tea and the delightful atmosphere of her home."[44] Her portraits, painted "in bold vertical strokes" reminiscent of Sargent, hung on the line at both the San Francisco Art Association and the Royal Academy.[45] Her copies of Velasquez were deemed "splendid."[46] Her charcoal heads were said to be "full of rare life, spirit and charm," as the one of Mrs. Patrick Campbell, the famous actress, under a "drooping black hat."[47]

Heyneman herself would sit for Sargent, who captured her matter-of-factness in a remarkably honest manner. She looks directly at the viewer — a striking woman with a long neck, heavily lidded eyes, and a mass of hair, kept in place, one assumes, with some effort.

In photographs by San Francisco photographer Arnold Genthe, she is seen posing in her studio, either seated in a high-backed chair, or standing by a window in the kind of soft back-lighting which came to be Genthe's trademark. Her long sloping bust suggests one of those straight-fronted corsets which Edwardian women used to wear. A lace shawl is tied over her shoulders. Her waist is small, with the fullness of the skirt trailing behind. She carries herself very erect — everything about her bespeaks a self-assured, proud woman, at the peak of her career. A letter written during that first heady London summer suggests, though, that her success came at a price. "And you, my dear little mother, take care of yourself and make your hair very pretty. Believe me, my ideal of a woman is very much nearer realized in the wife and mother you have been than it is likely to be in the embryo artist, in Your very deeply loving if unsatisfactory Julie."[48]

Meantime, far from French chateaux and English tea parties, Grace Hudson had set up a studio in her home town of Ukiah, in the redwoods north of San Francisco. Since her graduation from the California School of Design, her subject had become the Pomo Indians, a stocky people with heavy faces. In the past, they had lived off the land, on acorns, berries, roots, bulbs, and tubers. They fished the streams for salmon and steelhead, and hunted the woods for deer, rabbit, and birds. The women wove baskets for practical and ceremonial purposes. The men made "wampum," strings of polished shells worn as a measure of personal worth and used in trade with other tribes. However, with the arrival of the white man, the wilderness was transformed into vineyards and orchards. Laws were passed sanctioning the kidnapping and slavery of Indians. "Indian hunters" became local heroes. In the late 1850s the Pomo were forced onto the Round Valley Reservation and the Mendocino Reserve, near Fort Bragg. From then on they remained dependent on white settlers for their livelihood. Some of

Hudson's earliest childhood recollections were of Pomo coming to her parents' house, looking for food and work.

Hudson began painting the Pomo in 1891 at the suggestion of her husband John, a young physician with a strong interest in ethnology. Her first effort, called "National Thorn," showed the child of Whisky Jennie tied up in an Indian baby basket and guarded by a small terrier. The following year, she finished a portrait of an old Pomo chief, his rabbit-skin robe brought with "faultless precision."[49] That same year "Belle of the Tribe" was hung at the SFAA. It represented a young woman, "with a wealth of hair unbound and streaming over a voluptuous form, the curves of which are lost in a deerskin jacket."[50]

In 1893 "Little Mendocino," a painting of a crying Pomo baby wrapped in a blanket and strapped in his basket, earned an honorable mention at the Chicago World's Fair (PLATE 31). *Frank Leslie's Monthly* called it "a miracle of homely expression with no vestige of Digger grime wanting — papoose, blanket and basket being sensibly dirty and ill-smelling."[51] The San Francisco *Call* considered it "a somewhat daring subject" which might well have turned "ridiculous": "But the Indian baby is not ridiculous; it is charming in spite of the fact that it is crying. Every one admires the little brown thing and longs to comfort it."[52]

By the mid-1890s Hudson's paintings of the Pomo were much in demand from buyers on both coasts. Her large canvases brought as much as $500, the small ones from $150 up: the male artists of San Francisco were said to be "astonished at their eclipse by a slip of a woman who a few years back was unheard of even in local art circles."[53] Reporters sought her out for interviews and were charmed by the young *Californienne* who greeted them with a firm handshake and talked so confidently about "her" Indians. *Western Field* called her "a charming type of the higher Western Evolution — a lovable genius because she is a purely womanly one."[54] One photograph showed the dainty brunette with a twelve-gauge gun and a string of dead squirrels around her waist, looking up a tree for more (PLATE 32).

All the while John Hudson immersed himself in studies of the Pomo and spent less and less time on his medical practice. His articles, illustrated by Grace, were published by the *Overland Monthly*. His collection of baskets promised to become the finest of its kind. By 1896, the local newspaper no longer included him on its roster of practicing physicians. Grace was now the main breadwinner and turned out painting after painting to make ends meet. Finding willing models was difficult: the Pomo believed that the taking of their image might cause disfigurement or death. She often bribed prospective models with clothes, food or money. Through "unwearied patience," wrote *Frank Leslie's Monthly*, she overcame their "childish" unwillingness to make even "the slightest alteration" in their dress.[55] When she wanted to paint a baby, she would hire the mother to help with some housework. The mother would bring the infant, tied to its basket. On a secret command, Hudson's St. Bernard would jump up and bark, which gave Hudson the perfect excuse to remove the papoose to the safety of her studio.

"In a jiffy, I have that baby propped up in the light against the front door of my studio," she explained to a reporter for the *Call*. "Then comes the task of getting a sketch of one fleeting expression on the face of the baby, indicative of interest in life. They are regular little stoics. They will sit and stare without blinking an eye or moving muscle, while I perform the most grotesque antics in order to provoke a laugh. I can occasionally interest them by giving them something to eat, but there is always something about the way they accept food from me that reminds me of the caged animal."[56]

In 1901 John and Grace went their separate ways. John became a collector of Indian artifacts for the Field Museum of Chicago. He traveled extensively to collect Indian artifacts and record tribal customs. Grace, who at this time was showing signs of exhaustion, sailed off, alone, to Hawaii. The following months she wrote John often. "I am feeling very well only I cannot sleep enough. Please tell me something to do. I fall asleep as soon as I get in bed, then awaken about four and sleep no more. Night after

night.... I tried to paint a little last week, but the same old tired feeling came back so I put away the paints and will go on resting; if only I could sleep ... Good night, Johnnie boy, you cannot imagine how much I miss you."[57]

In a later letter, she felt better. "My desire to paint has returned. I had a model and worked hard today. A young girl with leis. I think I will rent a studio and paint for a month anyway. I would be ashamed to go back with nothing ... You ask if I am ever homesick, yes and no. I long to see you but I am not homesick for Ukiah. I could not live there without you and I cannot think of any place I would rather be alone than here."[58]

John's letters were less frequent. He anticipated a reunion and a better life for both of them. "You have worked too hard, my dear, in these past years and I see no reason for its repetition as long as we live. I forget what sum you have stored away, but its interest with what sales you may make in the future should supply you with pin money. I don't want you to quit painting but it should be not for revenue only, but for pleasure and honor."[59] He also continued to offer ideas for her work. A topless Hula dancer, he wrote, "would stir the souls and purses, at least the tongues." He advised her to paint everything very accurately, for details were "the real fire and stage settings." Grace, again, could not bring herself to paint. "You certainly give me good advice about my work," she wrote, "but alas you do not realize I have no work — my working brain is still weary. I have tried so hard and accomplished so little that it made me unhappy, now I have given up for the present." However, she also wrote about attending the opera, swimming in the moonlight, yachting, and going horseback riding with a "beautiful young man." John leaped to defend her reputation. "A real woman," he decided, "is the most susceptible to injury when absent from her natural lover and protector." Brusquely he announced: "Your time is up, my girl — come home!"[60]

Grace did. With John, she took buggy rides and camped along the Russian River. She found herself carrying a sketchbook. Occasionally, on some excursion, she would come upon a group of Pomo and sketch them hurriedly from some hidden vantage point. Soon new paintings of the

Pomo began appearing at San Francisco galleries, unflinching in their exactitude, incorporating every stitch in the mesh of a basket, every notch in a ceremonial flute, every bead and feather in a dancer's headdress (PLATE 33).

The critic for the *Western Field* objected to her subject as well as her methods. The Pomo Indian, he wrote, was "at best picturesque only in tradition, being in real life and actual evidence about the most squalid, degenerate, and altogether uninviting subject imaginable."[61] Instead he asked for something more "serious," perhaps a "historical" canvas depicting California's Spanish past. He also criticized Grace for the very sort of approach John demanded. "The almost painful faithfulness of her rendering evinces close and conscientious study, but it is work thrown away," he wrote. "She attempts to justify it by saying that she is painting futurity and aims at ethnological value, forgetting that in matters of prosaic details of value only to ethnologists, the camera can do even more severely accurate work in a fraction of the time and expense and without any waste of precious talent and nervous energy."[62]

Nevertheless, Hudson made her mark. Leading art journals ranked her as one of the greatest painters of American Indians. The *New York Journal* lauded her for having "surmounted what to a woman of less persistent perseverance would have seemed crushing and overpowering obstacles."[63] Husdson herself, most likely, put on her brown alpaca shooting jacket, loaded the gun, summoned the dog, and said she owed it all to her husband.

THE HOUSE
ON THE HILL

I n 1893 the days of shooing rats at the California School of Design ended. The lease was up and the Pine Street building condemned. As the students carried away their belongings, workers were tearing down chimneys and ripping off the roof. Hauling wet canvases, paintbrushes, rolls of drawing-paper, and boxes of charcoal, the students climbed Pine Street to the top of Nob Hill, where a large mansion loomed dark and cold, laced with intricate woodwork, and scratching the sky with spires and turrets and steeply pitched roofs (PLATE 34). Here the school was housed on the third story, "in high, light rooms with clean walls and polished floors." From the windows of the old school, students had glimpsed only a few chimney pots and a bit of the sky. In their opulent new quarters, they "looked through gleaming plate-glass windows clean over the top of San Francisco, above murk, squalor, grime."[1]

Mary Frances Hopkins, the wife of railroad magnate Mark Hopkins, directed artistic aspects of the building of the mansion. Mark Hopkins died a few months before its completion. Described as "painfully penurious," he was the sort of man who would ransack waste baskets for usable

scraps of blotting paper discarded by his careless clerks.[2] He had been against the mansion from the start. Building it had merely been a way of humoring his wife. In the early days of their marriage, when money was still rather scarce — in Hopkins' mind it never ceased to be — his wife had been as frugal a housekeeper as he could ever have hoped for. It was later, much later, that she began to change, though some said she never quite forgot her humble beginnings and never really abandoned her penny-pinching ways. At any rate, the house on the hill was ample proof that "Uncle Mark" had accumulated as much wealth as any of his partners, and that his wife was eager to spend it.

When Hopkins died he left his widow with seventy million dollars, which supposedly made her the richest woman in the country. At that point Mrs. Hopkins began to entertain ostentatiously. All the windows of her mansion would be ablaze with bright electric lights, and the effect from the city below was said to be "enchanting."[3] Gertrude Atherton, who stemmed from one of San Francisco's most prominent families, recalled these occasions literally "with a shudder," for Mrs. Hopkins did not waste money on heating fuel and the mansion was freezing. "Nothing could be colder, excepting her manners, which were polaric, not from ill nature, but some sort of internal ice box. I always remember her standing still and solemn at the head of the room, clad in white and armored in diamonds. She looked like a large spectacled white cat covered with crystal chandeliers."[4]

Presently Mrs. Hopkins embarked on yet another building project. Modeled after the great French palace of Chambord, it was to be a chateau located in Great Barrington, Massachusetts, the birthplace of Mark Hopkins' father. Here she met Edward T. Searles, a rather good-looking interior decorator, a dozen years her junior, with "charming manners" and "exquisite taste."[5] The two of them spent a couple of years getting to know each other, mostly rearranging furniture, an activity they both enjoyed. Mary Frances paid for the European honeymoon. By the time they reached Nice, she had signed over both Great Barrington and the Nob Hill mansion to her new husband.

In 1891, after less than four years of supposed connubial bliss, Mary Francis died, willing all her earthly possessions to Searles. Searles blithely confessed to having married Mrs. Hopkins not just for love or money, but for both. Despite columns of abuse in the San Francisco newspapers — including intimations that Mrs. Hopkins' death had not been entirely natural — Searles did not turn his back on San Francisco. For one thing, there was the matter of the mansion. He wished to give it to the San Francisco Art Association. However, since the SFAA could not afford the property taxes, Searles deeded the building to the University of California, thus making it exempt from taxation. Under the terms of the bequest, the SFAA was still to be the main tenant, and only the rooms not claimed by the SFAA were to be used by the university.

Some of the regents resented "having the University used as a cat's paw to pull the Art Association's chestnuts out of the fire."[6] It was no secret that cohabitation was strained. "Between the regents and the AA there does not exist that cordiality which one is entitled to expect of bodies so dignified and prominent," wrote the *Wave*. "Accusations of ingratitude and greediness are cast back and forth with more venom than appears requisite."[7] The exchange grew particularly ugly when the SFAA suggested that the regents use one of the back bedrooms for their office (as a back bedroom it was certainly as good as they come). "I guess it was the poetry that killed them," explained a spokesman for the SFAA, pointing to a verse emblazoned in the ceiling, beginning "Now I lay me down to sleep."[8] Still, Mary Frances had had similar sentiments inscribed all over the house and finding an office without them would have been close to impossible.

With the SFAA moving in, the house revived. At the Mardi Gras *Bals Masqués*, staged on the Eve of Lent, the great hall was hung with garlands and balloons. For one brief night nothing was quite what it appeared to be. SFAA officers, dressed up as courtiers, led off the grand march, followed by hundreds of confetti-flinging maskers — society girls in red Mephisto robes, Carmens and Pompadours, opium-smugglers and vaqueros, peasants in russet leggings, and Burlingame clubmen in red hunting coats

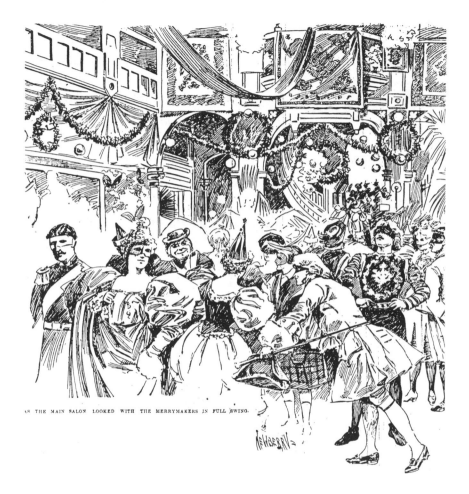

*As the Main Salon Looked with the Merrymakers in Full Swing
Mardi Gras at the Hopkins House*

(which happened to be the real thing). As the revelers grouped themselves around the hall, King Carnival mounted the throne, trumpets sounded, and the proclamation was read, commanding everyone to forget dull care and join the merrymaking. The orchestra started up a waltz, and the floor filled with whirling couples, reflected by large wall mirrors in a sea of color and movement that bewildered the senses like a giant kaleidoscope.

However, trouble was brewing. Young men, possibly artists, were taking shocking liberties on the dance floor and "cutting capers" in the supper rooms.[9] Invitations to dance were turned down, as mask looked upon mask with dread and distrust. Time and again society threatened to withdraw its patronage — *and* its debutantes — unless conduct improved. Someone suggested introductions, which of course made no sense whatsoever (short of introducing, say, Hamlet to Mary Stuart). Next it was suggested that only women be allowed to wear masks. Robbed of their anonymity, male ticket holders arrived in conventional evening clothes, which delighted the dowagers but most definitely dampened the festivities. Finally, it was pretty much understood that the SFAA was by no means the right forum for solving "questions of propriety," and that those not willing to enter into the true spirit of carnival might as well stay away.[10]

The mansion was also in full glory on regular reception nights. Throughout the evening the heavy doors swung continuously as the throng poured in — men in claw-hammer coats, white shirtfronts, and top hats; women in silk dresses with striped puff sleeves and quivering plumes. While soft strains of music floated through the air, the guests crossed the great hall and spread out through the back rooms, winding up and down the magnificent staircases, filling the salons, the music room, the library, the conservatory, even the boudoirs. They moved from painting to painting, as they fixed their eyeglasses and secretly consulted their catalogues. In between, they marveled at the wood carvings, the onyx mantelpieces, the rich velvet hangings, and the ponderous tassels (the artists complained that the tassels took away from the paintings). When, on occasion, some elderly gentleman was caught yawning at the head of a staircase, there was

always a cup of punch below to bring him back into circulation.

Other than works by local artists, the exhibitions also included European paintings on loan from private collections. Of the "old masters," the less said the better. No more than five were thought genuine, and some questioned even those. In other areas, the offerings were quite impressive. Mrs. Will Crocker, no doubt the most venturesome of the San Francisco collectors, had acquired "Man with a Hoe" by Jean-François Millet, "Landscape" by Gustave Courbet, "Sunlight Effect on the Riviera" by Claude Monet, "Woodland Scene" by Camille Pissarro, and "*La Baigneuse*" by Edgar Degas.

The *Wave* obligingly published an "Art Critics' Guide" for those not yet sufficiently acquainted with the very latest in art. "First and foremost, bear this well in mind: Whatever you think remarkably good, is ordinary. Whatever you believe to be remarkably poor is superb.... When you see before you a canvas, that, to all appearances, has fallen flat upon a palette freshly stocked with paint, custom demands that you murmur 'Impressionist,' and then pass on. 'Careful workmanship' is occasionally added, but that is a matter of taste.... 'Tone' is not to be despised. It is capable of yeoman's service. Use it freely. Select sombre, murky compositions in which you can distinguish nothing, then call attention to their tone. After a time vary with epithets such as deep or rich. Just before leaving turn around with a comprehensive scowl, mutter something about the barbarous way in which the paintings are hung, growl a little because the light is wretched and then depart, vanity untouched, self-appreciation intact. For the nervous prostration which, of course, will follow, bromide of cafein is widely recommended."[11]

In time the school, renamed the Mark Hopkins Institute of Art, was removed from the mansion proper and housed in the old stables, remodeled for their new purpose. Under Emil Carlsen, it had gained an excellent reputation—Jean Joseph Benjamin-Constant himself was said to have commended it before his class in Paris. More affluent than in earlier years, it was a "thoroughly modern institution, fully equipped in all its many

branches."[12] The students averaged about a hundred in number; the best received medals and free scholarships. Largely European-trained teachers were in charge of an impressive rostrum of classes, matching those given by the schools in the East. Douglas Tilden, a deaf-mute sculptor, taught modeling (his "Baseball Player" had been shown at the Paris Salon and was installed in Golden Gate Park). All students, even those who intended to become painters, were encouraged to take his class because of "the splendid opportunity it affords for the study of form."[13] In landscape, Raymond Dabb Yelland and Lorenzo Latimer took their students on sketching expeditions into the surrounding countryside. Students began with very simple subjects, such as "bits of fences, a post with grasses growing about its base, or a corner of an old barn with a clambering vine." Next they advanced to "a whole house with trees and shrubbery," and finally a "solid" landscape, perhaps "a hillside with clumps of trees and cloud masses."[14]

In the still life class, pervaded by the smell of dead fish, Amédée Joullin stood behind his charges and roared "Scrape!" and "Scrape again!" until through sheer frustration they got it right.[15] Despite his methods, students kept enrolling and still life was by far the most popular subject at the school exhibitions. In the portrait class, taught by Oscar Kunath, students no longer had to take turns posing. Instead, the school employed "professional" models garnered from various corners of the city. Almost always drunk, "The Soak" was best when impersonating himself and highly respected for his ability to take a pose and keep it, no matter what. Portuguee Joe, "The Pirate," had sailed around the world eighteen times. Now, at eighty, he cut a most convincing figure as a mendicant friar. John Walker was a fine type of "digger" Indian, "tall and heavy but nimble and alert."[16] He had long since stopped worrying about authenticity and posed in anything from Navajo blankets to Omaha snowshoes, occasionally both at the same time.

At the core of the teaching was the life class, taught by Arthur Mathews, who took over the school directorship in 1890 after Carlsen had resigned (PLATE 35). Under Mathews, the prolonged agony of drawing

from casts was no longer necessary. The students drew from the antique only long enough to become familiar with lights and shades and the handling of charcoal. They then entered the sacred precincts of the life class, where they arranged themselves in a half circle around the nude model. Concentration was everything, and all that could be heard was Mathews' stinging criticisms, the rustle of a dress, or the scraping of an easel against the wooden floor (PLATE 36).

Among the models, Corinne was in constant demand. Although willful and mendacious, she was of splendid proportions (even her knees were good and good knees were rare). The students were abjectly fond of her, and she took advantage of it. Eventually she would pose for no more than ten minutes and rest for thirty, wrapped in a big fur coat, collar turned up around her ears, her beautiful legs sticking out from underneath.

Once a well-dressed and evidently respectable young man called at the

Mathews Grunts

school. Introducing himself as Corinne's brother, he was duly horrified when he found out that she was posing in "the altogether." Save for this incident, there were few clues to Corinne's past. One of her "idiosyncrasies" was never to give her correct address. The address she claimed was hers — 818A Broad Avenue, Room 8 — actually belonged to an elderly German preacher, who, whenever someone rang the bell asking for Corinne, was "shocked all through, not only because of the dreadful trade of the woman who had polluted the house by borrowing so accurately its number, but because of the boldness of the intruder who came seeking her."[17]

In Mathews, the city — as well as the school — found a powerful leader. He had studied under Gustave Boulanger and Jules Lefèbvre at the Académie Julian, where in 1886 he had received the Grand Gold Medal for distinction in composition, drawing, and painting. In San Francisco, he and his wife Lucia would help shape the California version of the arts and crafts movement, as launched in England by William Morris and on the American East Coast by Elliot Hubbard. His enthusiasm for Japanese prints found resonance in living rooms and parlors all over San Francisco.

"The profusion of Oriental art had a decided influence on the decor of many of the wealthy, sophisticated San Francisco homes in the nineties, and their color schemes were generally determined by the prints on the walls," recalled one of his former students. "Home after home reflected this trend, with neutral tinted walls, taupe carpets, carved teak-wood chests, tables, and chairs, the touch of color given by the handsome old brocades thrown on top of pianos or tables. The effect was genteel, subdued — a fitting reflection of the even tenor of those days — refined, chaste — without any garish note to upset the serenity."[18]

Both in his easel paintings and in his murals, Mathews' emphasis was on the figure, often with a background landscape. Lissome Isadora Duncan look-alikes — athletic, handsome, in flowing gowns — danced across a meadow like the women along a frieze of a Greek vase. A young girl held on to a broad-brimmed hat in a field of marguerites, the whole flooded

with light. A seated woman, nude to the waist, crushed purple grapes into an earthen bowl. The lower part of her body was wrapped in deep scarlet; above her were branches of Monterey cypresses and a patch of turquoise sk. (PLATE 37).

California, said Mathews, had yet to be painted. "It hasn't been touched," he said, lighting yet another cigarette. "The forms and colors of our countryside haven't begun to yield their secrets."[19] His own forms were evocative and elegant, shunning anything excessive, so much so that one critic accused him of carrying simplicity "into its extreme, till it means nothing."[20] His colors were rich and subdued, laid on in close value harmonies, often with gray as a dominant hue. "I never work outside until after 4 o'clock in the afternoon," he said, "for to me the most extraordinary color effects that we find here in the west come only in the diffused afternoon lights."[21] On the subject of art versus nature, he was characteristically forceful. "[T]he arts parallel nature or play at her. It were folly to suppose for a moment that they are ever quite base enough to imitate her except in irony or as a matter of illustration."[22]

In time there were concerns about Mathews' strong influence and dictatorial tendencies in general. "Mr. Mathews is essentially a low-tone painter," wrote the *Call*. "He sees things that way and paints them very properly—as he sees them. And being the potent and wholly worthy inspiration of the pupils, they too paint in low tones, whether they see it that way or not." Yet, added the writer, it "cannot be that all of these young, vigorous, red-blooded young animals in the School of Design, who ought to paint what they see and feel, see things done up in gray. It is contrary to the primal laws of nature."[23] The *Town Talk* turned openly hostile, arguing that the school had been "made a home of mere faddism," calling Mathews the "pseudo-Whistler of the West," and likening his teaching to a "continual watercure" designed to rob the students of their "individuality."[24]

Mathews himself was confident that the individuality of his students, if they had any, would in due time manifest itself. For the time being, his main concern was to teach his students basic techniques and prepare them

for study abroad. Only in Europe could they immerse themselves in art, both the great art of the past and in more modern movements. But then they must come home. "Thank heaven! the young American artists are showing a strong inclination to 'study' abroad and 'live' on their native soil," he said. This, he felt, would eventually lead to the formation of what might be indeed qualify as "an American school of painting."[25] He scoffed at objections that young Americans studying abroad might return more European than American. Perhaps it might be best for some to "cling to Eureka's apron strings." True artists, however, must reach for "knowledge" where best they could find it, "regardless of danger, for danger lies everywhere."[26]

As if to prove Mathews' point, in 1896 the *Wave* published "An Art Student" by Frank Norris, a promising young reporter recently back from Harvard. Whether from lack of talent or lack of courage, Norris' art student seemed destined to fail. "On week days he works — and he works hard — at the School of Design — the Art Institute. For the past five years he has been working away here desperately, painting carrots, dead fish, bunches of onions, and above all, stone jugs. He toils at these jugs with infinite pains. If he can manage to reproduce truthfully the little film of dust that gathers upon them, he is happy. A dusty stone jug is his ideal in life."

He could also be spotted "at the opening days of spring exhibits, and in and about the art gallery in the Mechanics' Fair. . . . He thinks he is an artist and he is quite conscientious about it, and thoroughly believes himself capable of passing opinions upon any picture painted. He expresses these opinions in a loud voice before the picture, in question, looking at it with half-shut eyes, making vague gestures at it with his closed fist, moving the thumb as though it were a brush. . . . Art with him is *paint*. He condescends to no other medium than oil and colored earths. Bouguereau is his enthusiasm; he can rise no higher than that, and he looks down with an amused smile upon the illustrators, the pen-and-ink men, Gibson, Smedley, Remington, and the rest. . . . Once in a while you see his pictures — still life

'studies' of stone jugs and bunches of onions—in the exhibits. Occasionally these are noticed in the local papers. He cuts out these notices and carefully pastes them in his scrap-book, which he leaves about in conspicuous places in his studio." Time goes by, and he works as hard as ever. "You meet him on his way home in the evening and he takes you to supper and shows you his latest 'piece.'. . . He never sells a picture. He has given his life to his work. He grows older; he tries to make his 'art' pay. He drifts into decorative art; is employed perhaps as a clerk in an art store. If he's lucky he is taken on a newspaper and does the pen-and-ink work that he once affected to despise. He's over thirty by this time, and is what he will be for the rest of his life. All his ambitions have vanished, his enthusiasm's dead, but little by little he comes to be quite contented."[27]

AN AMERICAN
SCHOOL OF PAINTING

y the turn of the century, most every American artist who painted broadly and rapidly, avoiding details and high finish, was called an "impressionist." Few, however, were impressionists in the pure sense of the word. Most resisted Claude Monet's optical dissolution and emotional detachment. Like Cézanne, who said he "wanted to make of Impressionism something solid like the art of the museums," they maintained a basic respect for form.[1] Like Gauguin and the Symbolists, many tended to depict an inner rather than an outer reality. Their interest in light was more poetic than scientific — their "impressions" were not so much the effect of light on nature as the effects of nature on man. On the whole there were no fast rules. Even as the exchange with Europe was at its peak, more and more American artists tended to find their own way, no longer looking to Europe — or each other — for directions. If they were indeed beginning to form an American "school," eclecticism was its main component.

A student at the California School of Design, Theodore Wores left for Munich in 1875 at the invitation of Toby Rosenthal. He soon joined the group around Frank Duveneck, and thus found himself in the hotbed of

"dark impressionism."[2] Around 1879, in the company of Frank Duveneck, John Twachtman, and William Merritt Chase, he traveled to Venice, where his colors became brighter, perhaps in response to the Italian sun or to the new art emerging in France. Upon his return to San Francisco in 1880, he took over the studio of Joe Strong and Jules Tavernier, where, in a marked change of ambiance, he employed English butlers who served "perfectly safe claret punch"[3] (PLATE 38).

He was often seen sketching in San Francisco's Chinatown, a serious young man with a small moustache, sitting inside a covered express wagon with his easel in front of him and his color box and brushes at his side. The press, which ordinarily associated Chinatown with opium dens, prostitution, and tong wars, viewed his choice of subject with fascination as well as horror. However, most everyone agreed that the paintings themselves were masterful — images of alleyways and shanties; store fronts in greens, reds, or yellows; lavish displays of meat and fish; interiors of murky incense, gold embroidery, and polished black wood (PLATES 39, 40). Critics typically praised their "rich" color, their "broad and easy style," and their "wonderfully complete representation of the inner life and customs of the Chinese." Even "a few intelligent Chinese" allegedly approved.[4] Several of the paintings sold to New York. Others sold to England, where Sir Thomas Hesketh, the Lancashire baronet, and Lord Rosebury, Chairman of the London County Council, counted among Wores' patrons.

In 1885, in search of new subject matter, Wores left for Japan. One of the first American artists to visit the country (John La Farge arrived a year later), he took a small house in the outskirts of Tokyo. He soon realized that painting indoors in Japan was "a great mistake" and began working *en plein air* in an even higher key than before. "Two months have been enough to convince me that Japan is the place for an artist interested in Oriental life and character," he wrote in a letter to a friend. "I am certainly spoiled for any other place after having enjoyed all the wealth and splendor of material I see around me here. I have only one fault to find — there is too much of it. The result is I feel like a small boy who has been given the liberty of

a whole candy store and who is so overwhelmed by the abundance of good things that he does not know where to commence."

He also wrote about his meeting with local artists at a tea house in Tokyo, where they all "squatted on the floor and drank tea and talked art": "I was surprised how thoroughly cultivated are their art ideas and how exactly identical with those of the best European artists." When he showed his Japanese colleagues photographs of his paintings, they appeared "pleased" but also much surprised at how long Wores worked on each painting. "They argued that a painter should spend a great deal of time in observing nature and thinking out his picture perfectly in his mind. Then, when saturated with the subject, he should seize the brush and dash off the picture in a few hours or minutes." In theory, Wores agreed. However, he told his Japanese colleagues, any American artist who worked in the Japanese manner "would have a very hard time," since American art buyers valued "laborious mechanical qualities" much higher than "artistic suggestiveness."[5]

In 1888, after two and a half years in Japan, Wores left for America with some fifty sketches and paintings of Japanese life: temples, wayside shrines, lotus flowers, cherry groves, tea-houses, candy sellers, koto players, and street shows (PLATE 41). After a successful show at the San Francisco Art Association, and one equally successful at the Reichard Galleries in New York, he continued to London in 1889. Oscar Wilde, remembering well the pale young man who had painted his portrait for the Bohemian Club, wrote him up in his column "London Day by Day," calling him "one of the cleverest of the young American painters."[6] Whistler, whom Wores had met in Venice, engineered a showing of one of his Chinatown paintings at the posh Grosvenor Gallery, where, according to a San Francisco paper, it hung "very prominently on a gold pillar" and was "much admired."[7]

After the Grosvenor, Wores was given a one-man show at the Dowdeswell, featuring scenes of San Francisco's Chinatown as well as Japan. Much was made of his shift to brighter colors. "Sunshine is Mr.

Wores' strong point, and it is a strong point," wrote *Land and Water*, referring to Wores' Japanese work. "On everything he paints, he sees the blue reflection of the blue sky, on water, road, roof, and above all on broad green leaf."[8]

The *Echo* was struck by his attention to detail. "Mr. Wores went to Japan from Munich somewhat of an impressionist and a striver after general effect; he came back the most practical realist — a painter of minute detail, a very Meissonier in finish."[9] In the words of the *Star*, Wores' chief object had been "to give a realistic record rather than to seek an artistic effect." Indeed, "[d]etail is worked out with such an elaboration that the whole is sacrificed."[10] Still, most of the paintings sold, and London society was quite taken with the young American, who, despite "a fairly cosmopolitan experience," had retained his "American gravity of speech and aspect,"[11] and was "as diffident in his manner as he [was] enthusiastic in his love of art."[12]

In early 1891 Wores returned to San Francisco. Even though Whistler called his return "careless,"[13] it proved quite prudent. Amédée Joullin, one of the teachers at the Art Institute, had been poaching on Wores' territory, painting Chinese scenes and selling them at good prices. Open hostilities reportedly broke out between Wores and Joullin when James Phelan, the mayor of San Francisco, bought Joullin's "Interior of a Joss House" at the highest price "paid in some time" for a canvas by a local artist.[14] The *News Letter* recorded the circumstances, thinly disguising identities. Two San Francisco artists, it reported, had both "made a hit in their treatment of a certain class of work." One, "conscientious and intelligent," had been "lionized" in England and returned to San Francisco a wealthy man. The other, "talented but lazy as a gopher on a wet day," had stayed at home and recently sold "a big picture." Now, at the Bohemian Club, the two gentlemen went at each other. One, supposedly Wores, would complain about an "utter lack of atmosphere" in the other's work. "Pity it should be so, dear boy, but it spoils the picture." Joullin declared that his colleague knew "less about drawing than a pig about astronomy," which only made matters

worse. "And so the merry war goes on," grinned the *News Letter*, "and when things are dull in the club,the wags hunt up the artists, and put them into the pit of criticism to fight it out."[15] Eventually the situation defused itself. Old Chinatown was passing. The Board of Health decided to whitewash the entire neighborhood, ending Chinatown's appeal and forcing both Wores and Joullin to move on to other subjects.

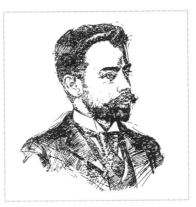

Charles Rollo Peters

Meanwhile Charles Rollo Peters, a former pupil of Jules Tavernier, had returned to San Francisco from studies in Paris, first under Jean-Léon Gérôme at L'École des Beaux-Arts, later under Gustave Boulanger and Jules Lefèbvre at the Académie Julian. In 1889, the *Chronicle* called him "a broad impressionist" and predicted that his work would be found lacking compared to "less artistic paintings which have more detail and less art in them."[16] Such was certainly the case in 1894, when the *Wave* reviewed a series of "a series of landscapes, town, and waterscapes" which Peters had painted during a second stay in Europe. "The question arises, Did he see nature as he painted it, or don't we see nature as it is; or is there anything the matter with his eyesight? All the known qualities which are expected to be put on canvas are wanting in these pictures — distance, perspective, the effect of light and shade, the elementary appreciation of values — all and everything seems to be jumbled about and carelessly ostracized, while an impression or something of the kind has been rendered by the artist which is puzzling in the extreme, unaccountable and to a great extent remarkable."[17]

By 1897 Peters had taken up residence in Monterey. No longer the quiet little town that Jules Tavernier had known, Monterey was now the site of the famous Del Monte Hotel and a fashionable resort for people of wealth and leisure. Peters, however, posted a Do Not Disturb sign on his

door, and buckled down to work. Ignoring the sign, Frank Norris sought him out for an interview. In knee-high boots and sombrero, Peters received Norris on the whalebone steps of his hill-top house and studio, looking in every part the successful California artist. On a tour of the house, Norris admired Peters' collection of European arms, furniture and "stuffs," including a chair of brocade silk said to have been used by Josephine at Malmaison and a ship-model of ivory given to Bonaparte by the city of Toulon.

The studio — "redwood, unfinished, and a huge north light, a couch or two, a black dog, lots of sunshine, and an odor of good tobacco"—was filled with paintings of moonlight, "painted very broad and flat, as with Brobdignag brushes." One painting in particular caught Norris' eye. It showed a sheer cliff overlooking a moonlit ocean. On the edge — "on the very uttermost edge, you understand" — stood a man in cocked hat and large coat. "There was nothing more, not a single detail, and the man was standing with his back turned, yet it was Bonaparte and St. Helena, beyond all shadow of doubt. Clever, you say? Enormously so, I say. A single huge broad 'note,' as it were, simple, strong, conveying but a single impression, direct as a blow."

"It's the specialists that 'arrive' now-a-days," said Peters, "whether they specialize on diseases of the ear, or on the intricacies of the law of patents, or on Persian coins of the 14th century." His "going in" for moonlights, he assured Norris, was in no way limiting. "You would be surprised to see how many different kinds of moons there are. There is the red moon, when she's very low, and the yellow moon of the afternoon, and the pure white moon of midnight, and the blurred, pink moon of a misty evening She's never the same."

Next, Norris inquired about Peters' methods. "After dark he goes out and looks at the moon, and the land and the shore in her light, and at the great cypresses." During these nightly walks Peters took "mental photographs, as it were — impressions he remembers and paints the next day in his studio." He also kept a sketch book, an intricate mix of "pencil

scratching" and "words such as 'blue,' 'carmine and cobalt,' 'warm gray,' 'sienna,' 'bitumen' and 'red.'" The result, according to Norris, was something altogether new. "There are two ways of painting a moonlight sky — one as I have seen it done by scores of artists hitherto, who paint in the sky a sort of indeterminate dark gray or very 'warm' black. The other way is as Peters does it. Night skies are blue — deep, deep blue. Look into the sky the next time you are out at night. Maybe you thought the sky was black at night. Look at it. Blue! of course it's blue — bluer than the bluest thing you ever saw. But I never noticed the fact until Peters' pictures called my attention to it."[18]

By 1899, even the hard-to-please New York critics became enthusiastic over Peters' work. Peters had spent the summer sketching and painting in East Hampton, Massachusetts. Among the visitors to his studio was Thomas B. Clarke, a noted New York art patron who collected American paintings, bought for merit rather than signature, and was credited with having discovered George Inness, Winslow Homer, Homer Martin, and Albert Ryder. Thanks to Clarke, Peters was given a one-man show at the Union League Club in New York.

Most of the paintings were nocturnes. One showed a red light shining from the window of a lone cottage. In another, tall trees lined a river of shimmering gray. A third showed a solitary cross rising up against the deep blue of a summer's night. "Mr. Peters is a colorist and a tonalist," wrote the *New York Times*. "His night effects are suggestive of Cazin, and also show the influence of the French impressionists, but they have sufficient individuality and originality to make him a welcome addition to the growing band of younger and stronger American landscape painters."[19] The *Mail and Express* called Peters "a man who says interesting things in a personal, distinctive, and admirable manner," and described his color as "solid, yet vibrant; full and decided, yet never obtruding itself without a reason."[20] Henri Pène du Bois saw a classically trained artist who had learned "to be original within the rules": "There are all the subtleties of the most modern colorists at his will. He mixes paints, superimposes them, counteracts them,

with an incessant knowledge of what he is doing and of the effect that he is to produce."[21]

Critical acclaim brought prosperity. In 1900 Peters purchased about thirty acres on the outskirts of Monterey, where he built a large house with a separate studio and exhibition gallery. In 1902, his wife died when giving birth to twins. Two years later one of the twins died of burns sustained when she fell into an unguarded fireplace.

About that time Peters began earning his reputation as "one of the last great Bohemians."[22] Among his legendary parties was an *al fresco* dinner for some one hundred guests, illuminated by Japanese lanterns hanging from the pine trees. On another occasion he built an artificial lake around which the entire membership of the Bohemian Club was supposed to camp out for the weekend. By the time the guests arrived, the water had drained away and only mud remained. As Arnold Genthe recalled, no one seemed to mind. "The party went on with the gondolas parked in the mud, an Italian trio singing Venetian boat-songs at its edge, and everyone having such a good time that the water was not missed."[23]

In 1909 Peters married a "widow of means," an attractive Englishwoman who was wintering at the Del Monte Hotel.[24] The honeymoon was spent in Dorset. More travel followed. Indeed, according to his son, Peters "never really settled down anywhere again."[25] He lived in Paris, London, and New York, sketching "almost everywhere."[26] Though alcoholism undermined his life, he kept painting and exhibiting. For a while a burst of sunshine appeared in his work, as in the paintings exhibited in London in 1910. However, he soon returned to twilight and darkness. Recurring over and over again was the image of a strip of light radiating from beneath a door or through a shuttered window, a sign of warmth and togetherness which did not necessarily extend to the viewer (PLATE 42).[27] But the main attraction was always that vast, magnificent sky.

Unlike his younger colleagues, William Keith was remarkably stationary. He claimed he had no need for Europe, nor for New York; he much preferred to stay in California and "dig it all out for himself."[28]

In 1893, against his better knowledge, Keith went back to Europe. He found London "too beastly foggy," the Paris Salon disappointing, Madrid too hot and in the midst of a cholera epidemic.[29] After only about five weeks in Europe, he shipped out of Le Havre for New York. "It's hard and harassing work to go about the Galleries," Keith wrote to Worcester. "One sees so much, and so little that is really interesting." On the whole, the trip confirmed what he knew all along, that "this modern thing is a sort of imitation of that older thing." Corot was "a looser Claude." Constable, though supposedly "the founder of the Modern French School," in turn owed much to Ruysdael and Hobbema. "The whole affair shows me plainly that there were a few big men and the balance are copying them and so on till you get to the tail end of it."[30]

At home Keith concluded that his own broad suggestive style was also being copied. Jules Mersfelder, a former student of Virgil Williams, would show up at Keith's studio, looking for pointers. He was recently back from three years in New York, where he showed at the first annual exhibition of the Society of American Artists. In San Francisco he now gave "parlor art talks," in which he discussed "the manner of work, style and scheme of color of Corot, illustrating the same upon his canvas as he talked, and presenting to his audience at the close of a brief fifteen minutes a very good imitation of one of the famous artist's landscapes."[31]

Despite the success of these "art talks," Mersfelder's paintings did not sell. To help him out, his San Francisco friends put on a benefit concert in Golden Gate Hall. The Press Club Quartet gave a rousing performance, and a Mrs. Alvina Heyer-Wilson, in violets and ivory white brocade, "captivated the audience with her magnificent voice, her personality being, perhaps, almost as charming." Giuseppe Cadenasso, an artist of arresting good looks and matching talents, sang *La Donna è Mobile* and the drinking song from *Cavalleria Rusticana*. Mersfelder modestly kept himself in the background until the very end of the program when he drew some sketches and also gave several readings from *The Merchant of Venice*, in a "singularly soft" and "expressive" voice.[32]

The proceeds from the concert gave Mersfelder a new start and set him up in a studio at Eddy and Powell, decorated with borrowed Turkish rugs and costly draperies. "Now, indeed, do I feel inspired to perform great deeds," he told a reporter, while reclining on his oriental couch.[33] For a month or so he worked assiduously, producing half a dozen large paintings of dimly lit forest glades. In an interview with the *Call*, he declared himself an exponent of the "quality" school of painting, as seen in the work of Corot and Inness.[34] Any suggestions that he was imitating Keith he found ridiculous. He and Keith, he said, were merely working "in the same direction."[35] That was all.

One morning there appeared in a Geary Street gallery, next to originals by Keith, paintings eerily reminiscent of those originals but carrying Mersfelder's signature. Keith shook his lion's mane and roared, the gallery owner trembled, and Mersfelder left town in a hurry. When last seen, he was heading East.

On the whole, however, copying Keith was no mean task. "It is little use asking Keith how he paints," wrote the *Wave*. "His explanations are different each day."[36] In one experiment, described tongue-in-cheek by the *Call*, Keith brought out "a wonderful impressionistic result" by simply using "a pair of number nine feet." First, "in a reckless way," he covered two matting-boards with a combination of colors, laid on in thick layers of paint. Next he pressed the boards together, face to face, and threw them on the floor. Then, "with the agility of an Apache Indian," he began jumping up and down on top of boards, "from corner to corner and in all directions of the compass, until his feet had traversed the entire surface." Finally, "with the noise of a North Beach kiss," he pulled the boards apart, squinting, trying to determine what was up and what was down. "By George," he said as he held up one of the boards to the reporter, "that's the way you get effects. See the trees, the pathway leading into the woods, the — and by the eternal, there's a cow, and a strip of water, and some autumn leaves See the sunlight breaking through the leaves. Look at it. Wonderful, wonderful!"[37]

Most of Keith's experiments, however, appeared to be in search of "old master effects." One of his students described one such procedure. "He often painted a picture brighter or lighter than he meant to keep it." After it dried, "he would take it out and wash it over with some darkish, but transparent color and then start in with painting rags, wiping out lights and scraping surfaces with a razor, giving breadth and tone and that effect of etching work."[38]

Keith next attempted to translate sound into color, as he painted to the rich, mellow vibrations of an old Japanese gong, the gift of his patron Harry Tevis. The power surging within him, he would be "feeling, rocking, dabbling at

William Keith Demonstrates a New Technique

the canvas, to find his way — and then suddenly flying at it in the very agony of inspiration, daubing, swiping, touching, rending, with force enough for a Berserker, and the wrist of a Saladin."[39]

With Keith the "idea" was everything. "It is myself, my idea that I paint, with trees and brooks for interpreters," he told one reporter.[40] "My subjective pictures are the ones that come from the inside. I feel some emotion and I immediately paint a picture which expresses it. The sentiment is the only thing of real value in my pictures, and only a few people understand that."[41] He no longer painted outdoors. "I cannot paint in the presence of Nature," he said. "Every flower, every blade of grass cries out, 'Put

me in; put me in!' Then there is change all the time. The only thing a poor bewildered artist can do is to seize in his mind some flash of sun upon tree, some light of God in the sky, brood upon it, work it into his soul, and some day — suddenly, before he knows it, he has fixed his thought — God's thought he hopes it may be—upon the canvas."[42]

The work of the French Impressionists he dismissed as "a sort of extravagant fancy" that would eventually run its course.[43] Though better technically than the old masters, the Impressionists had sacrificed art for science. "The purely scientific habit of reproducing the thing set before us has little by little extinguished the sense of the ideal," he explained in one of his lectures.[44] In Keith's opinion, any artist who attempted to "copy Nature" was attempting the impossible. "The old masters frankly accepted this truth and never attempted to compete with Nature. They knew art's limitation and also knew that Nature and Art were two distinct things."[45]

By the early 1900s, despite his complaints of "a limited clientele," Keith was "probably one of the wealthiest artists in the US" and "certainly the richest in California."[46] In San Francisco, clients from all parts of the country sought out his studio. Typically, Keith would step behind a pair of black velvet curtains, rummage around, and reappear a few moments later. Solemnly, he ordered everyone to be quiet. The curtains would part, revealing one of his paintings on an easel, flooded in light. Several minutes would pass, giving the visitors ample time to be impressed. Next, Keith would put another painting on the easel, issue yet another command for silence, and everyone would go back to admiring. After the ritual had been reenacted about a dozen times, favorites were selected and money changed hands. Buying nothing, or even questioning a price, was unthinkable.

In New York, the Macbeth Gallery was rarely without examples of his work. "The experience of Mr. Keith has intensified his unlikeness to other painters," wrote William Macbeth in the catalogue for a one-man show in 1893. "Largely self-taught, working for years apart from other men, remote from the influence of schools and traditions, and living in an atmosphere of unusual freedom, his spirit has had free play."[47] The New York *Tribune*,

testily, suggested that "it does not need the announcement that Mr. Keith is 'largely self-taught' to tell us that his pictures are thoroughly his own. He paints broadly, boldly, with a looseness that might perhaps be traced to a lack of schooling, and obtains strong, simple, truthful and really artistic effects." The critic detected a certain similarity with Inness, but dismissed it as coincidental. He also compared Keith to Courbet, "but only because he is blunt and peculiarly masculine in his work as Courbet was."[48]

In London, a private show in 1898 was said to be wildly successful. "William Keith is receiving the honor due him in London," wrote the *Overland Monthly*. "The paintings are receiving especial praise from the London press, and members of the royal family have become enthusiastic admirers of the American artist. Princess Hohenlohe, grand-niece of the Queen, is seen at the exhibition very frequently."[49] The London *Daily News* engaged in the usual groping for labels. "His work belongs to the order of feeling and interpretation associated with the Barbizon school and following; though the resemblance is a matter of analogy and accident rather than bias in a particular direction"[50] (PLATE 43). The greatest praise came from Alfred East, landscape painter and a member of the Royal Academy.

"A grand old man," said East, "a genius who would have received recognition and encouragement had he exhibited in Europe, whereas the product of a new country must needs be dead a hundred years, before that country could awaken to the fact that she produced him."[51]

Piping Faun

FIN DE SIÈCLE

n the early 1900s a small Italian restaurant named Coppa's was housed in the Montgomery Block, a three-story brick building in San Francisco's Latin Quarter. The names of Aristotle, Kant, Nietzsche, Rabelais, Villon, Verlaine, Velasquez, and other European greats were written in large, decorative letters close to the high ceiling. Figures in charcoal, chalk, and crayon covered the walls: a grinning devil toasted his hoof over a burning grate; a woman, lodged in a giant champagne glass, watched her male companion with studied boredom; strange-looking creatures, vaguely human with oversized heads and boneless limbs, turned cartwheels or posed as hand-holding lovers. Mixed in with the figures were nonsense jingles and esoteric literary allusions, including a line from Oscar Wilde's *Salomé*, warning the diners that "Something terrible is going to happen." The murals were there for one reason only, to play "that most engaging of games — fooling the public."[1] By the turn of the century, that game had been played successfully for quite some time by artists and writers throughout the Western world. The San Francisco version was the most light-hearted, but the underlying message was nonetheless the same. Art bore no

relation to Nature. It no longer had to be "useful," morally or otherwise. It did not exist to please the Philistines. Art served no purpose but its own: it had a right to be baffling, bizarre, distorted, even lack meaning altogether (PLATE 45).

The originators of the murals, a group of young San Francisco artists and writers, dined at the restaurant almost every night. Seated at the big pine table in the middle of the long, narrow room, they feasted on heaping platefuls of pasta, hot sourdough bread, black coffee, and fruity red wine (the first bottle came with the meal, the rest cost extra). Because of them, Coppa's was as famous as any restaurant in Paris' Montmartre. Tourists asked for directions the minute they stepped off the ferry boat. Local "slummers" arrived in newfangled automobiles and were ushered to their tables by an accommodating restaurant owner. Most of the time, the Coppans managed to ignore the stares. On occasion, they "responded by eating and drinking in sullen silence."[2] Some gave in to the temptation and started playing to the gallery — "the talk scintillated to the best of their ability, for well they knew that half a hundred culturists were straining ears to catch every golden word that fell."[3]

Gelett Burgess, sharp-tongued and witty, with clerical glasses and a "puckish" smile,[4] conversed effortlessly on anything from Renaissance verse to the very latest in European artistic and literary movements. At the time Burgess, like most everyone else, was reading the *Yellow Book*, a quarterly magazine published in London and sold at Doxey's bookstore in San Francisco. A miscellany of short stories, articles, and poetry, the *Yellow Book* was rumored to be borderline scandalous and eminently *fin de siècle*. Adding to its notoriety, Oscar Wilde was said to have carried a copy on his way to prison, where he would serve a two-year sentence for immorality (actually, Wilde took with him not the Yellow Book but Pierre Louÿs's *Aphrodite*). Despite its reputation, however, the *Yellow Book* was quite traditional and but rarely skirted the risqué. The only truly decadent contributions were some of Aubrey Beardsley's exotic drawings, startling *Art Nouveau* effects resembling nothing on earth, at least nothing a civilized

person would dare recognize (even the cab horses were said to have shied at one of his posters outside a London theater).

Thus inspired, Burgess decided to give San Francisco its own "little magazine." Printed on bamboo paper with old-style lettering and novel type effects, *The Lark* began appearing in the spring of 1895. Porter Garnett, art critic and man-about-town, contributed what Burgess referred to as "some remarkable vagaries of style," mostly in the form of essays and short fiction.[5] Ernest Peixotto, a former student of Emil Carlsen and recently back from Paris, did some striking cover designs. Bruce Porter, the Edward Burne Jones of California, wrote poems and drew a piping faun. Burgess himself drew a "Map of Bohemia" with the Hills of Fame, the Isle of Idleness, and Philistia with its capital, Vanitas, on the fringe of the Great Philistine Desert. He also crafted nonsense jingles, such as the one about the purple cow, presumably meant as a joke on Beardsley: "I never saw a purple cow/I never hope to see one/But I can tell you anyhow/I'd rather see than be one."[6] The ditty traveled all over the country, confounding the

Ah, yes, I wrote the "Purple Cow"—
I'm Sorry, now, I wrote it;

But I can tell you Anyhow
I'll Kill you if you Quote it!

more "sedate" wits of New York, Philadelphia, and Chicago, who could not decide whether it was in earnest or in fun.[7]

After two years, *The Lark* abruptly ended its flight. In the words of Burgess, the very mood of it had been "too enthusiastic to last."[8] Yet it had accomplished what it set out to do. It had "mingled whimsicality with serious purpose,"[9] celebrated "the joy of life, the gladness of youth and love," and ridiculed "the commonplace, the prosaic, those who think by syndicate, use stock phrases and opinions, whose practical minds deprive them of imagination."[10] At the farewell dinner Burgess was "bedecked in strange skins and crimson robes and purple things — all in memory of his famous cow."[11] In the very last issue, *The Epilark*, he bid his readers farewell: "Ah, yes, I wrote the 'Purple Cow'/I'm Sorry, now, I wrote it/But I can tell you Anyhow/I'll kill you if you Quote it!"[12]

Although Burgess eventually moved to New York, he returned to San Francisco frequently. In knee-length cape with an eighteen-inch carnation on the lapel, he arrived at Coppa's, where the clinking of tableware ceased as he made his way past the tourists and the slummers. At the middle table, the rest of the Coppans had already begun their first round of wine.

Sprawled all over the table, talking about the class struggle and the brotherhood of man, was Jack London, a husky young man with keen gray eyes and bad teeth. Former oyster pirate, drifter, and gold seeker in the Klondike, he belonged to the Socialist Labor party and was well on his way

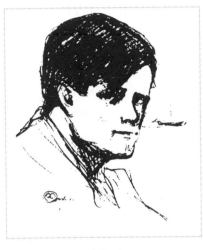

Jack London

to becoming one of America's highest paid fiction writers. Listening intently, now and then interrupting, was Anna Strunsky, a Russian Jew of dark skin, shiny black hair, and eyes "distinctly Oriental." San Francisco knew her as the "girl socialist," whose "pleading, sorrowful voice, vibrant with passion and unremedied wrongs," made quite an impression at city lecture halls.[13]

George Sterling, the poet, introduced his latest woman friend, while the others were taking a secret vote as to whether she could stay or not. Supremely indifferent to the outcome, Sterling concentrated on turning his head just so, showing off his classic profile, likened to "a Grecian coin run over by a Roman chariot."[14] The Coppans gave a thumbs down to Mary Austin. "She was writing beautiful stuff but she wasn't pretty," explained one of them. "The pretty ones didn't have to write very much to get in again."[15]

Among the artists, the topic of the evening might well have been an upcoming exhibition, mounted by their new society, the Society of California Artists, formed in opposition to Arthur Mathews their one-time teacher — and the alleged academic restrictions of the San Francisco Art Association. Loose-jointed and tall, Maynard Dixon leaned back in his chair, trying to make room for his legs. Other than the Stetson and the boots, there was little in his boyish appearance to indicate the strength of his future work: haunting renderings of deserts, cowboys, and Indians, "breathing in every line the spirit of the boundless West."[16]

The small chap in "a black hat with a wide brim" was Gottardo Piazzoni, who painted low-tone murals and easel paintings of the California hills[17] (PLATE 44). After studies in Paris, he would help bring

twentieth-century modernism to California, where it would flourish beyond expectation. Seated next to Piazzoni was Robert Ingersoll Aitken, who had recently finished his bronze "Victory," placed on a column high above San Francisco's Union Square, in commemoration of Admiral Dewey's victory at Manila Bay. After going back to Paris, he would eventually settle in New York, where he showed at the 1913 Armory Show, the first major show of modern art in America. Spicing up the conversation with a few profanities — laughing at the sound of them — was sculptor Arthur Putnam, arrogant and handsome, with flashing white teeth, hat on

Xavier Martinez

the back of his head. In him, genius was already unmistakable, although only a few years later he would be felled by a brain tumor. Still, his magnificent bronze pumas would live on—muscles taut, ears flattened, terrifying in their force and precision.

The most eye-catching of the Coppans was Xavier Martinez, part Aztec, with uncombed black hair, drooping mustache, and jet-black eyes. He had recently returned from Paris, where he studied under Eugène Carrière, defended Paul Cézanne, made friends with Diego Rivera, and sat through the Dreyfus trial, sketching Émile Zola as he delivered "*J'accuse.*" Among his contributions to the Coppa murals was a row of black cats with eerie yellow eyes, most likely an allusion to the *Chat Noir*, the famous cabaret in the Rue Victor Masse. Back in San Francisco he dressed as if he had never left Paris, in baggy corduroys, a velvet coat, and red Windsor tie. At Coppa's he sang arias from *La Bohème* and *Pagliacci*. As the evening wore on, he turned to "wildly improper" student *chansons*, sending some of the girls into hysteric giggles.[18] Finally he would burst into the *Marseillaise* with such gusto that even

Jack London thought he was a fellow revolutionary. Martinez, however, was more an artist than an activist. Case in point was his painting of an old plowman, who, under a leaden sky, halts his oxen and bends his head as the angelus rings from the village church tower. London saw the painting as a powerful symbol of the downtrodden and wanted to name it "The Burden." Martinez, however, went with Sterling's suggestion and called it "The Prayer of Earth." The public probably approved. The subject, as once treated by Gustave Courbet and Jean-François Millet, had long since lost its ability to shock. What once seemed scandalous was now merely nostalgic (PLATE 46).

At dawn on April 18, 1906, this same Martinez was making his way back to his studio after a wet night on the town. It was unusually warm for the season. The air was sultry, no fog, no wind. The city stood proud around him. Los Angeles was as yet no threat; with a population approaching 500,000, San Francisco was the undisputed capital of the Pacific West, a center for leading financial, railroad, shipping, lumber, and manufacturing interests. Steel-framed skyscrapers added a bold new look to the city skyline. Built in 1891, the *Chronicle* building stood nine stories high and was topped by a 210-foot-high bronze clock tower. The nineteen-story Claus Spreckels Building, home of the *Morning Call*, had been added a few years later. More construction was under way. Architect Daniel H. Burnham from Chicago had worked with local architects Bernard Maybeck and Willis Polk and developed a plan which now lay on the mayor's desk. Modeled on the Athens of Pericles, the Rome of the Caesars, and the Paris of Napoleon III and Baron Haussman, it envisioned a grand neoclassical civic center, heroic boulevards, great parks, and, on top of Twin Peaks, a white acropolis with courts and terraces.

Up on Nob Hill, it was time for the annual spring exhibition. As usual, the factotum had harnessed his bays and made his rounds of the studios, trying to pick up paintings. As was to be expected, some canvases were still wet; some were not quite "pulled together;" some had yet to be varnished. And as always, "without an audible cuss-word," he cheerfully shrugged his

shoulders and agreed to come back the following day.[19] Of the five artists who made up the vetting committee, four were also exhibitors, by now "a customary but a manifestly unfair and unwise provision."[20] At the opera house the season had just started. Enrico Caruso had arrived from Kansas City on the Santa Fe Limited, put up at the Palace Hotel, and extolled San Francisco "in a colorative assortment of Italian adjectives."[21] Only a few hours ago, he had brought down the house as Don Jose in *Carmen*. Afterwards society gathered at Tait's, Delmonico's, Techau's, or the Palace for Welsh rarebit with *Münchenbrau*, oysters *poulette* with *Liebfraumilch*, or terrapin Maryland with *Asti tipo chianti*. The traffic to and from the upper floors of the Poodle Dog, with their private dining rooms and adjoining bedroom suites, had been particularly dense. Only the elevator man knew the identity of the guests, which was why he "wore diamonds and was a heavy investor in real estate."[22]

Once in his studio — he made a short stop at Champro's, a coffee house around the corner — Martinez was sketching and thinking about next day's work. A thunder rose from inside the earth, as if from the shot of a huge cannonball. His mirror, the one his models used, spun around wildly on its casters. His Michelangelo cast flew past his head and shattered into pieces. "I can't be as drunk as that!" he muttered as his chair turned into a bucking bronco.[23] Instinctively he ducked into the alcove, seconds before the outside wall caved in and crashed into the alley. Afterwards, as soft light filtered through the dust, he saw nothing but a gaping hole where moments earlier his bed had stood. Save for distant, unbelieving voices, all was silent. Dazed, he grabbed a few paintings and headed for the stairs and the open street.

The earthquake had snapped gas and water mains. Almost instantly, fires broke out all over the city. As the wind picked up, firefighters could do little to stop them from spreading. By late morning the *Call* building was gone, followed by the rest of "Newspaper Row" at the intersection of Market, Third, and Kearny. The Financial District and South of Market were a giant firestorm. What did not burn, melted. By five, after the

sprinkler system ran dry, the Palace Hotel was gutted. Caruso found his way to the St. Francis Hotel, where he was seen with a fur coat over his pajamas, smoking a cigarette and muttering to himself "'Ell of a place, 'ell of a place."[24] As the flames kept rolling skywards, wrapping the city in thick, stifling smoke, thousands of people took refuge in parks and open squares, carrying whatever they could. Many carried paintings (PLATE 47).

Through the night the fire raged. Buildings that might help feed the fire were blown up by dynamite. Explosion after explosion punctured the air, accompanied by the crash of falling walls. By early morning, the wind had shifted, shooing the flames up the sides of Nob Hill. At the Hopkins house the quake itself had done little damage, save for the cracking of some plaster. Because of its lofty location and private water reservoirs, the house was deemed safe, at least for the time being. An officer of the guard was put in charge of the rescue efforts, commanding soldiers and civilians, using his revolver to motivate some of the latter. Paintings were cut out of their frames and carried to safety; furniture and large statuary were left on the sidewalk, awaiting transportation. The fire caught first at the corner of Mason and Pine, threatening the old stables now housing the classrooms. No sooner was it put out than it flared anew, this time by the Mary Frances Searles Gallery, adjacent to the main house. Next, in one mighty blaze, the house itself lit up, all the windows shining brighter than on any opening night. Within the hour it was gone. By the end of the day, most of the other mansions were gone as well.

The city burned for three days and two nights. Close to 30,000 buildings were destroyed; about 3,000 people were reported dead. In the Latin Quarter, as through a miracle, the Montgomery Block still stood. Here, amidst the ashes and the ruins, the Coppans gathered for their last supper. With a sentry posted outside, they ate and drank by candlelight. Then they scattered, ghostly figures in the dark. Around them a persistent wind stirred up dust of lime and brick which landed on twisted steel, crumbled masonry, and charred telegraph poles. On Nob Hill, someone had found a life-size bust of Virgil Williams, carefully wrapped and placed in a coal bin.

Last Meal at Coppa's

At the Crocker mansion, the butler had saved canvases by Charles Daubigny, Théodore Rousseau, and Jean-François Millet, and left behind those by Edgar Degas and Camille Pissarro. The Bohemian Club was gone. So were most of the studios, and much of the art. "It was a glorious fire," said William Keith, who lost some forty large paintings and thousands of sketches. "It was so big that a man couldn't very well find fault with it."[25] Old San Francisco had vanished (PLATE 48). It was, in the words of Will Irwin, "as though a pretty, frivolous woman had passed through a great tragedy."[26] She might survive, but she would never be the same again.

ACKNOWLEDGEMENTS

It is impossible in a few words to thank all those who helped me write this book. I am deeply grateful to all the librarians and archivists who gave so freely of their time and expertise. Special mention is due the staff of the interlibrary loan department of the San Francisco Public Library: there never was a request they could not fill.

I am indebted to Bert Holtje, my agent, who recognized the book's potential from the start. Peter Fairbanks inducted me into the world of auctions and always gave support. John Garzoli let me use his library, answered all my questions, and kept pulling out paintings to prove his points. Dr. A. Jess Shenson showed me his collection and talked with insight and humor about Theodore Wores. I also owe much to Mary Jo Hoffman, Carleen Keating, Ida Leach, Malcolm Margolin, Leslie Martin, Daphne Reece, Toby Rose, Valerie Tumins, Linda Twichell, Jaap Van Hiele, and Duane Wakeham, all of whom read the manuscript at different stages and offered valuable suggestions along the way.

Most important, I want to thank my husband Phillip, who for the last several years has shared his life not just with me but with the artful players too. Even when the house was crowded, not once did he protest

ARTISTS' BIOGRAPHIES [1]

Aitken, Robert Ingersoll (1878–1949). Sculptor. Born in San Francisco. Studied at the Mark Hopkins Institute of Art under Arthur Mathews and Douglas Tilden. Studied briefly in Paris in 1897. After returning to San Francisco, taught at the Mark Hopkins Institute of Art. Went back to Paris in 1904 for three years of studies. Ultimately settled in New York where he taught at the National Academy of Design. Exhibited at the 1913 New York Armory Show.

Works held: Art Museum, Princeton University, Princeton, N.J.; Columbus Museum of Art, Columbus, Ohio; Corcoran Gallery of Art, Washington, D.C.; Harvard University Art Museums, Cambridge, Mass.; Hirshhorn Museum and Sculpture Garden, Smithsonian Institution, Washington, D.C.; Metropolitan Museum of Art, New York, N.Y.; Museum of Fine Arts, Boston, Mass.; National Museum of American Art, Smithsonian Institution, Washington, D.C. Monuments in San Francisco: Dewey Monument in Union Square (the model was young society matron Alma Spreckels); William McKinley Monument in Golden Gate Park.

Alexander, Henry (1860–1894). Painter. Born in San Francisco. Studied in Munich under Wilhelm Lindenschmit and Ludwig Loefftz. Worked in San Francisco in the early 1880s. "As a painter of bric-a-brac, still life, and rich interiors, Alexander has no equal here, and perhaps no superior in America," wrote the *San Franciscan* in 1885.[2] In 1887 he moved to New York, where, unable to sell his paintings, he took a lethal dose of carbolic acid. Some hundred years later Paul Karlstrom called his life "yet another tragic example of the late 19th-century American artist, trained in Europe, who returned with great expectations that his country was not able to fulfill."[3]

Works held: Berkeley Art Museum, Berkeley, Calif.; Metropolitan Museum of Art, New York, N.Y.; M. H. de Young Memorial Museum, San Francisco, Calif.; Oakland Museum of California, Oakland, Calif.

Arriola, Fortunato (1827–1872). Painter. Born in Cosala, State of Sinaloa, Mexico. Self-taught. Moved to San Francisco in 1857. Taught several local artists, including Toby Rosenthal and Ransom Gillet Holdredge. Exhibited at the National Academy of Design in New York in 1871.

Works held: California Historical Society, San Francisco, Calif.; Crocker Art Museum, Sacramento, Calif.; M.H. de Young Memorial Museum, San Francisco, Calif.; Oakland Museum of California, Oakland, Calif.

Bierstadt, Albert (1830–1902). Painter. Born in Solingen, Germany. Studied in Düsseldorf with Emanuel Leutze and Worthington Whittredge. Toured Germany, Italy, and Switzerland with Whittredge in 1856. Elected member of the National Academy of Design in 1860. Exhibited at the Paris Salon, at the Royal Academies of London and Berlin, and at the 1876 Philadelphia Centennial. In 1889 "The Last of the Buffalo" was deemed old-fashioned and rejected by the American jurors for the Paris Exposition. Today, in the words of Nancy Anderson, Bierstadt's large panoramic landscapes have come to be appreciated for what they truly were: a "near

perfect combination of technical expertise, European experience, national enthusiasm, and marketing savvy — everything required to turn the western landscape into an iconic image of national definition."[4]

Works held: Albright-Knox Art Gallery, Buffalo, N.Y.; Amon Carter Museum, Fort Worth, Tex.; Art Institute of Chicago, Chicago, Ill.; Art Museum, Princeton University, Princeton, N.J.; Berkeley Art Museum, Berkeley, Calif.; Birmingham Museum of Art, Birmingham, Ala.; Brooklyn Museum, Brooklyn, N.Y; Corcoran Gallery of Art, Washington, D.C.; California Historical Society, San Francisco, Calif.; Columbus Museum of Art, Columbus, Ohio; Crocker Art Museum, Sacramento, Calif.; Detroit Institute of Arts, Detroit, Mich.; Frye Art Museum, Seattle, Wash.; Gilcrease Museum, Tulsa, Okla.; Haggin Museum, Stockton, Calif.; Harvard University Art Museums, Cambridge, Mass.; Hearst Art Gallery, St. Mary's College, Moraga, Calif.; Hermitage, St. Petersburg, Russia; Hirshhorn Museum and Sculpture Garden, Washington, D.C.; Honolulu Academy of Arts, Honolulu, Hawaii; Los Angeles County Museum of Art, Los Angeles, Calif.; Metropolitan Museum of Art, New York, N.Y.; M.H. de Young Memorial Museum, San Francisco, Calif.; Minneapolis Institute of Art, Minneapolis, Minn.; Museum of Fine Arts, Boston, Mass.; National Museum of American Art, Smithsonian Institution, Washington, D.C.; Oakland Museum of California, Oakland, Calif.; Phoenix Art Museum, Phoenix, Ariz.; San Diego Museum of Art, San Diego, Calif.; Santa Barbara Museum of Art, Santa Barbara, Calif.; Southwest Museum, Los Angeles, Calif.; Toledo Museum of Art, Toledo, Ohio; University of Kansas Museum of Art, Lawrence, Kans.; Wadsworth Athenaeum, Hartford, Conn.; Whitney Gallery of Western Art, Cody, Wyoming; Yale University Art Gallery, New Haven, Conn.

Brookes, Samuel Marsden (1816–1892). Painter. Born in Newington Green, Middlesex, England. As a young man, studied under F.T. Wilkins and Thomas H. Stevenson, two migrant portrait painters from Chicago. Spent 1845-1846 in England, copying paintings at the National Gallery

and Hampton Court. Exhibited at the 1876 Philadelphia Centennial (painting lent by Albert Bierstadt). In 1953 Alfred Frankenstein noted that Brookes appears to have been the first to paint "the open book and the glasses," a subject that would become very popular with other still life painters of the time, including William Harnett and Claude Raguet Hirst.[5]

Works held: Brooklyn Museum, Brooklyn, N.Y.; California Historical Society, San Francisco, Calif.; Crocker Art Museum, Sacramento, Calif.; M.H. de Young Memorial Museum, San Francisco, Calif.; Monterey Museum of Art, Monterey, Calif.; Nevada Museum of Art, Reno, Nev.; Oakland Museum of California, Oakland, Calif.

Bush, Norton (1834–1894). Painter. Born in Rochester, New York. Studied under James Harris and Jasper Cropsey. Encouraged by Frederic Church to paint tropical scenery; sketched in Nicaragua, Peru, and Equador. Worked in San Francisco and New York, where he shared a studio with Henry Alexander. Exhibited at the National Academy of Design.

Works held: California Historical Society, San Francisco, Calif.; Crocker Art Museum, Sacramento, Calif.; Hearst Art Gallery, Saint Mary's College, Moraga, California; M.H. de Young Memorial Museum, San Francisco, Calif.; Oakland Museum of California, Oakland, Calif.; Stanford University Museum and Art Gallery, Stanford, Calif.

Cadenasso, Giuseppe Leone (1858–1918). Painter. Born near Genoa, Italy. In San Francisco, studied privately under Joseph Harrison and under Arthur Mathews at the Mark Hopkins Institute of Art. Often referred to as "the Corot of California." Awarded gold medal at the Alaska-Yukon Exposition in Seattle in 1909.

Works held: California Historical Society, San Francisco, Calif.; Hearst Art Gallery, Saint Mary's College, Moraga, Calif.; M.H. de Young Memorial Museum, San Francisco, Calif.; Monterey Museum of Art, Monterey, Calif.; Nevada Museum of Art, Reno, Nev.; Oakland Museum of California, Oakland, Calif.; Stanford University Museum and Art Gallery, Stanford, Calif.

Carlsen, Søren Emil (1853–1932). Painter. Born in Copenhagen, Denmark. Studied at the Danish Royal Academy; later in Paris at the Académie Julian. Taught at the Chicago Art Institute, the California School of Design, the San Francisco Art Students' League, the Pennsylvania Academy of Fine Arts, and the New York National Academy of Design. Awarded gold medal at the Louisiana Purchase Exposition in St. Louis in 1904; Inness medal at the National Academy of Design in 1907; Temple medal at the Pennsylvania Academy of Fine Arts in 1912; medal of honor at the Panama-Pacific International Exposition in San Francisco in 1915. In 1921 Arthur Edwin Bye called him "unquestionably the most accomplished master of still-life painting in America today."[6]

Works held: Albright-Knox Art Gallery, Buffalo, N.Y.; Art Institute of Chicago, Chicago, Ill.; Art Museum, Princeton University, Princeton, N.J.; Brooklyn Museum, Brooklyn, N.Y.; California Historical Society, San Francisco, Calif.; Columbus Museum of Art, Columbus, Ohio; Corcoran Gallery of Art, Washington D.C.; Crocker Art Museum, Sacramento, Calif.; Detroit Institute of Art, Detroit, Mich.; Frye Art Museum, Seattle, Wash.; Gilcrease Museum, Tulsa, Okla.; Harvard University Art Museums, Cambridge, Mass.; Hirshhorn Museum and Sculpture Garden, Smithsonian Institution, Washington, D.C.; Honolulu Academy of Arts, Honolulu, Hawaii; Los Angeles County Museum of Art, Los Angeles, Calif.; Metropolitan Museum of Art, New York, N.Y.; M.H. de Young Memorial Museum, San Francisco, Calif.; Monterey Museum of Art, Monterey, Calif.; National Museum of American Art, Smithsonian Institution, Washington, D.C.; Oakland Museum of California, Oakland, Calif.; San Diego Museum of Art, San Diego, Calif.; Santa Barbara Museum of Art, Santa Barbara, Calif.; Toledo Museum of Art, Toledo, Ohio; Wadsworth Athenaeum, Hartford, Conn.

Chittenden, Alice Brown (1859–1944). Painter. Born in Brockport, New York. Studied under Virgil Williams at the California School of Design. Taught at the Mark Hopkins Institute of Art for over forty years.

Made several trips to New York, France, and Italy to exhibit and study. Showed at the Lewis & Clark Exposition in Portland in 1905, and at the Alaska-Yukon Exposition in Seattle in 1909.

Works held: California Historical Society, San Francisco, Calif.; Monterey Museum of Art, Monterey, Calif.

Coulter, William Alexander (1849–1936). Painter. Born in Glenariffe, Ireland. Studied in Antwerp, Brussels, Copenhagen, London, and Paris, under marine artists Wilhelm Melbye, Jacob Jacobsen, and François Musin. Showed at the World's Columbian Exposition in Chicago in 1893.

Works held: Bishop Museum, Honolulu, Hawaii; California Historical Society, San Francisco, Calif.; Hearst Art Gallery, Saint Mary's College, Moraga, Calif.; M.H. de Young Memorial Museum, San Francisco, Calif.; Monterey Museum of Art, Monterey, Calif.; Oakland Museum of California, Oakland, Calif.; San Francisco Maritime National Historical Park, San Francisco, Calif.; U.S. Merchant Marine Academy, Kings Point, N.Y.

Deakin, Edwin (1838–1923). Painter. Born in Sheffield, England. Largely self-taught. Emigrated to Chicago, Illinois, in 1856. Moved to San Francisco in 1870. Traveled and sketched in Europe 1878–1880. Exhibited at the 1879 Paris Salon. In California, known for his paintings of the missions.

Works held: California Historical Society, San Francisco, Calif.; Crocker Art Museum, Sacramento, Calif.; Hearst Art Gallery, Saint Mary's College, Moraga, Calif.; M.H. de Young Memorial Museum, San Francisco, Calif.; National Museum of American Art, Smithsonian Institution, Washington, D.C.; Nevada Museum, Reno, Nev.; Oakland Museum of California, Oakland, Calif.; Palm Springs Desert Museum, Palm Springs, Calif.; State Capitol, Sacramento, Calif.

Denny, Gideon Jacques (1830–1886). Painter. Born in Wilmington, Delaware. Took his first art lessons from Samuel Marsden Brookes, at the

time living in Milwaukee. One of the few San Francisco artists who did not study or travel in Europe. Per his obituary, he "was a man of great independence and character, caring little for the comments of the world upon his methods, and pursuing his career in the way which he deemed best."[7]

Works held: Bishop Museum, Honolulu, Hawaii; California Historical Society, San Francisco, Calif.; Crocker Art Museum, Sacramento, Calif.; Hearst Art Gallery, Saint Mary's College, Moraga, Calif.; M.H. de Young Memorial Museum, San Francisco, Calif.; Oakland Museum of California, Oakland, Calif.; San Francisco Maritime National Historical Park, San Francisco, Calif.; Stanford University Museum and Art Gallery, Stanford, Calif.

Dixon, Lafayette Maynard (1875–1946). Painter. Muralist. Illustrator. Born near Fresno, California. After seeing his sketch book, Frederic Remington encouraged him to pursue a career as an artist. Studied briefly at the Mark Hopkins Institute of Art, where, in his own words, he was "too easily disheartened by the favoritism and sarcastic criticisms of [Arthur] Mathews."[8] Moved to New York in 1907 and worked as an illustrator for *Century* and *Scribner's*. Returned to San Francisco in 1912. Helped revive the San Francisco Art Students' League in 1935. Awarded bronze medal at the Panama-Pacific International Exposition in San Francisco in 1915. Settled in Tucson, Arizona, in 1939.

Works held: Amon Carter Museum, Fort Worth, Tex.; Brigham Young University, Provo, Utah; California Historical Society, San Francisco, Calif.; Cook Museum of Honolulu, Honolulu, Hawaii; Crocker Art Museum, Sacramento, Calif.; M.H. de Young Memorial Museum, San Francisco, Calif.; Monterey Museum of Art, Monterey, Calif.; Nevada Museum of Art, Reno, Calif.; Pasadena Art Institute, Pasadena, Calif; Phoenix Art Museum, Phoenix, Ariz.; San Diego Museum of Art, San Diego, Calif.; Santa Barbara Museum of Art, Santa Barbara, Calif.; Southwest Museum, Los Angeles, Calif.; Stanford University Museum and Art Gallery, Stanford, Calif.; Whitney Gallery of Western Art, Cody, Wyo.

Frenzeny, Paul (1840–1902). Painter. Illustrator. Born in France. Studied in Paris, where he was a fellow student of Adrien Moreau and Jules Tavernier. More than one hundred of his illustrations were included in *Fifty Years on the Trail*, by Harrington O'Reilly (1889).

Works held: Amon Carter Museum, Fort Worth, Tex.; California Historical Society, San Francisco, Calif.; Denver Public Library, Denver, Colo.; Museum of Fine Arts, Boston, Mass.

Gariboldi, Giuseppe.G. Mural and fresco painter. Born in Italy. Studied at the Royal Academy of Brera-Milan, later at the Académie Julian in Paris. Before leaving for America in 1857, worked on several palaces in Milan, Rome, Verona, and Vienna. Frescoed numerous private residences in New York, Buffalo, Syracuse, Milwaukee, Albany, Detroit, Erie, and San Francisco. In New York he was also engaged to decorate the Maison Dorée, the Grand Opera House, and the building that housed the *New York Tribune*. Supposedly he mastered all "the various recognized styles of decoration," including "the schools of Louis XV, Pompeii, the Renaissance period, the Raphaelesque order, and the modern teachings of Eastlake."[9]

Hahn, Karl Wilhelm (William) (1829–1887). Painter. Born in Ebersbach, Saxony, Germany. Studied under Julius Hübner at the Royal Academy of Art in Dresden; also for two years in Düsseldorf where he joined the artists around Emanuel Leutze. Worked in Boston, New York, San Francisco, and London. Exhibited at the National Academy of Design.

Works held: California Historical Society, San Francisco, Calif.; Crocker Art Museum, Sacramento, Calif.; Dresden Museum, Dresden, Germany; Gilcrease Museum, Tulsa, Okla.; Hudson River Museum of Westchester, Yonkers, N.Y.; Los Angeles County Museum of Art, Los Angeles, Calif.; M.H. de Young Memorial Museum, San Francisco, Calif.; National Gallery, Dusseldorf, Germany; Oakland Museum of California,

Oakland, Calif.; Phoenix Art Museum, Phoenix, Ariz.; State Capitol, Sacramento, Calif.

Heyneman, Julie Helen (1867–1942). Painter. Born in San Francisco. Studied under Emil Carlsen and Frederick Yates at the San Francisco Art Students' League; later under John Singer Sargent in London. Showed at the London Royal Academy. Bronze medalist at the Panama-Pacific International Exposition in San Francisco in 1915.

Works held: California Historical Society, San Francisco, Calif.; Hearst Art Gallery, St. Mary's College, Moraga, Calif; San Diego Museum of Art, San Diego, Calif.; Santa Barbara Museum of Art, Santa Barbara, Calif.; Tor House, Carmel, Calif.

Hill, Thomas (1829–1908). Painter. Born in Birmingham, England. Studied at the Pennsylvania Academy of Fine Arts, reportedly under Peter F. Rothermel; later in Paris under Paul Meyerheim. Won bronze medal at the New York Palette Club in 1871; "best in landscape" at the Philadelphia Centennial Exposition in 1876; Temple Medal at the Pennsylvania Academy of Fine Arts in 1884. Like Bierstadt, lived to see his large mountain landscapes fall out of favor with the critics as well as the public. Almost a century later curator George W. Neubert would refer to his work as "a native proto-impressionism predating many of the French Impressionist influences in American painting."[10]

Works held: Art Institute of Chicago, Chicago, Ill.; Berkeley Art Museum, Berkeley, Calif.; California Historical Society, San Francisco, Calif.; Crocker Art Museum, Sacramento, Calif.; Gilcrease Museum, Tulsa, Okla.; Hearst Art Gallery, Saint Mary's College, Moraga, Calif.; Hudson River Museum of Westchester, Yonkers, N.Y.; Los Angeles County Museum of Art, Los Angeles, Calif.; M.H. de Young Memorial Museum, San Francisco, Calif.; Monterey Museum of Art, Monterey, Calif.; Palm Springs Desert Museum, Palm Springs, Calif.; Phoenix Art Museum, Phoenix, Ariz.; Santa Barbara Museum of Art, Santa Barbara,

Calif.; Stanford University Museum and Art Gallery, Stanford, Calif.; State Capitol, Sacramento, Calif.; Silverado Museum, St. Helena, Calif.; University of Kansas Museum of Art, Lawrence, Kans.

Holdredge, Ransom Gillet (1836–1899). Painter. Born in New York. Studied in Paris. In San Francisco, his landscapes brought high prices and were by some considered as good, if not better, than those of William Keith. "His ambition" wrote the San Francisco *Call*, "was to be a great portrait artist, but his natural talents turned towards landscapes. He has often stated that this was the disappointment of his life, and was the direct cause of leading him to drink."[11]

Works held: California Historical Society, San Francisco, Calif.; Crocker Art Museum, Sacramento, Calif.; Hearst Art Gallery, Saint Mary's College, Moraga, Calif.; M.H. de Young Memorial Museum, San Francisco, Calif.; Monterey Museum of Art, Monterey, Calif.; Oakland Museum of California, Oakland, Calif.

Hopps, Ella C. (Nellie) (1855–1956). Painter. Born in San Francisco. Studied under Virgil Williams at the California School of Design. Following her marriage in 1884, she moved to the Orient. Gave a retrospective of her work at the San Francisco Palace Hotel in 1942.

Works held: California Historical Society, San Francisco, Calif.

Hudson, Grace Carpenter (1865–1937). Painter. Born near Ukiah, California. Studied under Virgil Williams, Raymond Yelland, and Oscar Kunath at the California School of Design. Received honorable mention at the World's Colombian Exposition in Chicago in 1893.

Works held: California Historical Society, San Francisco, Calif.; Los Angeles County Museum of Art, Los Angeles, Calif.; Monterey Museum of Art, Monterey, California; National Museum of American Art, Smithsonian Institution, Washington, D.C.; Oakland Museum of California, Oakland, Calif.; Palm Springs Desert Museum, Palm Springs

Desert, Calif.; Stanford University Museum and Art Gallery, Stanford, Calif.; Sun House, Ukiah, Calif.

Inness, George (1825–1894). Painter. Born near Newburgh, New York. Studied with George Jesse Barker, Newark, New Jersey c. 1840, and with Régis François Gignoux in Brooklyn c. 1843. Elected member of the National Academy of Design in 1853. Traveled and lived in France, Italy, and England. Exhibited at the 1889 Paris International Exposition and at the 1893 Chicago World's Fair.

Works held: Most major American museums.

Joullin, Amédée (1862–1917). Painter. Born in San Francisco. Studied under Jules Tavernier and at the California School of Design; later at the Académie Julian and L'École des Beaux Arts under Tony Robert-Fleury, William-Adolphe Bouguereau, and Jules Lefèbvre. Sketched in Mexico and in the American Southwest, but did most of his work in California. Taught at the California School of Design/Mark Hopkins Institute of Art. Exhibited at the National Academy of Design in 1896 and 1901; Union League in New York in 1901; Louisiana Purchase Exposition in St. Louis in 1904; Société des Artistes Français in Paris in 1904.

Works held: California Historical Society, San Francisco, Calif.; M.H. de Young Memorial Museum, San Francisco, Calif.; Stanford University Museum and Art Gallery, Stanford, Calif.

Keith, William (1838–1911). Painter. Born in Old Meldrum, Aberdeenshire, Scotland. Studied in Düsseldorf under Albert Flamm. Exhibited at the National Academy of Design, and at the World's Columbian Exposition in Chicago in 1893. Won bronze medal at the Pan-American Exposition in Buffalo in 1901; gold medal at the Alaska-Yukon Exposition in Seattle in 1909. His work was given an entire room at the Panama Pacific Exposition held in San Francisco in 1915. Half a century after Keith's death, Alfred Frankenstein preferred "the creamy but highly

realistic style of mountain landscape [Keith] practiced when he first came here" to the "dark, almost monochromatic formula pictures of his last years."[12] Then as now there were those who begged to differ.

Works held: Art Institute of Chicago, Chicago, Ill.; Berkeley Art Museum, Berkeley, Calif.; Brooklyn Museum, Brooklyn, N.Y.; Cleveland Museum of Art, Cleveland, Ohio; Corcoran Gallery of Art, Washington, D.C.; Crocker Art Museum, Sacramento, Calif.; Gilcrease Museum, Tulsa, Okla.; Hearst Art Gallery, Saint Mary's College, Moraga, Calif.; Los Angeles County Museum of Art, Los Angeles, Calif.; Metropolitan Museum, New York, N.Y; M.H. de Young Memorial Museum, San Francisco, Calif.; Monterey Museum of Art, Monterey, Calif.; National Museum of American Art, Smithsonian Institution, Washington, D.C.; Oakland Museum of California, Oakland, Calif.; Palm Springs Desert Museum, Palm Springs, Calif.; San Diego Museum of Art, San Diego, Calif.; Santa Barbara Museum of Art, Santa Barbara, Calif.; Stanford University Museum and Art Gallery, Stanford, Calif.; State Capitol, Sacramento, California.

Kunath, Oscar (1830–1909). Painter. Born in Dresden, Germany. Studied in Munich. Worked in New York, Los Angeles, and San Francisco, where he also taught at the California School of Design. Exhibited at the 1876 Philadelphia Centennial.

Works held: Bishop Museum, Honolulu, Hawaii; M.H. de Young Memorial Museum, San Francisco, Calif.; Oakland Museum of California, Oakland, Calif..

Latimer, Lorenzo Palmer (1857–1941). Painter. Born in Gold Hill, Placer County, California. Studied under Virgil Williams at the California School of Design, where he later taught. Awarded gold medal at the World's Columbian Exposition in Chicago in 1893.

Works held: California Historical Society, San Francisco, Calif.; Hearst Art Gallery, Saint Mary's College, Moraga, Calif.; M.H. de Young

Memorial Museum, San Francisco, Calif.; Monterey Museum of Art, Monterey, Calif.; Oakland Museum of California, Oakland, Calif.; Silverado Museum, St. Helena, Calif.

L'Aubinière, Madame de. Painter. Information sketchy. Born in England. Arrived in San Francisco in the early 1880s, "having already gained a recognized position in London, Paris and New York." [13]

Lotz, Matilda (1858–1923). Painter. Born in Franklin, Tennessee. Studied under Virgil Williams at the California School of Design; later in Paris under Felix Barrias and Émile Van Marcke. Spent many years in England, France, and Hungary, and traveled frequently to the Orient, the Middle East, and North Africa. Received honorable mention at the Paris Salon where she was a frequent exhibitor.

Works held: M.H. de Young Memorial Museum, San Francisco, Calif.

Martinez, Xavier (1869–1943). Painter. Etcher. Lithographer. Born in Guadalajara, Mexico. Studied at the Mark Hopkins Institute of Art under Arthur Mathews; later at L'École des Beaux-Arts under Jean-Léon Gérôme (1897-99), and at the Académie Carrière (1900–1901). Received honorable mention at the 1900 Paris International Exposition, and at the Panama-Pacific International Exposition in San Francisco in 1915. From 1908 to 1942 he taught at the California School of Arts and Crafts/California College of Arts and Crafts.

Works held: Carmel Museum of Art, Carmel, Calif.; Crocker Art Museum, Sacramento, Calif.; M.H. de Young Memorial Museum, San Francisco, Calif.; Mills College Art Gallery, Oakland, Calif.; Monterey Museum of Art, Monterey, Calif.; National Museum of American Art, Smithsonian Institution, Washington, D.C.; Oakland Museum of California, Oakland, Calif.; San Diego Museum of Art, San Diego, Calif.

Mathews, Arthur Frank (1860–1945). Painter. Muralist. Craftsman. Born in Markesan, Wisconsin. Studied under Virgil Williams at the California School of Design; later under Gustave Boulanger and Jules Lefèbvre at the Académie Julian (1885–89), where he was awarded Grand Gold Medal in 1886. Showed at the World's Columbian Exposition in Chicago in 1893; Paris Salons of 1887-1889 and 1898; Paris Expositions of 1889 and 1898. In 1906, after the San Francisco earthquake, Mathews and his wife Lucia helped launch the magazine *Philopolis*, "to consider the ethical and artistic aspects of the rebuilding of San Francisco."[14]

Works held: California Historical Society, San Francisco, Calif.; Hirshhorn Museum and Sculpture Garden, Washington, D.C.; Metropolitan Museum of Art, New York, N.Y.; M.H. de Young Memorial Museum, San Francisco, Calif.; National Museum of American Art, Smithsonian Institution, Washington. D.C.; Oakland Museum of California, Oakland, Calif.; State Capitol, Sacramento, Calif.; San Diego Museum of Art, San Diego, Calif.; Santa Barbara Museum of Art, Santa Barbara, Calif.; Stanford University Museum and Art Gallery, Stanford, Calif.

Mersfelder, Jules (1865–1937). Painter. Born in Stockton, California. Studied under Virgil Williams at the California School of Design; advised by George Inness, Alexander H. Wyant, and Robert Minor. Showed regularly with the Society of American Artists in New York. In the early 1900s returned to San Francisco where he and his wife Lou, also an artist, often joined the crowd at Coppa's. Received bronze medal at the 1904 Louisiana Purchase Exposition, St. Louis.

Mezzara, Pietro (1820–1883). Sculptor. Born in France. Sculpted rooftop figures, urns, and emblems for the Sacramento State Capitol. A copy of his statue of Lincoln can be seen at San Francisco's Abraham Lincoln High School.

Nahl, Charles Christian (1818–1878). Painter. Born in Kassel, Germany. Studied at the Kassel Academy; later in Paris under Horace Vernet and Paul Delaroche. Showed at the 1847 Paris Salon. In California, he painted large genre scenes with miners and *rancheros*.

Works held: Amon Carter Museum, Fort Worth, Tex.; Brooklyn Museum, Brooklyn, N.Y.; California Historical Society, San Francisco, Calif.; Crocker Art Museum, Sacramento, Calif.; Gilcrease Museum, Tulsa, Okla.; Huntington Art Gallery, San Marino, Calif.; M.H. de Young Memorial Museum, San Francisco, Calif.; National Museum of American Art, Smithsonian Institution, Washington, D.C.; Oakland Museum of California, Oakland, Calif.; Santa Barbara Museum of Art, Santa Barbara, Calif.; Stanford University Museum and Art Gallery, Stanford, Calif.

Nahl, Perham Wilhelm (1869–1935). Painter. Lithographer. Illustrator. Etcher. Born in San Francisco. Studied at the Mark Hopkins Institute of Art; later in Paris and Munich. Taught drawing at University of California, Berkeley. Awarded bronze medal at the Alaska-Yukon Exposition in Seattle in 1909; silver medal at the Panama-Pacific International Exposition in San Francisco in 1915.

Works held: California Historical Society, San Francisco, Calif.; Crocker Art Museum, Sacramento, Calif.; Honolulu Academy of Art, Honolulu, Hawaii; Museum of Fine Arts, Boston, Mass.; Oakland Museum of California, Oakland, Calif.

Narjot, Ernest (1826–1898). Painter. Born in Saint-Malo, France. Studied at the Académie Julian in Paris. After joining the gold rush to California, he spent 13 years mining and sketching along the border of Arizona and Mexico. In 1884, when he was painting the ceiling of Leland Stanford's mausoleum, paint splashed into his eyes and damaged his vision. In 1885 he was in charge of the male life class at the California School of Design. After yet another stay in Mexico, returned to San

Francisco in 1891. Deteriorating eyesight and a "softening of the brain" eventually forced him to stop painting.[15] Showed at the World's Colombian Exposition in Chicago in 1893.

Works held: California Historical Society, San Francisco, Calif.; Gilcrease Museum, Tulsa, Okla.; Hearst Art Gallery, Saint Mary's College, Moraga, Calif.; Los Angeles County Museum of Art, Los Angeles, Calif.; M.H. de Young Memorial Museum, San Francisco, Calif.; Oakland Museum of California, Oakland, Calif.; Santa Barbara Museum of Art, Santa Barbara, Calif.; Silverado Museum, St. Helena, Calif.

Peixotto, Ernest Clifford (1869–1940). Muralist. Painter. Illustrator. Born in San Francisco. Studied under Emil Carlsen at the California School of Design; later under Jean Joseph Benjamin-Constant and Jules Lefèbvre at the Académie Julian in Paris. Lived most of his life in New York and France, where he was a member of the Société des Artistes Français.

Works held: Brooklyn Museum, Brooklyn, N.Y.; National Museum of American Art, Smithsonian Institution, Washington, D.C.

Perry, Enoch Wood, Jr. (1831–1915). Painter. Born in Boston. Studied under Emanuel Leutze in Düsseldorf and Thomas Couture in Paris. Sketched in London, Rome, and Venice. In 1864, after his stay in California, he visited the Sandwich Islands. Spent most of his life in New York.

Works held: Albright-Knox Art Gallery, Buffalo, N.Y.; Bishop Museum, Honolulu, Hawaii; Corcoran Gallery of Art, Washington, D.C.; Honolulu Academy of Arts, Honolulu, Hawaii; Louisiana State Museum, Baton Rouge, La.; Oakland Museum of California, Oakland, Calif.; Wadsworth Athenaeum, Hartford, Conn.

Peters, Charles Rollo (1862–1928). Painter. Born in San Francisco. Studied at the California School of Design under Virgil Williams and

Christian Jorgensen, and privately under Jules Tavernier. From 1886 to 1890 he was a student of Jean-Léon Gérôme and Fernand-Ann Cormon at L'École des Beaux Arts, and of Gustave Boulanger and Jules Lefébvre at the Académie Julian. Exhibited at the Paris Salon and at the Union League in New York. Received a bronze medal at the 1901 Pan-American Exposition, Buffalo, and a silver medal at the 1904 Louisiana Purchase Exposition, St. Louis.

Works held: California Historical Society, San Francisco, Calif.; Crocker Art Museum, Sacramento, Calif.; Hearst Art Gallery, Saint Mary's College, Moraga, Calif.; M.H. de Young Memorial Museum, San Francisco, Calif.; Monterey Museum of Art, Monterey, California; Oakland Museum of California, Oakland, Calif.; Phoenix Art Museum, Phoenix, Ariz.

Piazzoni, Gottardo Fidele Ponziano (1872–1945). Painter. Muralist. Etcher. Sculptor. Born in Intragna, Switzerland. Came to California in 1886. Studied at the California School of Design under Arthur Mathews and Raymond Dabb Yelland; later under Jean-Léon Gérôme at L'École des Beaux Arts. Received honorable mention at the 1904 Louisiana Purchase International Exposition in St. Louis; also showed at the 1906 International Exposition in Rome, and at the 1907 Paris Salon. Taught at the California School of Fine Arts from 1918-1935.

Works held: Berkeley Art Museum, Berkeley, Calif.; Honolulu Academy of Arts, Honolulu, Hawaii; M.H. de Young Memorial Museum, San Francisco, Calif.; Monterey Museum of Art, Monterey, Calif.; National Museum of American Art, Smithsonian Institution, Washington, D.C.; Oakland Museum of California, Oakland, Calif.

Pixley, Emma Catherine O'Reilly (1836–1911). Painter. Born in Rochester, New York. Studied in New York at the Cooper Union and in San Francisco at the California School of Design.

Porter, Bruce (1865–1953). Painter. Muralist. Stained-glass designer. Born in San Francisco. Studied in San Francisco, Paris, Venice, and London. After visiting the studio of Edward Burne Jones, he became a champion of *Art Nouveau* in California.

Works held: Brooklyn Museum, Brooklyn, N.Y.; Museum of Fine Arts, Boston, Mass. Designed the "ship memorial" to Robert Louis Stevenson in San Francisco's Portsmouth Square. In San Francisco, his work can also be seen at the Pacific Union Club and at the First Unitarian Church.

Putnam, Arthur (1873–1930). Sculptor. Born in Waveland, Mississippi. Studied under Julie Heyneman at the San Francisco Art Students' League. Assisted Rupert Schmid in his San Francisco studio, and learned animal anatomy while working at a slaughter house. Also studied briefly under Edward Kemeys in Chicago. While in France, he showed at the 1906 Paris Salon and was greatly influenced by Rodin. Upon his return to San Francisco in 1907, he built a house and a studio with a small foundry on Ocean Beach. In 1911 brain surgery left him partially paralyzed. Spent the last years of his life in Paris, unable to work, suffering from paranoia and alcoholism. Exhibited at the 1913 New York Armory Show.

Works held: California Historical Society, San Francisco, Calif.; Los Angeles County Museum of Art, Los Angeles, Calif.; Metropolitan Museum of Art, New York, N.Y.; M.H. de Young Memorial Museum, San Francisco, Calif.; Museum of Fine Arts, Boston, Mass.; Oakland Museum of California, Oakland, Calif.; San Diego Museum of Art, San Diego, Calif.

Raschen, Henry (1854–1937). Painter. Born in Oldenburg, Germany. Studied at the California School of Design; later for eight years in Munich, where he befriended Frank Duveneck and William M. Chase. Painted the Pomo Indians around his father's ranch north of San Francisco. Also painted several portraits of Geronimo, after the Apache chief surrendered in 1886. Upon his return to Europe in 1890, he sketched Bavarian peasants

and helped establish a small art colony in the German village of Dachau. Awarded gold medal at the Munich Exposition in 1898, and at the Alaska-Yukon Exposition in Seattle in 1909.

Works held: Brooklyn Museum, Brooklyn, N.Y.; California Historical Society, San Francisco, Calif.; Frye Art Museum, Seattle, Wash.; Gilcrease Museum, Tulsa, Okla.; San Diego Museum of Art, San Diego, Calif.; Whitney Gallery of Western Art, Cody. Wyo.

Richardson, Mary Curtis (1848–1931). Painter. Born in New York. Studied at the California School of Design under Virgil Williams, and at the New York Art Students' League under Benoni Irwin and John Sartain. Because of her portraits of women and children, often referred to as the Mary Cassatt of the West. Showed at the National Academy of Design and at the 1893 Chicago World's Colombian Exposition. Silver medalist at the Panama-Pacific International Exposition in San Francisco in 1915.

Works held: California Historical Society, San Francisco, Calif.; Hearst Art Gallery, Saint Mary's College, Moraga, Calif.; M.H. de Young Memorial Museum, San Francisco, Calif.; Monterey Museum of Art, Monterey, Calif.; Oakland Museum of California, Oakland, Calif.; Stanford University Museum and Art Gallery, Stanford, Calif.

Rix, Julian Walbridge (1850–1903). Painter. Born in Peacham, Vermont. Studied briefly under Virgil Williams at the California School of Design. Moved back East in the early 1880s. Set up a studio in New York where he showed regularly at the National Academy of Design.

Works held: Art Institute of Chicago, Chicago, Ill.; Brooklyn Museum, Brooklyn, N.Y.; California Historical Society, San Francisco, Calif.; Corcoran Gallery of Art, Washington, D.C.; Crocker Art Museum, Sacramento, Calif.; M.H. de Young Memorial Museum, San Francisco, Calif.; Monterey Museum of Art, Monterey, Calif.; Oakland Museum of California, Oakland, Calif.; State Capitol, Sacramento, Calif.; Toledo Museum of Art, Toledo, Ohio.

Robinson, Charles Dormon (1847–1933). Painter. Born in Monmouth, Maine. Studied under William Bradford, George Inness, Régis Gignoux, and Jasper Cropsey; later under Eugene Boudin in Paris. In California, he spent more than twenty summers in Yosemite, where he fought for the preservation of the valley and sold his paintings to wealthy European tourists.

Works held: California Historical Society, San Francisco, Calif.; Crocker Art Museum, Sacramento, California; Hearst Art Gallery, Saint Mary's College, Moraga, Calif.; M.H. de Young Memorial Museum, San Francisco, Calif.; Monterey Museum of Art, Monterey, Calif.; Nevada Museum of Art, Reno, Nev.; Oakland Museum of California, Oakland, Calif.; San Francisco Maritime National Historical Park, San Francisco, Calif.

Rosenthal, Tobias Edward (1848–1917). Painter. Born in Strassburg, Prussia. Studied under Fortunato Arriola in San Francisco; later under Karl von Piloty in Munich. Won gold medal at the Philadelphia Centennial Exposition in 1876. Lived most of his life in Munich, where he was a trustee of the Kunstgenossenschaft and gained a solid reputation in figure and genre.

Works held: Art Institute of Chicago, Chicago, Illinois; California Historical Society, San Francisco, Calif.; M.H. de Young Memorial Museum, San Francisco, Calif.; Oakland Museum of California, Oakland, Calif.

Schmid, Rupert (1864–1932). Sculptor. Born in Munich, Bavaria. Studied at the Munich Royal Academy. Came to San Francisco c. 1889. Executed many commissions, including several portrait busts of prominent San Franciscans.

Works held: California Historical Society, San Francisco, Calif.; Oakland Museum of California, Oakland, Calif. ("California Venus").

Shaw, Stephen William (1817–1900). Painter. Born near Windsor, Vermont. Self-taught. Director and teacher at the Boston Athenaeum. Joined the gold rush to California in 1849. Painted many portraits of famous Californians, including one of John Sutter at Hock Farm.

Works held: Corcoran Gallery of Art, Washington, D.C.; Crocker Art Gallery, Sacramento, Calif.; M.H. de Young Memorial Museum, San Francisco, Calif.

Straus, Meyer (1831–1905). Painter. Born in Bavaria. Self-taught. In his early years he was the head scene painter at the San Francisco Grand Opera House. Received honorable mention at the 1885 World's Fair in New Orleans.

Works held: Amon Carter Museum, Fort Worth, Tex.; California Historical Society, San Francisco, Calif.; M.H. de Young Memorial Museum, San Francisco, Calif.; Oakland Museum of California, Oakland, Calif.; Nevada Museum of Art, Reno, Nev.

Strong, Elizabeth (1855–1941). Painter. Born in Hartford, Connecticut. Studied under Virgil Williams at the California School of Design, later under William Merritt Chase in New York, and under Émile Van Marcke in Paris. Showed regularly at the Paris Salon. After spending about twenty years in Europe, returned for good to the Monterey Peninsula. Won silver medal at the Alaska-Yukon Exposition in Seattle in 1909.

Works held: Monterey Museum of Art, Monterey, Calif.

Strong, Joseph Dwight, Jr. (1852–1899). Painter. Born in Bridgeport, Connecticut. Studied under Virgil Williams at the California School of Design, later under Alexander Wagner and Karl von Piloty in Munich. In 1888, after Strong and Jules Tavernier were detained in Honolulu because of unpaid bills, Strong was bailed out by his father-in-law, Robert Louis Stevenson. During the next few years Joe and his wife Isobel were part of the Stevenson household in Samoa where Joe oversaw the workmen on

Stevenson's cocoa plantation. Returned to San Francisco in the mid-1890s.

Works held: Bishop Museum, Honolulu, Hawaii; M.H. de Young Memorial Museum, San Francisco, Calif.; Silverado Museum, St. Helena, Calif.

Tavernier, Jules (1844–1889). Painter. Born in Paris, France. Studied under Felix Barrias in Paris. Showed at the Paris Salon in 1865, 1866, 1869, and 1870. "Tavernier was a man of perception and kindliness," wrote Robert Nichols Ewing in 1978. "He had a keen insight into the very real problems an artist faced in the late nineteenth century, and his concern led him into becoming an active organizer in an attempt to resolve these difficulties."[16]

Works held: Amon Carter Museum, Fort Worth, Tex.; Bishop Museum, Honolulu, Calif.; California Historical Society, San Francisco, Calif.; Crocker Art Museum, Sacramento, Calif.; Gilcrease Museum, Tulsa, Okla.; Hearst Art Gallery, Saint Mary's College, Moraga, Calif.; Honolulu Academy of Arts, Honolulu, Hawaii; M.H. de Young Memorial Museum, San Francisco, Calif.; Monterey Museum of Art, Monterey, Calif.; Oakland Museum of California, Oakland, Calif.; Society of California Pioneers, San Francisco, Calif.; Stanford University Museum and Art Gallery, Stanford, Calif.

Tilden, Douglas (1860–1935). Sculptor. Born in Chico, California. Studied briefly under Virgil Williams at the California School of Design; later under John Quincy Adams Ward and Harry Siddons Mowbray at the New York National Academy, and under Paul Chopin in Paris. In 1894, became the first instructor of sculpture at the Mark Hopkins Institute of Art. Exhibited with the Société des Artistes Français and Société National des Beaux-Arts in Paris from 1889 to 1892, and again in 1894; World's Columbian Exposition in Chicago in 1893. Received honorable mention at the 1890 Paris Salon; bronze medal at the 1900 Paris Exposition; gold medals at the 1904 Louisiana Purchase Exposition in St. Louis and the 1909 Alaska-Yukon Exposition in Seattle.

Works held: Hearst Art Gallery, Saint Mary's College, Moraga, Calif.; National Museum of American Art, Smithsonian Institution, Washington, D.C. Monuments in San Francisco: "Junipero Serra" and "Baseball Players" in Golden Gate Park; "Mechanics' Fountain" at Market, Bush and Battery; "Admission Day" at Market, Post and Montgomery; "California Volunteers" at Market and Dolores.

Tojetti, Domenico (1806–1892). Painter. Born in Rome, Italy. Studied at the Rome Academy, with Vincenzo Camuccini and possibly Giuseppe Murani. Executed commissions for Popes Gregory XVI and Pius IX. In 1867 left Rome to form the Guatemala Academy of Fine Art. Arrived in San Francisco in 1871. Taught portraiture at the California School of Design. With his sons, painted many frescoes for San Francisco mansions and churches, most of which were destroyed in the fire following the 1906 earthquake.

Works held: California Historical Society, San Francisco, Calif.; M.H. de Young Memorial Museum, San Francisco, Calif.; Oakland Museum of California, Oakland, Calif.

Walter, Solly H. (1846–1900). Painter. Illustrator. Born in Vienna, Austria. Founded a drawing school in San Francisco, where he was active throughout the 1890s.

Work held: California Historical Society, San Francisco, Calif.

Weeks, Marian. Painter. Information not just sketchy, but apparently non-existent.

Williams, Dora (Deborah) Norton (1829–1915). Painter. Born in Livermore, Maine. Studied under her husband Virgil Williams, first in Boston, later in San Francisco.

Works held: Silverado Museum, St. Helena, Calif.

Williams, Virgil Macey (1830–1886). Painter. Born in Dixfield, Maine. Studied under Daniel Huntington in New York; later under William Page in Rome, where he knew Worthington Whittredge, Sanford Robinson Gifford, Nathaniel Hawthorne, and Robert and Elizabeth Browning. Taught at the California School of Design from 1874 to 1886.

Works held: California Historical Society, San Francisco, Calif.; Crocker Art Museum, Sacramento, Calif.; M.H. de Young Memorial Museum, San Francisco, Calif.; Monterey Museum of Art, Monterey, Calif.; National Museum of American Art, Smithsonian Institution, Washington, D.C.; Oakland Museum of California, Oakland, Calif.; Silverado Museum, St. Helena, Calif.

Von Perbandt, Carl (1832–1911). Painter. Born in Lagendorf, Prussia. Studied in Düsseldorf under Andreas Achenbach and Karl Friedrich Lessing. After painting in Monterey, sketched with Henry Raschen in the Sonoma, Mendocino and Humboldt counties north of San Francisco. Exhibited at the National Academy of Design in 1874. Died in Germany.

Works held: California Historical Society, San Francisco, Calif.; Oakland Museum of California, Oakland, Calif.

Withrow, Evelyn Almond (1858–1928). Painter. Born in Santa Clara, California. Studied under Virgil Williams at the California School of Design and under Frank Currier in Munich. Showed at the Munich Kunstverein, the London Royal Academy, and the Paris Salon. Her paintings became symbolical, at times almost abstract, as her interest in mysticism and the occult grew stronger.

Works held: California Historical Society, San Francisco, Calif.; Louvre, Paris, France; M.H. de Young Memorial Museum, San Francisco, Calif.; Oakland Museum of California, Oakland, Calif.; Palais de Luxembourg, Paris, France.

Woodleigh, Almeigh. Painter. Information sketchy. Worked in San Francisco in the 1880s. When forced to lower his prices, he apparently signed his work "F.L. Montague."

Wores, Theodore (1859–1939). Painter. Born in San Francisco. Studied under Virgil Williams at the California School of Design; later under Ludwig Locfftz and Alexander Wagner at the Munich Royal Academy where he was given free use of studio and models. Traveled to Venice in 1879 with Frank Duveneck, William Merritt Chase, and John Twachtman. Sketched in Japan (1885–1887; 1892–1894), in Samoa and Hawaii (1901), in Spain (1903), in the Canadian Rockies (1913), and in the American Southwest (1915–1917). Taught at the San Francisco Art Students' League in 1884 and was dean of the San Francisco Art Institute from 1907 to 1913. Exhibited at the London Royal Academy, with the Society of British Artists, at the New York National Academy of Design, and at the World's Colombian Exposition in Chicago in 1893. Awarded gold and bronze medals at the Royal Academy of Munich in 1876 and 1878; gold medals at the Alaska-Yukon Exposition in Seattle in 1909 and at the Panama-Pacific International Exposition in San Francisco in 1915. "Theodore Wores was one of the most highly regarded American artists of his time," wrote Professor Joseph Armstrong Baird in 1978. "His career is a mirror of both the period's temper and the individual components of the art world between 1874 and 1939; he knew virtually all of the persons in that historic drama, and was himself a principal player on its stage."[17]

Works held: Brooklyn Museum, Brooklyn, N.Y.; Bishop Museum, Honolulu, Hawaii; California Historical Society, San Francisco, Calif.; Crocker Art Museum, Sacramento, Calif.; Honolulu Academy of Arts, Honolulu, Hawaii; Los Angeles County Museum of Art, Los Angeles, Calif.; M.H. de Young Memorial Museum, San Francisco, Calif.; Monterey Museum of Art, Monterey, Calif.; National Museum of American Art, Smithsonian Institution, Washington, D.C.; Oakland Museum of California, Oakland, Calif.; Santa Barbara Museum of Art,

Santa Barbara, Calif.; Stanford University Museum and Art Gallery, Stanford, Calif.

Yates, Frederick (1854–1919). Painter. Born in England. Studied in Paris under Leon Bonnat, Gustave Boulanger, and Jules Lefèbvre. Taught at the San Francisco Art Students' League. Also kept a studio in London, and "a beautiful country seat, where he entertains his friends in true Western style."[18] Showed at the London Royal Academy and at the Paris Salon.

Works held: Art Museum, Princeton University, Princeton, N.J,; Bishop Museum, Honolulu, Hawaii; Honolulu Academy of Arts, Honolulu, Hawaii,

Yelland, Raymond Dabb (1848–1900). Born in London, England. Emigrated to New York in 1851. Studied at the New York National Academy of Design under William Page, L(emuel) E(verett) Wilmarth, and James R. Brevoort (1869-71); later in Paris under Luc Olivier Merson. Exhibited at the 1877 Paris Salon; National Academy of Design in the 1880s; World's Colombian Exposition in 1893. Taught at the California School of Design/Mark Hopkins Institute of Art from 1877 to 1894.

Works held: Berkeley Art Museum, University of California, Berkeley; California Historical Society, San Francisco, Calif.; Harvard University Art Museums, Cambridge, Mass.; M.H. de Young Memorial Museum, San Francisco, Calif.; Monterey Museum of Art, Monterey, Calif.; Oakland Museum of California, Oakland, Calif.; Stanford University Museum and Art Gallery, Stanford, Calif.; State Capitol, Sacramento, Calif.

LIST OF
ILLUSTRATIONS

PAINTINGS AND PHOTOGRAPHS

PLATE 1
VIRGIL MACEY WILLIAMS (1830–1886)
Along the Mariposa Trail, 1863
Oil on canvas, 41 ¹/₂ x 35 ¹/₂ inches
California Historical Society
Gift of A.K. Browne

PLATE 2
ALBERT BIERSTADT (1830–1902)
Domes of Yosemite, 1867
Oil on canvas, 116 x 180 inches
St. Johnsbury Athenaeum, St. Johnsbury,
Vermont

PLATE 3
Art Gallery, Woodward Gardens
San Francisco Public Library

PLATE 4
SAMUEL MARSDEN BROOKES (1816–1892)
Sacramento River Fish, 1872
Oil on canvas, 25 x 30 inches
Courtesy Garzoli Gallery, San Rafael,
California

PLATE 5
THOMAS HILL (1829–1908)
*Thomas Hill and Virgil Williams with
Wives Fishing*, n.d.
Oil on canvas, 14 x 11 inches
Courtesy Garzoli Gallery, San Rafael,
California

PLATE 6
*In Camp, Thomas Hill and Virgil Williams
in Yosemite*
Photo by Carleton Watkins
Courtesy National Park Service
Yosemite Collection

PLATE 7
KARL WILHELM HAHN (1829–1887)
*Gibb Warehouse and Government Corral
(Front and Vallejo Streets)*, n.d.
Oil on canvas, 17 ¹/₂ x 28 inches
Courtesy Maxwell Galleries, Ltd.

PLATE 8
EDWIN DEAKIN (1838–1923)
Samuel Marsden Brookes in His Studio, 1876
Oil on canvas, 20 x 16 inches
Fine Arts Museums of San Francisco, Gift
of Mrs. Virginia Dakin

PLATE 9
ALBERT BIERSTADT (1830–1902)
Winter in Yosemite Valley, 1872
Oil/paper mtd., 14 1/4 x 19 1/8 inches
Garzoli Gallery, San Rafael, California

PLATE 10
TOBIAS EDWARD ROSENTHAL
(1848–1917)
Elaine, 1874
Oil on canvas, 38 9/16 x 62 1/2 inches
The Art Institute of Chicago
Gift of Mrs. Maurice Rosenfeld, 1917.3

PLATE 11
JULES TAVERNIER (1844–1889)
Carmel Mission, 1873
Oil on canvas, 14 x 24 inches
Courtesy Garzoli Gallery, San Rafael,
California

PLATE 12
JULES TAVERNIER (1844–1889)
In the Forest, n.d.
Pastel on canvas, 36 x 20 inches
Courtesy Maxwell Galleries, Ltd.

PLATE 13
JOSEPH DWIGHT STRONG (1852–1899)
Isobel at Monterey, 1879
Oil on canvas, 24 1/4 x 13 inches
Courtesy Garzoli Gallery, San Rafael,
California

PLATE 14
Robert Louis Stevenson
San Francisco Public Library

PLATE 15
Leland Stanford
San Francisco Public Library

PLATE 16
THOMAS HILL (1829–1908)
Yosemite Valley, 1876
Oil on canvas, 72 x 120 inches
Collection of the Oakland Museum of
California
The Oakland Museum Kahn Collection
Photo credit: M. Lee Fatherree

PLATE 17
THOMAS HILL (1829–1908)
The Driving of the Last Spike, c. 1881
Oil on canvas,
96 3/8 inches x 144 1/2 inches
California State Railroad Museum

PLATE 18
*Exhibition of Paintings at the San
Francisco Art Association on Pine Street,
c. 1880*
California Historical Society, FN-25948

PLATE 19
EDWIN DEAKIN (1838–1923)
Notre Dame, Paris, 1888
Oil on canvas, 50 x 30 inches
Courtesy Garzoli Gallery, San Rafael,
California

PLATE 20
ERNEST NARJOT (1826–1898)
Self-portrait in the Artist's Studio, 1890
Oil on canvas, 38 x 26 inches
Garzoli Gallery, San Rafael, California

PLATE 21
EMIL CARLSEN (1853–1932)
White Bowl and Chocolate Pot, 1906
Oil on canvas, 20 x 16 inches
Courtesy Garzoli Gallery, San Rafael,
California

PLATE 22
SAMUEL MARSDEN BROOKES
(1816–1892)
Salmon Trout and Smelt, 1873
Oil on canvas, 40 3/8 x 31 1/8
Fine Arts Museums of San Francisco,
Gift of Collis P. Huntington

PLATE 23
SAMUEL MARSDEN BROOKES
(1816–1892)
Bracket of Apples, n.d.
Oil on canvas, 20 x 16 inches
Garzoli Gallery, San Rafael, California

PLATE 24
Thomas Hill
Courtesy National Park Service
Yosemite Collection

PLATE 25
Interior, Thomas Hill's Yosemite Studio
Courtesy National Park Service
Yosemite Collection

PLATE 26
WILLIAM KEITH (1838–1911)
California Alpine Grandeur, c. 1878
Oil on canvas, 39 x 70 inches
Courtesy Maxwell Galleries. Ltd.

PLATE 27
WILLIAM KEITH (1838–1911)
*Glacial Meadow and Lake, High Sierra
(Tuolomne Meadows),*
c. 1870–79
Oil on canvas, 14 ¹/₂ x 26 inches
Collection of Saint Mary's College of
California
Gift of Dr. Wm. S. Porter

PLATE 28
GEORGE INNESS
California, 1894
Oil on canvas, 60 x 48 inches
Collection of The Oakland Museum of
California
Gift of the Estate of Helen Hathaway
White and the Women's Board of the
Oakland Museum Association
Photo credit: M. Lee Fatherree

PLATE 29
DOMENICO TOJETTI (1806–1892)
Night, 1877
Oil on canvas, 47 ¹/₂ x 85 ¹/₂ inches
Collection of The Oakland Museum of
California
Given in Memory of Vivian Frances
Mickelson
Photo credit: M. Lee Fatherree

PLATE 30
EVELYN ALMOND WITHROW
(1858–1928)
The Spirits of Creation, n.d.
Oil on canvas, 26 ¹/₄ x 26 ¹/₄ inches
Garzoli Gallery, San Rafael, California

PLATE 31
GRACE HUDSON (1865–1937)
Little Mendocino, 1892
Oil on canvas, 36 x 26 inches
California Historical Society
Louis Sloss, Jr., Collection

PLATE 32
Grace Hudson, the Crack Shot
Courtesy Dr. Searles R. Boynton

PLATE 33
GRACE HUDSON (1865–1937)
The Seed Conjurer, 1896
Oil on canvas, 25 x 15 inches
Grace Hudson Museum, City of Ukiah

PLATE 34
Mark Hopkins House
San Francisco Public Library

PLATE 35
Arthur Mathews in his Studio
Collection of The Oakland Museum
of California

PLATE 36
*Life Class at Mark Hopkins Institute of
Art, c. 1898*
Photograph by Isabel Porter Collins
California Historical Society, FN-25688

PLATE 37
ARTHUR FRANK MATHEWS
(1860–1945)
The Grape (The Wine Maker), c.1906
Oil on canvas, 26 x 24 inches
Fine Arts Museums of San Francisco,
Gift of Mrs. Henrietta Zeile

PLATE 38
Theodore Wores
Courtesy Dr. A. Jess Shenson

PLATE 39
THEODORE WORES (1859–1939)
Chinese Fishmonger, 1881
Oil on canvas, 34 ³/₄ x 46 ¹/₈
1972.153
National Museum of American Art,
Smithsonian Institution
Gift of Drs. Ben and A. Jess Shenson

PLATE 40
THEODORE WORES (1859–1939)
Chinese New Year's Day, San Francisco,
n.d.
Oil on canvas, 29 x 22 inches
Courtesy Dr. A. Jess Shenson

PLATE 41
THEODORE WORES (1859–1939)
A Japanese House, Nikko, Japan, n.d.
Oil on canvas, 26 x 34 inches
Courtesy Dr. A. Jess Shenson

PLATE 42
CHARLES ROLLO PETERS (1862–1928)
Nocturnal Street Scene, n.d.
Oil on canvas, 16 ¹/₂ x 24 ¹/₈ inches
Collection of The Oakland Museum of
California

PLATE 43
WILLIAM KEITH (1838–1911)
Evening, n.d.
Oil on canvas, 22 ¹/₂ x 28 ¹/₂ inches
Collection of the Oakland Musueum
Gift of International Business Machines
Corporation
Photo credit: M. Lee Fatherree

PLATE 44
GOTTARDO PIAZZONI (1872–1945)
Reflection, 1904
Oil on canvas, 22 ¹/₂ x 17 inches
Collection of The Oakland Museum of
California
Gift of Marjorie Eaton

PLATE 45
Coppa's Restaurant
San Francisco Public Library

PLATE 46
XAVIER MARTINEZ (1869–1943)
Oxen Plowing, n.d.
Oil on canvas, 20 x 25 inches
Collection of The Oakland Museum of
California

PLATE 47
WILLIAM ALEXANDER COULTER
(1849–1936)
San Francisco Fire, 1906
Oil on canvas, 60 x 120 ¹/₂ inches
Courtesy Montgomery Gallery

PLATE 48
THEODORE WORES (1859–1939)
*Ruins of City Hall after the Great
Earthquake and Fire, San Francisco*, 1906
Oil on canvas, 12 x 9 inches
Courtesy Dr. A. Jess Shenson

Front Cover: Detail Plate 37
Back Cover: Detail Plate 18
End Sheets: Detail Plate 36

CHAPTER ILLUSTRATIONS

Chapter 1
Albert Bierstadt
Scribner's Monthly (March 1872)

Chapter 2
San Francisco Hoodlums
Bulletin (1870s)

Chapter 4
The Ideal Bohemian Club
From "Crimes in Black and White"
by Paul Frenzeny
Annals of the Bohemian Club
(1872–1880)

Jules Tavernier
Call (April 16, 1911)

Alvarado Avenue, The Principal Street
of Monterey
By Jules Tavernier
Argonaut (October 26, 1878)

Store in Monterey-Business Hour
By Jules Tavernier
Argonaut (October 26, 1878)

Strolling Through the Sand
By Jules Tavernier
Argonaut (October 26, 1878)

The Modern Messiah. Oscar Wilde in
San Francisco
Wasp (March 31, 1882)

Chapter 5
Palace Hotel, San Francisco
News Letter (1975)

Chapter 6
Another Disputed Art Treasure
Wasp (November 17, 1894)

Chapter 7
The Hanging Committee
R. J. Bush, 1877
Annals of the Bohemian Club
(1872–1880)

Gem of Keith
News Letter (March 26, 1881)

Chapter 8
Emil Carlsen
From a Painting by Kenyon Cox
Examiner (September 27, 1891)

William Keith
By Nankivell
Call (October 29, 1895)

Chapter 9
A Local Candidate No. 12
Examiner (March 17, 1893)

A Local Candidate No. 15
Examiner (March 17, 1893)

Miss Mary M. James, the Third Candidate
Examiner (March 10, 1893)

Miss Marian Nolan, the Fifth Local
Contestant
Examiner (March 10, 1893)

Venus de Milo under the Tapeline
Examiner (February 24, 1893)

Sandow, "the Perfect Man"
Examiner (January 14, 1894)

Applying the Liquid Bronze
Examiner (April 14, 1895)

Draping One of the Living Bronze
Examiner (April 14, 1895)

Chapter 10
Female Art Students
News Letter (December 23, 1882)

Elizabeth Strong
By Joseph D. Strong
Call (June 12, 1896)

Julie Heyneman
After a sketch by John Singer Sargent
Examiner (May 9, 1923)

Chapter 11
As the Main Salon Looked with the
Merrymakers in Full Swing
Mardi Gras at the Hopkins House
By Max Newberry
Chronicle (February 19, 1906)

Mathews Grunts
By James Guilford Swinnerton
Wave (December 23, 1893)

Chapter 12
Charles Rollo Peters
Call (October 24, 1897)

William Keith Demonstrates a New
Technique
By Lewis (Arthur M. ?)
Call (January 14, 1896)

Chapter 13
Piping Faun
By Bruce Porter
Lark (May 1895)

The Purple Cow
Verse and Cartoon by Gelett Burgess
Lark (May 1895)

The Purple Cow, Suite
Verse and Cartoon by Gelett Burgess
Lark (May 1897)

Jack London
By Xavier Martinez
Pacific Monthly (January 1907)

Xavier Martinez
By Xavier Martinez
Pacific Monthly (January 1907)

Last Meal at Coppa's
By Maynard Dixon
Sunset Magazine (October 1906)

NOTES

CHAPTER ONE

1. Fitz Hugh Ludlow, "Salt Lake City to San Francisco," *Golden Era*, April 17, 1864.
2. "San Francisco—Past and Present," *Golden Era*, October 4, 1863.
3. Ludlow, "Letters from Sundown, No. V," *New York Evening Post*, October 24, 1863.
4. Ludlow, "Plain Talks.—No. 1," *Golden Era*, November 8, 1863.
5. Ludlow, "A Good-Bye Article," *Golden Era*, November 22, 1863.
6. Ludlow, "Seven Weeks in the Great Yo-Semite," *Atlantic Monthly*, June 1864.
7. Ludlow, "Plain Talks.—No. 1," *Golden Era*, November 8, 1863.
8. Ludlow, "A Good-Bye Article," *Golden Era*, November 22, 1863.
9. Ludlow, "Plain Talks.—No.2," *Golden Era*, December 20, 1863.
10. Ludlow, "Seven Weeks in the Great Yo-Semite," *Atlantic Monthly*, June 1864.
11. Ibid.
12. Bierstadt to John Hay, August 22, 1863, John Hay Collection, John Hay Library, Brown University, Providence, RI, quoted in Nancy K. Anderson and Linda S. Ferber, *Albert Bierstadt: Art & Enterprise* (Hudson Hills Press, New York, in association with the Brooklyn Museum, 1990), p. 178.
13. "Personal," New York Independent, May 23, 1867.
14. Barry Gray, "Hawksrest. The Home of Albert Bierstadt," *Home Journal*, dated 1871 by the keeper of the clippings album in the collection of Mrs. Orville DeForest Edwards, Dobbs Ferry, New York, quoted in Gordon Hendricks, *Albert Bierstadt: Painter of the American West* (New York: Harrison House/Harry N.Abrams, 1988), p. 172.
15. Reprinted in preface to John Ruskin, *Pre-Raphaelitism: Lectures on Architecture and Painting* (J.M. Dent & Co., London; E.P. Dutton & Co., New York, 1906).
16. "Personal," *New York Independent*, May 23, 1867.
17. *New York Day Book*, quoted by *Golden Era*, July 23, 1865.
18. *New York Leader*, quoted in Hugh Humphrey, "Art Criticism," *Golden Era*, July 30, 1865.
19. "Personal," *New York Independent*, May 23, 1867.

20. "Mr. Bierstadt's Last Work," *New York Evening Post*, May 7, 1867.
21. Clarence Cook, "Mr. Bierstadt's 'Domes of the Yo-Semite,'" *New York Tribune*, May 11, 1867.
22. "Letter from 'Mark Twain,'" *Alta California*, August 4, 1867.
23. "Living American Artists. No. III," *Scribner's Monthly*, March 1872.
24. Gene Hailey, ed., *California Art Research Monographs* (San Francisco: Works Progress Administration, 1937), 2:124.
25. Rosalie Osborne Mayer to Mrs. Ross Taggart, August 3, 1947, Museum of Fine Arts, Boston, quoted in Hendricks, *Albert Bierstadt*, p. 182.
26. *Morning Post* (London), July 10, 1868, quoted in Gerald Carr, "Albert Bierstadt, Big Trees, and the British: A Log of Many Anglo-American Ties," *Arts Magazine*, June/Summer 1986.
27. "Banquet at the Royal Academy," *Times* (London), May 3, 1869, quoted in Carr, "Albert Bierstadt, Big Trees, and the British."
28. *Art-Journal* (London), August 1868, quoted in Anderson and Ferber, *Albert Bierstadt: Art & Enterprise*, p. 208.
29. "Exhibition at the Royal Academy," *Times* (London), May 19, 1869, quoted in Carr, "Albert Bierstadt, Big Trees, and the British."
30. "Local Matters," *San Francisco Bulletin*, June 11, 1869.
31. "Local Art Items," *San Francisco Bulletin*, April 10, 1869.
32. "Local Matters," *San Francisco Bulletin*, June 11, 1869.
33. Susan Coolidge, "A Few Hints on the California Journey," *Scribner's Monthly*, May 1873.
34. Charles Nordhoff, "California. II.—What to See There, and How to See It," *Harper's New Monthly Magazine*, June 1872.
35. *San Francisco News Letter and California Advertiser*, September 4, 1869.

CHAPTER TWO
1. Elisabeth Margo, *Taming the Fortyniner* (New York: Rinehart V. Co., 1955), p. 34.
2. Ibid.
3. John Hittell, "Art in San Francisco," *Pacific Monthly*, July 1863.
4. C.H. Webb, "A Californian Caravansary," *Harper's New Monthly Magazine*, April 1867.
5. *North Pacific Review*, November 1862.
6. John P. Young, *San Francisco: A History of the Pacific Coast Metropolis* (San Francisco: S.J. Clarke Publishing Co., 1912), 1:465.
7. "City Items," *Alta California*, September 8, 1864.
8. Amelia Ransome Neville, *The Fantastic City: Memoirs of the Social and Romantic Life of Old San Francisco* (Boston: Houghton Mifflin, 1932) p. 95.
9. "Opening of the Mechanics' Fair," *San Francisco Bulletin*, August 11, 1865.
10. "Gigantic Statue of Lincoln," *Alta California*, July 20, 1865.
11. Bret Harte, "At the Fair," Californian, August 26, 1865.
12. "The California Art Union," *San Francisco News Letter and California Advertiser*, January 14, 1865.
13. "San Francisco Art Association," *Alta California*, March 27, 1872.
14. "The Art Union," *Alta California*, January 16, 1865
15. Ibid.
16. The California Art Union," *San Francisco News Letter and California Advertiser*,

January 14, 1865.

17. "Pictures," *Alta California*, February 16, 1871.

18. Caliban, "Art in San Francisco," *Alta California*, April 24, 1870.

19. "Art Union Prospects—New Pictures, etc.," *San Francisco Bulletin*, March 23, 1865.

20. Benjamin Champney, *Sixty Years' Memories of Art and Artists* (1900; reprint, with an introduction by H. Barbara Weinberg, New York: Garland Publishing Inc., 1977), pp. 145-146.

21. Mark Twain, "An Unbiased Criticism," *Californian*, March 18, 1865.

22. Ibid.

23. "San Francisco Art Association," *Alta California*, March 27, 1872; "The California Art Union," *San Francisco News Letter and California Advertiser*, January 14, 1865.

24. "Art in San Francisco," *San Francisco Bulletin*, March 29, 1871.

25. Benjamin Parke Avery, "Art in California," *Aldine*, April 1874.

26. "The Proposed Art Association," *Alta California*, March 28, 1871.

27. "San Francisco Art Association," *San Francisco Bulletin*, May 10, 1871.

28. "Opening of the New Art Rooms," *Alta California*, June 19, 1872.

29. "San Francisco Art Association," *San Francisco Bulletin*, May 10, 1871.

30. "A California Artist in New York," reprint from the *New York Times*, February 18, 1871, in *Alta California*, February 27, 1871.

31. "Etc.," *Overland Monthly*, October 1872.

32. "Painter and Palette," *San Francisco Chronicle*, April 22, 1877.

33. "Art Dottings," *San Francisco News Letter and California Advertiser*, December 20, 1873.

34. "Our Artists," *San Francisco News Letter and California Advertiser*, January 27, 1872.

35. *California Art Gallery*, April 1873.

36. "Etc.," *Overland Monthly*, November 1873.

37. "Art Notes," *San Francisco News Letter and California Advertiser*, May 23, 1874

38. "Art Notes," *San Francisco News Letter and California Advertiser*, November 8, 1873.

39. "Art Notes," *San Francisco News Letter and California Advertiser*, May 13, 1876.

40. "Art Notes," *Overland Monthly*, February 1874.

41. Ibid.

42. "Art Matters," *San Francisco Evening Post*, April 8, 1876.

43. "Art Notes," *San Francisco Chronicle*, October 8, 1876; "Art Jottings," *San Francisco News Letter and California Advertiser*, October 14, 1876.

44. "Art Notes," *San Francisco News Letter and California Advertiser*, January 3, 1874.

45. Fingal Buchanan, "The School of Design," *San Franciscan*, July 11, 1885.

46. Tremenheere L. Johns, "Art in California," *California Art Gallery*, January 1873.

47. John Ruskin, *Lectures on Art* (New York: Charles E. Merrill & Co., 1891), p. 107.

48. James Jackson Jarves, *Art Studies: The 'Old Masters' of Italy; Painting* (Derby and Jackson, New York; Sampson Low, Son and Co., London, 1861), pp. 8-9.

49. T.A. Barry, "Free Art Galleries," *California Art Gallery*, January 1873.

CHAPTER THREE

1. Edward Strahan, *The Fine Art of the International Exhibition*, vol. 1 of *The Masterpieces of the Centennial International Exhibition* (Philadelphia: Gebbie & Barrie, 1876; reprint, with an introduction by H. Barbara Weinberg, New York and London: Garland Publishing Inc., 1977), p. 290.

2. "Toby Rosenthal—How He Became a Painter," *Overland Monthly*, March 1875.

3. Toby E. Rosenthal, *Memoirs of a Painter*, trans. Marlene Rainman

(Northridge: Santa Susana Press, California State University, 1978), p. 147.
4. Thomas Mann, Glaudius Dei (1902), quoted in Maria Makela, *The Munich Secession: Art and Artists in Turn-of-the-Century Munich* (Princeton, NJ: Princeton University Press, 1990), p. 3.
5. Rosenthal, *Memoirs*, p. 167.
6. *Artists on Art*, compiled and edited by Robert Goldwater and Marco Treves (New York: Pantheon Books, 1972), pp. 216-217.
7. Ibid. p. 230.
8. Quoted in Gerald Needham, *19th Century Realist Art* (New York: Harper & Row, 1988), p. 137.
9. Quoted in H.W. Janson with Samuel Cauman, *History of Art for Young People* (New York: Harry N. Abrams, 1971), p. 304.
10. Rosenthal, *Memoirs*, p. 168.
11. E.P. Evans, "Artists and Art Life in Munich," *Cosmopolitan*, May 1890.
12. Rosenthal, *Memoirs*, p. 167.
13. S.G.W. Benjamin, "Contemporary Art in Germany," *Harper's New Monthly Magazine*, June 1877, pp. 7-8.
14. Matthew Baigell, *Dictionary of American Art* (New York: Harper & Row, 1982), p. 106.
15. Rosenthal, *Memoirs*, p. 168
16. "Famous Pictures Owned on the West Coast. III," *Overland Monthly*, March 1893.
17. "Affection's Last Offering," *San Francisco Call*, September 1, 1868.
18. Rosenthal, *Memoirs*, p. 198.
19. Ibid., p. 202.
20. "Toby Rosenthal," *San Francisco Chronicle*, January 9, 1879.
21. Ibid.
22. "Rosenthal's 'Elaine' — The True Story of Its Origin and Purchase," *San Francisco Chronicle*, April 1, 1875.
23. "Toby's Chef D'Oeuvre," *San Francisco Chronicle*, March 30, 1875.
24. "Elaine," *San Francisco Chronicle*, March 28, 1875.
25. "Toby Rosenthal," *San Francisco Call*, March 9, 1875.
26. "A Criticism on 'Elaine,'" *Alta California*, April 25, 1875.
27. Ibid.
28. "Tojetti's Elaine," *San Francisco Chronicle*, June 4, 1876.
29. "Elaine," *San Francisco Chronicle*, March 28, 1875.
30. "A Criticism on Elaine," *San Francisco Alta*, April 25, 1875; "Elaine," *San Francisco Chronicle*, March 28, 1875.
31. "Farewell, Sweet Sister," *San Francisco Chronicle*, March 28, 1875.
32. "The Picture Found," *San Francisco Chronicle*, April 5, 1875.
33. Ibid.
34. Rosenthal, *Memoirs*, p. 206.
35. "Art Jottings," *San Francisco News Letter and California Advertiser*, July 29, 1876.
36. "Art Jottings," *San Francisco News Letter and California Advertiser*, July 22, 1876; "Art Matters," *San Francisco Evening Post*, April 8, 1876.
37. "Tojetti's Elaine," *San Francisco Chronicle*, June 4, 1876
38. Ibid.

CHAPTER FOUR

1. Robert Nichols Ewing, "Jules Tavernier (1844-1889): Painter and Illustrator" (Ph.D. diss., University of California, Los Angeles, 1978), p.10; Betty Lochrie Hoag, "Jules Tavernier: Monterey's 'Knight of the Palette'" (master's thesis, University of Southern California, Los Angeles, 1967), p.5.
2. *Aldine*, November 1872.
3. Arthur McEwen, "Tavernier, the Painter," *Sacramento Bee*, July 3, 1885.
4. "Indian Sun Dance," *Harper's Weekly*, January 2, 1875.
5. Robert H. Fletcher, *Annals of the Bohemian Club*, 1872-1880 (San Francisco: Press of the Hicks-Judd Co., n.d.), p. 36.
6. Arthur McEwen, "Tavernier, the Painter," *Sacramento Bee*, July 3, 1885; "Arthur McEwen Discourses Delightfully of Art and Politics," *Los Angeles Evening Express*, November 15, 1890.
7. Arthur McEwen, "Tavernier, the Painter," *Sacramento Bee*, July 3, 1885.
8. As told by Jerome A. Hart, "Tavernier, Artiste-Peintre," *Argonaut*, March 2, 1907.
9. Ibid.
10. Deejay Mackart, "Monterey," *San Francisco Call*, July 10, 1892.
11. "In a Tropical Prison," *San Francisco Examiner*, January 22, 1888.
12. Charles W. Stoddard, *In the Footprints of the Padres* (San Francisco: A.M. Robertson, 1912) pp. 180-181.
13. Isobel Strong, *This Life I've Loved* (New York: Longmans, Green and Co., 1937) p. 116.
14. Fred M. Somers, "A Bohemian Revel," *Argonaut*, October 15, 1878.
15. "Painter and Palette," *San Francisco Chronicle*, April 22, 1877.
16. Deejay Mackart, "Monterey," *San Francisco Call*, July 10, 1892.
17. Stoddard, *In the Footprints of the Padres*, p. 164.
18. Fred M. Somers, "A Bohemian Revel."
19. Stoddard, p. 182.
20. Somers, "A Bohemian Revel."
21. Stoddard, pp.182–183
22. *Monterey Californian*, March 26, 1878.
23. "Art Notes," *San Francisco Chronicle*, October 13, 1878.
24. Gene Hailey, ed., *California Art Research Monographs* (San Francisco: Works Progress Administration, 1937), 4:9.
25. E.B., "Cow-County Art," *Argonaut*, February 2, 1878.
26. *California Art Research Monographs*, 4:9
27. "Tavernier's Last Picture," *Monterey Californian*, January 15, 1878.
28. "Art Notes—New Pictures," *San Francisco Bulletin*, June 5, 1876.
29. "Art Jottings," *San Francisco News Letter and California Advertiser*, November 4, 1876.
30. "Art Matters," *San Francisco Evening Post*, November 11, 1876.
31. "Art Items," *Alta California*, December 12, 1876.
32. "Our Local Artists," *San Francisco Chronicle*, December 11, 1876.
33. "Art Jottings," *San Francisco News Letter and California Advertiser*, December 9, 1876.
34. "Art Notes," *San Francisco Chronicle*, December 8, 1878.
35. "Bohemia," *Alta California*, January 27, 1879.
36. Ella Sterling Cummins, "Art in California," *Golden Era*, October 1885.
37. Strong, *This Life I've Loved*, p. 78.

38. "Art and Artists," *San Francisco Chronicle*, July 20, 1879.
39. "Bohemia," *Alta California*, January 27, 1879.
40. "Art and Artists," *San Francisco Chronicle*, July 20, 1879.
41. Robert Louis Stevenson, *Silverado Squatters*, (printed for the Silverado Museum, St. Helena, CA, by Lewis Osborne, Ashland, Oregon, 1974) p. 88.
42. Charles W. Stoddard, *Exits and Entrances* (Boston: Lothrop, 1903) p. 14.
43. Strong, *This Life I've Loved*, pp. 139-142
44. Ibid. p. 144.
45. Oscar Cargill, *Intellectual America: Ideas on the March* (New York: Macmillan Co., 1948), pp. 434-435.
46. "American Barbarism," *San Francisco Chronicle*, March 30, 1882.
47. "Oscar Wilde," *Alta California*, April 6, 1882.
48. "The Renaissance," *San Francisco Chronicle*, March 28, 1882.
49. "Wilde's Wisdom," *San Francisco Call*, March 28, 1882.
50. "Oscar Wilde," *Alta California*, April 6, 1882.
51. "Virgil Williams' Art Notes to a Deaf-Mute Pupil," *Overland Monthly*, March 1887.
52. "Oscar Wilde," *San Francisco Examiner*, April 11, 1882.
53. *California Art Research Monographs*, 10:101.
54. The description of the tea party is based on Strong, *This Life I've Loved*, pp. 145-149.
55. "Art and Artists," *Californian*, September 1881.
56. "Pencil and Palette," *San Francisco Chronicle*, November 29, 1885.

CHAPTER FIVE

1. "Thomas Hill, Artist," *Argonaut*, December 12, 1908.
2. "Painter and Palette," *San Francisco Chronicle*, April 22, 1877.
3. S.G.W. Benjamin, "Fifty Years of American Art, 1828-1878," *Harper's New Monthly Magazine*, October 1879.
4. Amelia Ransome Neville, *The Fantastic City: Memoirs of the Social and Romantic Life of Old San Francisco* (Boston: Houghton Mifflin, 1932), p. 202.
5. George H. Fitch, "Millionaires of the Pacific Coast," *Cosmopolitan*, September 1887.
6. "Heart of the Sierra," *San Francisco Bulletin*, January 25, 1875.
7. "Art Notes," *Overland Monthly*, March 1875.
8. "Pen Portraits," *San Francisco Evening Post*, April 14, 1877.
9. Thomas Hill, *History of the "Spike Picture" and Why It Is Still in My Possession* (San Francisco: R.R. Hill, Book and Job Printer, n.d.).
10. "Facts Gathered from the Lips of Charles Crocker, Regarding His Identification with the Central Pacific Railroad, and Other Roads Growing out of It," typescript, 1888, in Crocker Manuscripts (BANC MSS C-D 764), Bancroft Library, University of California, Berkeley, pp. 49-50.
11. "Journal Kept by Captain John Charles Currier of the 21st Infantry U.S.A.," *Golden Notes*, April 1969 (Golden Spike Centennial Edition).
12. Thomas Hill, *The Last Spike—a Painting by Thomas Hill Illustrating the Last Scene in the Building of the Overland Railroad, with a History of the Enterprise* (San Francisco, 1881).
13. "Journal Kept by Captain John Charles Currier of the 21st Infantry U.S.A."
14. Thomas Hill, *The Last Spike*.

15. Thomas Hill, *History of the "Spike Picture."*
16. "Art Jottings," *San Francisco News Letter and California Advertiser*, May 22, 1875.
17. Ibid.
18. Thomas Hill, *History of the "Spike Picture."*
19. "Art Jottings," *San Francisco News Letter and California Advertiser*, January 22, 1876.
20. "Art in San Francisco," *San Francisco Bulletin*, February 19, 1876.
21. Clara Erskine Clement and Laurence Hutton, *Artists of the Nineteenth Century and Their Work* (c. 1884; reprint, Saint Louis: North Point, Inc., 1969), 1:357; Peter C. Marzio, *The Democratic Art* (Boston: David R. Godine, 1979), p. 112.
22. Thomas Hill, *History of the "Spike Picture."*
23. "Facts Gathered from the Lips of Charles Crocker," p. 33.
24. Thomas Hill, *The Last Spike — A Painting by Thomas Hill.*
25. Quoted in Oscar Lewis, *The Big Four* (1938; reprint, Sausalito, CA: Comstock Editions, 1971), p.152.
26. "Art and Artists," *Californian*, March 1881.
27. "The Last Spike," *San Francisco Chronicle*, January 29, 1881.
28. "The Last Spike," *Alta California*, January 29, 1881.
29. Thomas Hill, *History of the "Spike Picture."*
30. Ibid.
31. "Hill's 'Last Spike'—Historical Inaccuracies—Humors and Minor Incidents," *San Francisco News Letter and California Advertiser*, February 12, 1881.
32. George T. Clark, *Leland Stanford—War Governor of California* (Palo Alto, CA: Stanford University Press, 1931), pp. 274-275.
33. Thomas Hill to Henry C. Peterson, September 11, 1905, courtesy of the California History Room, California State Library, Sacramento.
34. Hubert Howe Bancroft, *Retrospection, Political and Personal* (New York: The Bancroft Co., 1912), p. 147.
35. William Henry Bishop, "San Francisco," *Harper's New Monthly Magazine*, May 1883.
36. "Stocks," *San Francisco News Letter and California Advertiser*, October 18, 1884.

CHAPTER SIX

1. "Hindrances to Art Progress," *New York Times*, March 15, 1879.
2. "San Francisco Art," *San Francisco Examiner*, November 28, 1880.
3. "Private Collections of Pictures," *New York Times*, February 26, 1879.
4. "Hindrances to Art Progress," *New York Times*, March 15, 1879.
5. "Peculiar Pictures," *San Francisco Chronicle*, August 7, 1881.
6. "Old Masters at the Fair," *San Francisco News Letter and California Advertiser*, September 3, 1881.
7. "Artful Art," *San Francisco Chronicle*, August 14, 1881.
8. "Cheap Pictures," *San Francisco Call*, February 6, 1874.
9. "Art Notes and Summary," *San Francisco Bulletin*, March 25, 1878.
10. "Art Jottings," *San Francisco News Letter and California Advertiser*, March 25, 1876.
11. "The Keith Sale," *San Francisco Call*, December 12, 1874.
12. "Art Jottings," *San Francisco News Letter and California Advertiser*, April 8, 1876.
13. "Hill's Pictures," *San Francisco Examiner*, April 19, 1877.
14. "Sale of Hill's Paintings," *Alta California*, April 19, 1877.
15. "Art Jottings," *San Francisco News Letter and California Advertiser*, May 5, 1877.

16. "Art Jottings," *San Francisco News Letter and California Advertiser*, May 12, 1877.
17. "Art Jottings," *San Francisco News Letter and California Advertiser*, May 19, 1877.
18. "Art Notes—New Pictures," *San Francisco Bulletin*, May 12, 1877.
19. "Art Notes," *San Francisco Chronicle*, May 13, 1877.
20. "Art Jottings," *San Francisco News Letter and California Advertiser*, February 22, 1879.
21. "Art Jottings," *San Francisco News Letter and California Advertiser*, April 12, 1879.
22. "Art Jottings," *San Francisco News Letter and California Advertiser*, February 22, 1879, and March 1, 1879.
23. "Art Jottings," *San Francisco News Letter and California Advertiser*, March 1, 1879.
24. From the *New York Evening Post*, quoted in "Cheap Pictures," *San Francisco Call*, June 19, 1881.
25. "Private Collections of Pictures," *New York Times*, February 26, 1879.
26. "A Plea for Cheap Oil Paintings by Local Artists," *San Francisco Chronicle*, July 10, 1881.
27. Henry S. Brooks, "The Pot-Boiler in Art," *Overland Monthly*, June 1884.
28. Will H. Low and Robert Louis Stevenson, "A Letter to a Young Gentleman Who Proposes to Embrace the Career of Art," *Scribner's Magazine*, September 1888.
29. Ibid.
30. "Color-Mixers," *San Francisco Chronicle*, January 9, 1881.
31. Ibid.
32. "The Looker-On," *San Francisco News Letter and California Advertiser*, January 30, 1892.

CHAPTER SEVEN

1. "The Art World," *San Francisco Evening Post*, April 19, 1881.
2. "San Francisco Art," *San Francisco Examiner*, March 22, 1881.
3. "San Francisco's Salon," *Argonaut*, March 26, 1881.
4. "Artists' Reunion," *San Francisco Evening Post*, March 22, 1881.
5. "San Francisco Art," *San Francisco Examiner*, March 22, 1881.
6. "Pencil and Brush," *San Francisco Chronicle*, March 23, 1881.
7. "San Francisco's Salon," *Argonaut*, March 26, 1881.
8. "Pencil and Brush," *San Francisco Chronicle*, March 23, 1881.
9. "San Francisco Art," *San Francisco Examiner*, March 22, 1881.
10. "The Art Association," *Alta California*, March 23, 1881.
11. Ibid.
12. "Art Notes," *San Francisco Chronicle*, March 6, 1881.
13. "Pencil and Brush," *San Francisco Chronicle*, March 23, 1881.
14. "Art and Artists," *Californian*, May 1882.
15. "San Francisco Art," *San Francisco Examiner*, March 27, 1881.
16. "Art and Artists," *Californian*, May 1881.
17. "Pencil and Brush, *San Francisco Chronicle*, March 23, 1881.
18. "Art and Artists," *Californian*, June 1881.
19. "Art and the Artist," *San Francisco Chronicle*, April 3, 1881.
20. "The Art World," *San Francisco Evening Post*, April 23, 1881.
21. "The Rejected," *San Francisco News Letter and California Advertiser*, April 23, 1881.
22. "Spring Exhibition of Local Art," *San Francisco Bulletin*, April 24, 1882.
23. "The Rejected," *San Francisco News Letter and California Advertiser*, April 23, 1881.

24. "The Art World," *San Francisco Evening Post*, April 2, 1881.
25. "The Rejected," *San Francisco News Letter and California Advertiser*, April 23, 1881.
26. "The Art World," *San Francisco Evening Post*, April 2, 1881.
27. "Art and Artists," *Californian*, June 1881.
28. Fingal Buchanan, "Art Notes," *San Franciscan*, October 31, 1885.
29. "Miles o' Picters," *Wasp*, February 10, 1883.
30. Charles S. Greene, "California Artists," *Overland Monthly*, January 1896.
31. "California Palette Club," *San Francisco Call*, January 31, 1884.
32. "Angered Artists," *San Francisco Chronicle*, January 31, 1884.
33. "California Palette Club," *San Francisco Call*, January 31, 1884.
34. "The Artists," *San Franciscan*, August 23, 1884.
35. "The Painters," *San Franciscan*, May 3, 1884.
36. "Local Art," *San Francisco Evening Post*, August 23, 1884.
37. "The Painters," *San Franciscan*, May 3, 1884.
38. Ibid.
39. "San Francisco Art Association," *Wasp*, May 10, 1884.
40. "The Painters," *San Franciscan*, May 17, 1884.
41. "The Palette Club Exhibition," *San Francisco News Letter and California Advertiser*, May 24, 1884.
42. "Palette Club," *Wasp*, May 17, 1884.
43. "Local Art," *San Francisco Evening Post*, June 23, 1884.
44. "Local Art," *San Francisco Evening Post*, August 16, 1884.
45. "Local Art," *San Francisco Evening Post*, August 23, 1884.
46. "The Artists," *San Franciscan*, August 23, 1884.
47. "Tavernier Off for Honolulu," *San Francisco Call*, December 16, 1884.
48. "The Artists," *San Franciscan*, March 21, 1885.
49. "Art Notes," *Argonaut*, May 16, 1885.
50. "Art and Nature," *San Franciscan*, May 16, 1885.
51. Richard H. McDonald, Jr., "The City of San Francisco," *Californian*, August 1892.
52. William Henry Bishop, "San Francisco," *Harper's New Monthly Magazine*, May 1883.
53. "Painter and Palette," *San Francisco Chronicle*, November 1, 1885.
54. "Local Art," *San Francisco Evening Post*, August 16, 1884.
55. "Painter and Palette," *San Francisco Chronicle*, November 1, 1885.
56. "Flower Painting," *San Francisco Chronicle*, December 20, 1885.
57. Flora Haines Apponyi, "Art Notes," *San Franciscan*, December 26, 1885; "Flower Painting," *San Francisco Chronicle*, December 20, 1885.
58. "Flower Painting, *San Francisco Chronicle*, December 20, 1885; Justus, "The Lady Artists," *San Francisco News Letter and California Advertiser*, January 2, 1886.
59. "Flower Painting, *San Francisco Chronicle*, December 20, 1885.
60. Ibid.
61. Flora Haines Apponyi, "Art Notes," *San Franciscan*, December 26, 1885.
62. Fingal Buchanan, "Art Notes," *San Franciscan*, November 21, 1885; "The Exhibition," *San Francisco Evening Post*, December 17, 1885.
63. "Flower Painting," *San Francisco Chronicle*, December 20, 1885.
64. "Pencil and Palette," *San Francisco Chronicle*, November 29, 1885.
65. Fingal Buchanan, "Art Notes," *San Franciscan*, November 28, 1885.

CHAPTER EIGHT

1. Sam Hunter, *Modern French Painting: Fifty Artists from Manet to Picasso* (New York, Dell Publishing Co., 1956), p. 62.
2. Oscar Cargill, Intellectual America: Ideas on the March (New York: The Macmillan Company, 1948), pp. 421–424.
3. "Flinging Paint in the Public's Face," *New York Times*, December 15, 1878.
4. Theophilus d'Estrella, "Virgil Williams' Art Notes to a Deaf-Mute Pupil," *Overland Monthly*, March 1887.
5. Ibid.
6. Newlin Price, "Emil Carlsen—Painter, Teacher," *International Studio*, July 1922; Duncan Phillips, "Emil Carlsen," *International Studio*, June 1917.
7. "Lecture on 'Realism in the Art of the Netherlands,'" undated and unidentified newspaper clipping, Alice Chittenden Papers, Archives of American Art, Smithsonian Institution, microfilm reel 919; "Realism in Art," *San Francisco Examiner*, March 29, 1888.
8. "Flying from the Philistines," *San Francisco Examiner*, September 27, 1891.
9. "What is Art," *San Francisco Chronicle*, April 11, 1886.
10. "Art in California," *Golden Era*, July 1885.
11. "Studio Corners," *San Francisco Examiner*, January 29, 1888.
12. "Peeps into Bohemia," *San Francisco Chronicle*, July 10, 1881.
13. "Art Notes," *San Franciscan*, January 23, 1886.
14. Unidentified newspaper clipping in the archives of the California Historical Society, dated July 12, 1879; also see Laurence Binyon's introduction to John Ruskin, *Pre-Raphaelitism: Lectures on Architecture & Painting* (J. M. Dent & Co., London; E.P. Dutton & Co., New York, 1906).
15. "An Artist's Hand," *San Francisco Call*, March 25, 1883.
16. Quoted in "Art in California," *Golden Era*, July 1885.
17. "Art in California," *Golden Era*, July 1885.
18. "Studio Corners," *San Francisco Examiner*, January 29, 1888.
19. "Hill's Last Pictures," *Californian*, March 1882.
20. Theodora Guest, *A Round Trip in North America* (London: Edward Stanford, 1895), p. 141.
21. "Local Art," *San Francisco Evening Post*, June 21, 1884; "California Painters in Yosemite Valley," *San Francisco Chronicle*, October 8, 1899.
22. "Rare Works of Art," *San Francisco Chronicle*, June 7, 1885.
23. "Art Jottings," *San Francisco News Letter and California Advertiser*, February 17, 1877.
24. "Fine Arts," *San Francisco Evening Post*, February 10, 1877.
25. "Art Notes," *San Francisco Chronicle*, May 31, 1885.
26. "Brush and Palette Out of Doors," *San Francisco Call*, September 2, 1894.
27. "Spring Pictures," *San Francisco Call*, March 17, 1894.
28. "On American Art," *San Francisco Call*, December 1, 1893.
29. Diary notes from Thomas Hill's Bank of America passbook, 1893, Archives of the Oakland Museum of California.
30. Diary notes from Thomas Hill's Bank of America passbook, 1893, quoted in Marjorie Dakin Arkelian, *Thomas Hill: The Grand View* (Oakland, CA: The Oakland Museum Art Department, 1980), p. 36.
31. Thomas Virgil Troyon Hill, "Remarks in Father's Letters to Me," n.d., quoted in

Arkelian, *Thomas Hill: The Grand View*, p. 36.

32. Bruce Porter, "The Beginning of Art in California," *Art in California* (San Francisco: R.L. Bernier, 1916), p. 30.
33. "Hill's Yosemite," *San Francisco Call*, May 28, 1893.
34. Thomas Albright, "Thomas Hill: The Grand View," *San Francisco Chronicle*, October 5, 1980
35. *Wasp*, February 9, 1907.
36. "Art Notes," *Overland Monthly*, May 1875.
37. "The Art Exhibition Again," *Alta California*, March 9, 1879.
38. "Traveling Companions," *San Francisco Call*, June 13, 1897.
39. Letter, July 27, 1884, from Willam Keith to Joseph Worcester, in Keith Miscellanea (BANC MSS C-B 595), Bancroft Library, University of California, Berkeley.
40. Quoted in Brother Cornelius, Keith, *Old Master of California* (New York: Putnam, 1942), I:141-142.
41. Letters, July 13, 1884, and December 9, 1883, from William Keith to Joseph Worcester, in Keith Miscellanea.
42. Letter to Theodore Wores, January 30, 1884, quoted in Cornelius, *Keith, Old Master of California*, I:133.
43. Letter to Worcester, February 24, 1884, quoted in Eugen Neuhaus, *William Keith, the Man and the Artist* (Berkeley: University of California Press, 1938), p. 28.
44. Letter to Brother Cornelius from Mrs. Charles F. Pond, February 2, 1881, quoted in Cornelius, *Keith, Old Master of California*, I:173.
45. "Pencil and Palette," *San Francisco Chronicle*, November 15, 1885.
46. "Pencil and Palette," *San Francisco Chronicle*, September 20, 1885.
47. Cornelius, *Keith, Old Master of California*, I:208.
48. *Wave*, May 6, 1893.
49. The story is told in "William Keith, 'Artist Laureate' of California Scenery," *Stockton Daily Evening Record*, May 29, 1924; Eugen Neuhaus, *The History and Ideals of American Art* (Palo Alto, CA: Stanford University Press, 1931), p. 100; Neuhaus, *William Keith, the Man and the Artist*, p. 57; Cornelius, *Keith, Old Master of California*, 1:216-217.
50. Henry Atkins, "William Keith, Landscape Painter of California," *International Studio*, November 1907.
51. Samuel H. Monk, *The Sublime: A Study of Critical Theories in XVIII-Century England* (Ann Arbor: University of Michigan Press, 1960), p. 204.
52. Note to Worcester, April 9, 1891, quoted in Cornelius, *Keith, Old Master of California*, I:216.

CHAPTER NINE

1. Quoted in Donald Martin Reynolds, *The Nineteenth Century* (Cambridge and New York: Cambridge University Press, 1985), p. 51.
2. "Studio Notes, *California Spirit of the Times and Underwriters' Journal*, January 5, 1878.
3. "Art Jottings," *San Francisco News Letter and California Advertiser*, October 6, 1877.
4. "Tojetti's 'Venus and Cupid,'" *Alta California*, October 3, 1877.
5. "Mechanics' Fair Exhibition," *Californian*, October 1880.
6. "Nudity at the Fair," *Wave*, September 5, 1891.

7. "About Certain Pictures," *San Francisco Bulletin*, August 21, 1880.
8. "Art Jottings," *San Francisco News Letter and California Advertiser*, September 4, 1880.
9. "The Abused Picture to Remain," *San Francisco Chronicle*, August 29, 1880.
10. "The Nude Must Go," *San Francisco Morning Call*, January 5, 1893.
11. Ibid.
12. "The Venus Must Be Draped," *San Francisco Examiner*, February 23, 1893.
13. Ibid.
14. "Venus before the Camera," *San Francisco Examiner*, March 1, 1893.
15. "The Venus de California," *San Francisco Examiner*, February 22, 1893.
16. "The Artists and the Venus," *San Francisco Examiner*, February 24, 1893.
17. Ibid.
18. "The Ideal Venus," *San Francisco Examiner*, February 24, 1993.
19. "Round Woman and the Large Artistic Waist," *San Francisco Examiner*, March 24, 1895.
20. "We've a Venus," *San Francisco Morning Call*, May 3, 1893.
21. "Who's Our Venus?" *San Francisco Morning Call*, February 22, 1893.
22. "In Sorrow, Not in Anger," *San Francisco Examiner*, May 13, 1894.
23. "An Idol of the Ladies," *San Francisco Examiner*, January 14, 1894.
24. "Posed for the Ladies," *San Francisco Chronicle*, May 17, 1894.
25. "Muscle and Art," *San Francisco Morning Call*, May 17, 1894.
26. "Posed for the Ladies," *San Francisco Chronicle*, May 17, 1894.
27. *Wave*, May 19, 1894.
28. "Posed for the Ladies," *San Francisco Chronicle*, May 17, 1894.
29. "Art Jottings," *San Francisco News Letter and California Advertiser*, January 26, 1895.
30. "Living Bronze—Or Brass," *San Francisco Examiner*, April 14, 1895.
31. "The Bill Is Too Sweeping," *New York Times*, March 27, 1895.
32. "Living Bronze—Or Brass," *San Francisco Examiner*, April 14, 1895.
33. "Artist W.M. Chase a Witness," *New York Times*, March 27, 1895.
34. Kenyon Cox, "The Nude in Art," *Scribner's Magazine*, December 1892.
35. Samuel Isham, *The History of American Painting*, new edition with supplemental chapters by Royal Cortissoz (New York: Macmillan, 1936), p. 468.
36. Charles H. Caffin, *The Story of American Painting*, De Luxe Edition (Garden City, NY: Garden City Publishing Co., Inc., 1937), pp. 166-168.

CHAPTER TEN

1. Alice Rix, "She Who Would Be a Bohemian," *San Francisco Examiner*, January 19, 1896
2. John Hutton, "Picking Fruit: Mary Cassatt's *Modern Woman* and the Woman's Building of 1893," *Feminist Studies* 20, No. 2 (Summer 1994).
3. Mary Cassatt to Bertha Palmer, October 11, 1892; reprinted in *Cassatt and Her Circle: Selected Letters*, ed. Nancy Mowll Mathews (New York: Abbeville Press, 1984), pp. 237-238.
4. Emil Carlsen, "The Female Art Student," *San Francisco Examiner*, July 19, 1891.
5. Di Vernon, "Snap Shots," unidentified newspaper clipping, dated 1891, Alice Chittenden Papers, Archives of American Art, Smithsonian Institution, microfilm reel 919.
6. Pamphlet published by the Boston Art Students Association, 1887, quoted in

Jo Ann Wein, "The Parisian Training of American Women Artists," *Woman's Art Journal* 2, No. 1 (Spring-Summer 1981): 42.

7. *New York Times*, October 12, 1890.
8. *Wave*, January 19, 1995.
9. *San Franciscan*, May 30, 1885.
10. Ella Sterling Cummins, "Art in California," *Golden Era*, October 1885.
11. "Art Notes," *San Francisco Chronicle*, April 15, 1883.
12. Autobiographical sketch by Elizabeth Strong (BANC MSS C-H 171), Bancroft Library, University of California, Berkeley.
13. *Morning News* (Paris), quoted in "The Artists," *Argonaut*, April 25, 1885.
14. "Art Notes," *San Franciscan*, December 19, 1885.
15. "Features of the Ladies' Art Exhibition," *San Francisco Chronicle*, December 20, 1885.
16. "Art Notes," *San Franciscan*, December 19, 1885.
17. *Wave*, March 16, 1895.
18. "Miss E. Strong Returns Home," *San Francisco Call*, June 12, 1896.
19. Ibid.
20. *Morning News* (Paris), quoted in "The Artists," *Argonaut*, April 25, 1885.
21. "Miss E. Strong Returns Home," *San Francisco Call*, June 12, 1896.
22. "Among Artists," *Wasp*, August 8, 1885.
23. George Wharton James, "Evelyn Almond Withrow, Painter of the Spirit," *National Magazine*, August 1916.
24. Pierre N. Boeringer, "Original Sketches by San Francisco Painters. 1. Miss Eva Withrow," *Overland Monthly*, February 1896.
25. "Art Notes," *Argonaut*, December 10, 1887.
26. Sophia P. Comstock, "Painters of Northern California," lecture given before the Kingsley Art Club, Sacramento, March 15, 1909, courtesy of the California History Room, California State Library, Sacramento; "Art Notes," *Argonaut*, December 10, 1887.
27. Letter from William Vickery to William Macbeth, April 2, 1892, Alice Chittenden Papers, Archives of American Art, Smithsonian Institution, microfilm reel 919.
28. "What Two Californians Have Accomplished in London," *San Francisco Chronicle*, September 15, 1901.
29. "Some Celebrated People Visited by Eva Withrow," *San Francisco Evening Post*, January 8, 1898.
30. "Withrow Oil Display Will Be March Event," *San Francisco Call*, February 12, 1911.
31. "What Two Californians Have Accomplished in London," *San Francisco Chronicle*, September 15, 1901.
32. George Wharton James, "Evelyn Almond Withrow, Painter of the Spirit."
33. "What Two Californians Have Accomplished in London," *San Francisco Chronicle*, September 15, 1901.
34. Letter, September 15, 1888, from Julie Heyneman to her sister, in Julie H. Heyneman papers (BANC MSS C-H 152), Bancroft Library, University of California, Berkeley.
35. Letter, October 13, 1888, from Julie Heyneman to her sister, in Julie H. Heyneman papers.
36. Letter from "R.S." to J.L. Claghorn, President of the Pennsylvania Academy, April 11, 1882, in Sylvan Schendler, *Eakins* (Boston and Toronto: Little, Brown

and Co., 1967), p.92.

37. Letter, September 15, 1888, from Julie Heyneman to her sister, in Julie H. Heyneman papers.

38. Letter, September 20, 1888, from Julie Heyneman to her sister, in Julie H. Heyneman papers.

39. Julie Heyneman, "Tite Street and around the Corner," manuscript begun in 1941, in Julie H. Heyneman papers, p. 12.

40. Ibid., p. 14.

41. The Hon. Evan Charteris, K.C., *John Sargent* (1927; reprint, New York: Benjamin Blom Inc., 1972), p.181.

42. Note from John Singer Sargent to Julie Heyneman, July 1, 1901, Julie H. Heyneman papers.

43. Letter, July 11, 1892, from Julie Heyneman to Arthur Mathews, in Julie H. Heyneman papers.

44. "Brains and Culture Find Proper Altitude," *San Francisco Call*, April 3, 1909.

45. "Some California Paintings," *California Weekly*, May 28, 1909.

46. "Notes of the Studio," *San Francisco Chronicle*, June 4, 1906.

47. "Pupil of Sargent Exhibits Pictures," *San Francisco Call*, April 19, 1908.

48. Letter, June 24, 1892, from Julie Heyneman to her mother, in Julie H. Heyneman papers.

49. Ninetta Eames, "The California Indian on Canvas," *Frank Leslie's Popular Monthly*, April 1897.

50. Ibid.

51. Ibid.

52. "Pictures in the Art Gallery," *San Francisco Call*, January 23, 1893.

53. "Finds Art in the Digger," *San Francisco Examiner*, April 21, 1895.

54. Sobanichi, "Some Good Indians," *Western Field*, September 1902.

55. Eames, "The California Indian on Canvas."

56. "Little Indian Trilbies," *San Francisco Call*, October 27, 1895.

57. Searles R. Boynton, *The Painter Lady: Grace Carpenter Hudson* (Eureka: Interface California Corporation, 1977), p. 55.

58. Ibid., p. 56

59. Ibid.

60. The Grace Hudson Museum, City of Ukiah, Accession #4336–4590.

61. Sobanichi, "Some Good Indians."

62. Ibid.

63. *New York Journal*, February 19, 1896, quoted in Boynton, *The Painter Lady*, p. 44.

CHAPTER ELEVEN

1. Emily Carr, *Growing Pains* (Toronto: Oxford University Press, 1946), p. 86.

2. "Many Mansions East and West," *San Francisco Call*, August 9, 1891.

3. Amelia Ransome Neville, *The Fantastic City: Memoirs of the Social and Romantic Life of Old San Francisco* (Boston: Houghton Mifflin, 1932), p. 179.

4. Gertrude Atherton, "Woman in Her Variety," *San Francisco Examiner*, August 9, 1891.

5. "Many Mansions East and West," *San Francisco Call*, August 9, 1891.

6. "Hopkins Institute of Art," *San Francisco Examiner*, March 5, 1893.

7. *Wave*, June 3, 1893.
8. "The Association Has Gone to Nob Hill," *San Francisco Call*, April 23, 1893.
9. "The Mardi Gras Ball," *Wave*, March 3, 1900.
10. "The Mardi Gras Ball," *San Francisco Examiner*, March 8, 1889.
11. Harriet Lane Levy, "Art Critics' Guide," *Wave*, March 28, 1891.
12. Kate Montague Hall, "The Mark Hopkins Institute of Art," *Overland Monthly*, December 1897.
13. Ibid.
14. Eleanor Warren, "Art in a Great House," *San Francisco Chronicle*, November 2, 1893.
15. Emily Carr, *Growing Pains*, p. 61.
16. "Some Models of the Studio Quarter," *San Francisco Chronicle*, September 27, 1903.
17. "Adieu to Corinne," *San Francisco Chronicle*, March 10, 1895.
18. Annette Rosenshine, "Life's Not a Paragraph," typescript (BANC MSS 68/154 C film), Bancroft Library, University of California, Berkeley, p. 32.
19. Quoted in Harvey L. Jones, *Mathews: Masterpieces of the California Decorative Style* (Layton, UT: Gibbs M. Smith, Inc., Peregrine Smith Books in association with the Oakland Museum, 1985), p. 46.
20. *Wave*, December 15, 1894.
21. Quoted in Jones, *Mathews*, p. 46.
22. Arthur F. Mathews, "Mural Painting, or Painting as a Fine Art," *Philopolis*, November 25, 1907.
23. Laura Bride Powers, "Chance for Improvement in Art School," *San Francisco Call*, December 10, 1905.
24. "An Exhibition of Daubs," *Town Talk*, May 24, 1902.
25. "In Deutschland," *San Francisco Call*, August 6, 1893.
26. Arthur F. Mathews, "In the Fine-Arts Building," *Californian*, March 1894.
27. Frank Norris, "An Art Student," *Wave*, May 16, 1896.

CHAPTER TWELVE

1. H. Harvard Arnason, *History of Modern Art*, 2d ed. (Englewood Cliffs, NJ: Prentice-Hall; New York: Harry N. Abrams, 1978), p. 50.
2. Barbara Novak, *American Painting of the Nineteenth Century: Realism, Idealism, and the American Experience*, 2d ed. (New York: Harper & Row, 1979), pp. 238, 263.
3. *San Francisco Call*, quoted in Lewis Ferbraché, *Theodore Wores, Artist in Search of the Picturesque* (Alameda, CA: n.p., 1968), p. 15.
4. "A Chinese Concert," *San Francisco News Letter and Californiia Advertiser*, April 5, 1884.
5. Letter quoted in "Art and Artists," *San Francisco Chronicle*, June 14, 1885.
6. Oscar Wilde, "London Day by Day," *London Telegraph*, April 12, 1889, quoted in Ferbraché, *Theodore Wores*, p. 29.
7. "Wanderers from Home," *San Francisco Examiner*, May 18, 1890.
8. *Land and Water* (London), June 29, 1890, Theodore Wores papers, Archives of American Art, Smithsonian Institution, microfilm reel 691.
9. "Art in London," *Echo* (London), September 16, 1890, Theodore Wores papers, Archives of American Art, Smithsonian Institution, microfilm reel 691.
10. *Star* (London), July 1, 1890, Theodore Wores papers, Archives of American Art,

Smithsonian Institution, microfilm reel 691.

11. *Star* (London), July 9, 1890, Theodore Wores papers, Archives of American Art, Smithsonian Institution, microfilm reel 691.

12. *Echo* (London), July 8, 1890, Theodore Wores papers, Archives of American Art, Smithsonian Institution, microfilm reel 691.

13. Gene Hailey, ed., *California Art Research Monographs* (San Francisco: Works Progress Administration, 1937), 10:118.

14. *Wave*, October 3, 1891.

15. "Town Crier," *San Francisco News Letter and California Advertiser*, March 19, 1892.

16. "Art and Artists," *San Francisco Chronicle*, September 22, 1889.

17. Scarabeus, "The California Venus," *Wave*, May 5, 1994.

18. Frank Norris, "A California Artist," *Wave*, February 6, 1897.

19. "The Week in Art," *New York Times*, November 11, 1899.

20. *Mail and Express*, quoted in "A Californian Success," *Wave*, December 9, 1899.

21. Henri Pène du Bois, critique of Peters' exhibition at the Union League, New York, 1899, reprinted in catalogue for exhibition at the Hotel Saint Francis, San Francisco, 1912.

22. *California Art Research Monographs*, 10:86.

23. Arnold Genthe, *As I Remember* (New York: Reynal & Hitchcock, 1936), p. 71.

24. Betty Hoag McGlynn, "Charles Rollo Peters," in *Plein Air Painters of California: The North*, ed. Ruth Lily Westphal (Irvine, CA: Westphal Publishing, 1986), p. 152.

25. Rollo Peters, "My Father: Memoir of His Life and Time," *Monterey Peninsula Herald*, October 29, 1960.

26. Norris, "A California Artist."

27. Bram Dijkstra, "The High Cost of Parasols," *California Light, 1900–1930*, ed. Patricia Trenton and William H. Gerdts (1990; second printing, San Francisco: Bedford Arts, 1991), p. 36.

28. Cornelius, *Keith, Old Master of California*, p. 544.

29. John Tod, "Traveling Companions," *San Francisco Call*, June 13, 1897.

30. Keith to Worcester, Paris, June 25, 1893, Keith Miscellanea; also quoted in part in Cornelius, *Keith, Old Master of California*.

31. "A Parlor Art Talk, Illustrated by Lightning Imitations of Famous Artists," *San Francisco Call*, December 20, 1893.

32. "Mersfelder Benefit," *San Francisco Call*, January 29, 1896.

33. "Paintings like Keith's," *San Francisco Call*, May 1, 1896.

34. "Quality in Pictures," *San Francisco Call*, March 15, 1896.

35. "Paintings like Keith's," *San Francisco Call*, May 1, 1896.

36. "Our Old Master," *Wave*, April 14, 1894.

37. "Paints with His Feet," *San Francisco Call*, January 14, 1890.

38. Letter from Marie Brackenbury to Brother Cornelius, n.d., quoted in *Keith, Old Master of California*, p. 242.

39. Charles Lummis, *Out West*, January 1903.

40. "A California Artist," *Wave*, August 15, 1896.

41. Mary A. Miller, "William Keith, Artist," *Argonaut*, December 12, 1908.

42. Mary Bell, "William Keith," *University of California Magazine*, April 1897.

43. "Keith Goes with Him," *San Francisco Call*, May 15, 1893.

44. Lecture given in the mid-1890s, Cornelius, *Keith, Old Master of California*, p. 271.

45. Ibid. p. 274.
46. *Town Talk*, January 30, 1904.
47. Catalogue for exhibition at the Macbeth Gallery, February 27-March 18, 1893, Keith Miscellanea.
48. *New York Tribune*, March 5, 1893.
49. "Chit-Chat," *Overland Monthly*, February 1898.
50. *Daily News* (London), January 27, 1898, Keith Miscellanea.
51. *California Art Research Monographs*, 2:12.

CHAPTER THIRTEEN

1. Warren Unna, *The Coppa Murals* (San Francisco: Book Club of California, 1952), p. 13.
2. Ibid. p. 54.
3. *Town Talk*, June 16, 1906.
4. Notes on Gelett Burgess by Inez Haynes Irwin, in Gelett Burgess papers (BANC MSS C-H 52), Bancroft Library, University of California, Berkeley.
5. Gelett Burgess, *Behind the Scenes* (San Francisco: Book Club of California, 1968), p. 23.
6. Gelett Burgess, "The Purple Cow," *Lark*, May 1895.
7. "Books and Bookmakers," *San Francisco Call*, August 4, 1895.
8. Burgess, *Behind the Scenes*, p. 24.
9. Burgess, *Behind the Scenes*, p. 19.
10. Unna, *Coppa Murals*, p. 20.
11. "Gelett Burgess in Odd Skins," *San Francisco Call*, May 11, 1897.
12. Gelett Burgess, "The Purple Cow: Suite," *Epilark*, May 1897.
13. "Girl Socialist of San Francisco," *San Francisco Examiner*, October 3, 1897.
14. Unna, *Coppa Murals*, p. 17.
15. Unna, *Coppa Murals*, pp. 8-9.
16. Laura Bride Powers, "California Days Inspire Art," *San Francisco Call*, September 17, 1905.
17. E. Spencer and Constance Macky, "Reminiscences," an oral history conducted by Corinne L. Gilb (BANC MSS C-D 4005), Regional Oral History Office, Bancroft Library, University of California, Berkeley, p.30.
18. Gelett Burgess, *The Heart Line* (Indianapolis: Bobbs-Merrill Co., 1907), p. 140.
19. Laura Bride Powers, "Spring Exhibition to Open on Thursday Night," *San Francisco Call*, March 4, 1906.
20. Laura Bride Powers, "How About a Display of Rejected Canvases," *San Francisco Call*, April 1, 1906.
21. "Grand Opera Stars Arrive," *San Francisco Chronicle*, April 16, 1906.
22. Will Irwin, *The City That Was: A Requiem of Old San Francisco* (New York: B.W. Huebsch, 1906), p. 34.
23. Elsie Whitaker Martinez, *San Francisco Bay Area Writers and Artists* (Berkeley: Regional Oral History Office, 1969), p. 72.
24. Arnold Genthe, *As I Remember* (New York: Reynal & Hitchcock, 1936), p. 89.
25. Louis J. Stellman, "Local Artists Reestablishing Their Colony," *San Francisco Chronicle*, June 30, 1907.
26. Will Irwin, *The City That Was* (1906), p. 7.

NOTES TO ARTISTS' BIOGRAPHIES

1. In the preparation of these biographies, the author has relied largely on Edan Milton Hughes, *Artists in California, 1786-1940*, 2d edition (San Francisco: Hughes Publishing Co., 1989), and Peter Hastings Falk, ed., *Who's Who in American Art* (Madison, CT.: Sound View Press, 1985).

2. Fingal Buchanan, "Art Notes," *San Franciscan*, November 21, 1885.

3. Paul J.Karlstrom, "The Short, Hard, and Tragic Life of Henry Alexander," *Smithsonian*, March 1982.

4. Quoted on book jacket of *Albert Bierstadt: Art & Enterprise*, by Nancy K. Anderson and Linda S. Ferber (Hudson Hills Press, New York, in association with the Brooklyn Museum, 1990).

5. Alfred Frankenstein, *After the Hunt: William Harnett and Other American Still Life Painters, 1870–1900* (Berkeley: University of California Press, 1953), p. 148.

6. Arthur Edwin Bye, *Pots and Pans Or Studies in Still-Life Painting* (Princeton, NJ: Princeton University Press, 1921), p.213.

7. "Death of an Artist," *San Francisco Bulletin*, October 8, 1886.

8. Gene Hailey, ed., *California Art Research Monographs* (San Francisco, Works Progress Administration, 1937), 8:17.

9. "Men We Know," *San Francisco News Letter and California Advertiser*, March 8, 1879.

10. George W. Neubert, preface to *Thomas Hill: The Grand View*, by Marjorie Dakin Arkelian (Oakland, CA: The Oakland Museum Art Department, 1980), p. 7.

11. "Artist Holdredge Dies a Pauper," *San Francisco Call*, April 16, 1899.

12. Alfred Frankenstein, "California Art — Of Ships and Towns and Mountain Splendor," *San Francisco Chronicle*, October 5, 1969.

13. Fingal Buchanan, "The Arts," *San Franciscan*, June 20, 1885.

14. Quoted in Harvey L. Jones, Mathews: *Masterpieces of the California Decorative Style* (Layton, UT: Gibbs M. Smith, Inc., Peregrine Smith Books in association with the Oakland Museum, 1985), p. 92.

15. "A Pathetic Case," *San Francisco Call*, January 28, 1894.

16. Robert Nichols Ewing, "Jules Tavernier (1844-1889): Painter and Illustrator" (Ph.D. diss., University of California, Los Angeles, 1978), p. 231.

17. Joseph Armstrong Baird, Jr., introduction to *Theodore Wores and the Beginnings of Internationalism in Northern California Painting: 1874–1915* (Library Associates, University Library, University of California, Davis, 1878), p. 2; courtesy Special Collections Department, University of California, University Library, Davis.

18. "Successful Fred Yates," *San Francisco Call*, December 22, 1895.

BIBLIOGRAPHY

(sources consulted other than those mentioned in the notes)

BOOKS

Albronda, Mildred. *Douglas Tilden: The Man and His Legacy*. Seattle, WA: Emerald Point Press, 1994.

Arkelian, Marjorie. *The Kahn Collection of Nineteenth-Century Paintings by Artists in California*. Oakland, CA: The Oakland Museum, Art Department, 1975.

Arkman, Duncan, ed. *Taming of the Frontier*. New York: Minton, Balch & Company, 1925.

Atherton, Gertrude. *Ancestors*. 2 vols. Leipzig: Bernard Tauchnitz, 1908.

Austin, Mary. *Earth Horizon*. Cambridge, MA: Riverside Press, 1932.

Baur, John I.H. *American Painting in the Nineteenth Century. Main Trends and Movements*. New York: Frederick A. Praeger, 1953.

_____. *Revolution and Tradition in Modern American Art*. 1951. Reprint, New York: Frederick A. Praeger, 1967.

Bean, Walton. *California. An Interpretive History*. New York: McGraw-Hill, 1968.

Beaufort, Madeleine Fidell, and Herbert L. Kleinfield and Jeanne K. Welcher, eds. *Diaries 1871–1882 of Samuel P. Avery, Art Dealer*. New York: Arno Press, 1979.

Born, Wolfgang. *American Landscape Painting*. New Haven: Yale University Press, 1948.

Bosqui, Edward. *Memoirs*. San Francisco, 1904.

Brinton, Christian. *Impressions of the Art at the Panama-Pacific Exposition*. New York: John Lane Co., 1916.

Champlin, John Denison Jr., ed. *Cyclopedia of Painters and Paintings*. 4 vols. 1885. Reprint, New York: Charles Scribner's Sons, 1887.

Clement, Clara Erskine. *Women in the Fine Arts*. Boston and New York: Houghton, Mifflin and Co., 1904.

Combs, Barry B. *Westward to Promontory*. Palo Alto, CA: American West Publishing Co., 1969.

Constable, William G. *Art Collecting in the United States of America*. London: Thomas Nelson and Sons Ltd., 1964.

Dana, Julian. *The Man Who Built San Francisco — a Study of Ralston's Journey with Banner*. New York: The Macmillan Publishing Co., 1937.

Dickason, David Howard. *The Daring Young Men: The Story of the American Pre-Raphaelites*. Bloomington: Indiana University Press, 1953.

Editors of Art in America, comps. *The Artist in America*. New York: W.W. Norton & Co., Inc., 1967.

Ferlinghetti, Lawrence, and Nancy Peters. *Literary San Francisco: A Pictorial History from Its Beginnings to the Present Day*. San Francisco: City Lights Books and Harper & Row, 1980.

Finke, Ulrich. *German Painting from Romanticism to Expressionism*. Boulder, CO: Westview Press, 1974.

Fisher, Anne B. *No More a Stranger*. Palo Alto, CA: Stanford University Press, 1946.

Flayderman, Harry. *Henry Raschen, Painter of the American West*. Privately printed, n.p., 1958.

Flexner, James Thomas. *That Wilder Image: The Paintings of America's Native School from Thomas Cole to Winslow Homer*. Boston and Toronto: Little, Brown and Co., 1962.

Gerdts, William H. *American Impressionism*. New York: Abbeville Press, 1984.

————. *Art Across America. Two Centuries of Regional Painting*, 1710-1920. Vol. 3. New York: Abbeville Press, 1990.

————. *The Great American Nude*. New York and Washington: Praeger Publishers, 1974.

Gimpel, Jean. *The Cult of Art: Against Art and Artists*. New York: Stein and Day, 1969.

Glasscock, Carl B. *Lucky Baldwin: The Story of an Unconventional Success*. Indianapolis: The Bobbs-Merrill Company, 1933.

Goodwin, Charles C. *As I Remember Them*. Salt Lake City: Salt Lade Commercial Club, 1913.

Graham, F. Lanier. *Three Centuries of American Painting*. San Francisco: M.H. de Young Memorial Museum and the California Palace of the Legion of Honor, 1971.

Greer, Germaine. *The Obstacle Race*. New York: Farrar Straus Giroux, 1979.

Guerard, Albert L. *Art for Art's Sake*. 1936. Reprint, New York: Schocken, 1963.

Hansen, Gladys C., and Emett Condon. *Denial of Disaster, the Untold Story and Photographs of the San Francisco Earthquake and Fire of 1906*. San Francisco: Cameron and Company, 1989.

Harris, Neil. *The Artist in American Society: The Formative Years, 1790–1860*. New York: George Braziller, 1966.

Hart, James D. *A Companion to California*. New York: Oxford University Press, 1978.

Hart, Jerome A. *In Our Second Century: From an Editor's Note-Book*. San Francisco: Pioneer Press, 1931.

Haywood, Ian. *Faking It: Art and the Politic of Forgery*. New York: St. Martin's Press, 1987.

Heermann, Norbert. *Frank Duveneck*. Boston and New York: Houghton Mifflin, 1918.

Heyneman, Julie. *Desert Cactus, the Portrait of a Sculptor*. London: Geoffrey Bles, 1934.

Hittell, John S. *A History of the City of San Francisco and Incidentally of the State of California*. San Francisco: A.L. Bancroft, 1878.

Honour, Hugh, and John Fleming. *The Visual Arts: A History*. Englewood Cliffs, NJ: Prentice-Hall Inc., 1982.

Hyde, George E. *Red Cloud's Folk: A History of the Oglala Sioux Indians*. Norman, OK: University of Oklahoma Press, 1937.

Issler, Anne Roller. *Happier for His Presence*. Palo Alto, CA: Stanford University Press, 1948.

Jones, Idwal. *Ark of Empire*. New York: Doubleday & Co., 1951.

_____. "Retrospective of Bohemia." In *The Taming of the Frontier by Ten Authors*. Ed. Duncan Aikman. New York: Minton, Balch & Co., 1925.

_____. *Vines in the Sun*. New York. W. Morrow, 1949.

Koehler, Sylvester R. *American Art*. New York: Cassell & Co., 1886. Reprint, with an introduction by H. Barbara Weinberg, New York: Garland Publishing Co., 1978.

Kronenberger, Louis. *Company Manners: A Cultural Inquiry into American Life*. 1951. Reprint, Indianapolis and New York: Bobbs-Merrill Co., Inc., 1954.

Kurz, Otto. *Fakes*. New York: Dover Publications, 1848.

LaFollette, Suzanne. *Art in America*. New York and London: Harper & Brothers, 1929.

Larkin, Oliver W. *Art and Life in America*. New York: Rinehart V. Co., Inc., 1949.

Leider, Emily Wortis. *California's Daughter: Gertrude Atherton and Her Times*. Stanford, CA: Stanford University Press, 1991.

Lewis, Lloyd, and Henry Justin Smith. *Oscar Wilde Discovers America*. New York: Harcourt, Brace, & Co. 1936. Reprint, New York: Benjamin Blom, 1967.

Lewis, Oscar. *Bay Window Bohemia: An Account of the Brilliant Artistic World of Gaslit San Francisco*. New York: Doubleday & Co., 1956.

————. *San Francisco: Mission to Metropolis*. 1966. Reprint, San Diego: Howell North Books, 1980.

Lewis, Oscar, and Carroll D. Hall. *Bonanza Inn: America's First Luxury Hotel*. 1939. 8th printing, New York: Alfred A. Knopf, 1959.

Lloyd, Benjamin E. *Lights and Shades in San Francisco*. San Francisco: A.L. Bancroft and Co., 1876.

Lucas, George A. *An American Art Agent in Paris, 1857–1909*. Princeton, NJ: Princeton University Press, 1979.

Lynes, Russell. *The Art-Makers of Nineteenth-Century America*. New York: Atheneum, 1970.

————. *The Tastemakers*. New York: Harper & Brothers, 1954.

Manthorne, Katherine Emma. *Tropical Renaissance: North American Artists Exploring Latin America, 1839–1879*. Washington, DC and London: Smithsonian Institution Press, 1989.

McLanathan, Richard. *The American Tradition in the Arts*. New York: Harcourt, Brace & World, Inc., 1968.

Millard, Bailey. *History of the San Francisco Bay Region*. San Francisco: The American Historical Society, 1924.

Morgan, Wayne H. *New Muses: Art in American Culture, 1865–1920*. Norman, OK: University of Oklahoma Press, 1978.

Mumford, Lewis. *The Brown Decades: A Study of the Arts in America 1865–1895*. 1931. 2d revised edition, New York: Dover Publications, Inc., 1955.

Muscatine, Doris. *Old San Francisco: The Biography of a City from Early Days to the Earthquake*. New York: G.P. Putnam's Sons, 1975.

Neuhaus, Eugen. *History and Ideals of American Art*. Palo Alto, CA: Stanford University Press, 1931.

————. *Painters, Pictures and the People*. San Francisco: Philopolis Press, 1918.

————. *World of Art*. 1924. Reprint, New York: Harcourt, Brace and Co., 1936.

Novak, Barbara. *Nature and Culture: American Landscape Painting, 1825–1875*. New York: Oxford University Press, 1980.

O'Brien, Robert. *This is San Francisco*. New York and Toronto: McGraw-Hill Book Co., Inc., 1948.

Orr-Cahall, Christina, ed. *The Art of California, Selected Works from the Collection of the Oakland Museum.* Oakland, CA: The Oakland Museum Art Department and Chronicle Books, 1984.

Parry, Albert. *Garrets and Pretenders: A History of Bohemianism in America.* 1933. Revised edition, New York: Dover Publications, 1960.

Pevsner, Nikolaus. *Academies of Art, Past and Present.* Cambridge: Cambridge University Press, 1940.

Powers, Laura Bride. *Old Monterey.* San Francisco: San Carlos Press, 1934.

Redding, B.B. *A Sketch of the Life of Mark Hopkins of California.* San Francisco: Bancroft & Co., 1881.

Richardson. Edgar P. *Painting in America.* 1956. Reprint, New York: Thomas Y. Crowell Co., 1965.

Robertson, David. *West of Eden: A History of the Art and Literature of Yosemite.* San Francisco: Yosemite Natural History Association and Wilderness Press, 1984.

Rubinstein, Charlotte Streifer. *American Women Artists from Early Indian Times to the Present.* Boston: Avon, 1982.

Saarinen, Aline B. *The Proud Possessors.* New York: Random House, 1958.

Sears, Clara Endicott. *Highlights Among the Hudson River Artists.* Boston: Houghton Mifflin Co., 1947.

Seigel, Jerrold. *Bohemian Paris: Culture, Politics and the Boundaries of Bourgeois Life, 1830–1930.* New York: Elisabeth Sifton Books (Viking), 1986.

Sheldon, George William. *Recent Ideals of American Art.* D. Appleton, New York, c. 1888. Reprint, with an introduction by H. Barbara Weinberg, New York and London: Garland Publishing Co., 1977.

Shinn, Earl. Art *Treasures of America.* Vol. 2. Philadelphia: George Barrie, 1880.

Starr, Kevin. *Americans and the California Dream, 1850–1915.* New York: Oxford University Press, 1973.

Taft, Robert. *Artists and Illustrators of the Old West, 1850–1900.* New York: Charles Scribner's Sons, 1953.

Taylor, Frank J. *Land of Homes.* Los Angeles: Powell, 1929.

Taylor, Joshua C. *The Fine Arts in America.* Chicago and London: University of Chicago Press, 1979.

Tilton, Cecil G. *William Chapman Ralston: Courageous Builder.* Boston: The Christopher Publishing House, 1935.

Tippett, Maria. *Emily Carr.* Ontario: Oxford University Press, 1979.

Tuckermann, Henry Theodore. *Book of the Artists*. 1867. Reprint, New York: J.F. Carr, 1966.

Tyler, Sidney. *A Full Account of the Recent Terrible Destruction of Life and Property by Earthquake, Fire and Volcano*. Harrisburg, PA: Minter Co., 1906.

Walker, Franklin. *San Francisco's Literary Frontier*. 1939. Reprint, with a new introduction by the author, Seattle, WA and London: University of Washington Press, 1969.

Van Dyke, John C. *Art for Art's Sake: Seven University Lectures on the Technical Beauties of Painting*. New York: Charles Scribner's Sons, 1893.

Weimann, Jeanne Madeline. *The Fair Women*. Chicago: Academy Chicago, 1981.

Weintraub, Stanley. *London Yankees: Portraits of American Writers and Artists in England, 1894–1914*. New York: Harcourt Brace Jovanovich, 1979.

————. *Beardsley*. New York: George Braziller, 1967.

Wheeler, Keith. *The Railroaders*. New York: Time-Life Books, 1973.

Wilson, Carol Green. *Gump's Treasure Trade*. New York: Thomas Y. Crowell Co., 1949.

Wilson, James Russel. *San Francisco's Horror of Earthquake and Fire. Terrible Devastation and Heart-Rending Scenes*. Philadelphia: Percival Supply Co., 1906.

EXHIBITION CATALOGUES

Art Union Catalogue. San Francisco: Wade & Co., Steam Book and Job Printers, c. 1865.

Arkelian, Marjorie Dakin. *William Hahn, Genre Painter 1829–1887*. Oakland, CA: The Oakland Museum Art Department, 1976.

The Art of Emil Carlsen. Introduction by Catherine Hoover. San Francisco: Rubicon-Wortsman Row Publications, 1975.

Baird, Joseph Armstrong. *Samuel Marsden Brookes*. Contributions by Lucy Agar Marshall and Lewis Ferbraché. San Francisco: California Historical Society, 1962.

Bermingham, Peter. *American Art in the Barbizon Mood*. Washington DC: published for the National Collection of Fine Arts by the Smithsonian Institution Press, 1975.

Andersen, Timothy J., and Eudorah M. Moore and Robert W. Winter, eds. *California Design 1910*. Pasadena, CA: California Design Publications, 1974.

Corn, Wanda. *The Color of Mood: American Tonalism, 1880–1910*. San Francisco: M.H. de Young Memorial Museum and the California Palace of the Legion of Honor, 1972.

Driesbach, Janice T. *Bountiful Harvest: 19th-Century California Still Life Painting*. Sacramento: Crocker Art Museum, 1991.

————. *Direct from Nature: The Oil Sketches of Thomas Hill*. Sacramento: Yosemite Association and the Crocker Art Museum, 1997.

Harrison, Alfred C. *William Keith*. Moraga, CA: Hearst Art Gallery, Saint Mary's College of California, 1988.

Impressionism: The California View. Introduction by Harvey L. Jones, with essays by John Caldwell and Terry St. John. Oakland, CA: Oakland Museum Art Department, 1981.

Jones, Harvey L. *Twilight and Reverie: California Tonalist Painting 1890–1930*. Oakland, CA: Oakland Museum, 1995.

Loan Exhibition for Maria Kip Orphanage, March 1891.

Neubert, George W. *Xavier Martinez*. Oakland, CA: The Oakland Museum Art Department, 1974.

Paintings by Jules Mersfelder, exhibited at his studio on 220 Post Street, San Francisco, 1914.

Paintings by Toby Rosenthal, exhibited at the San Francisco Art Association, 1884.

Seavey, Kent L. *Charles Dormon Robinson*. San Francisco: California Historical Society, 1966.

_____. *Raymond Dabb Yelland*. San Francisco: California Historical Society, 1964.

West, Richard V. *Munich & American Realism in the 19th Century*. Essays by Michael Quick and Eberhard Ruhmer. Sacramento: E.B. Crocker Art Gallery, 1978.

DISSERTATION

Aloysius, George Weimer. "The Munich Period in American Art." Ph.D. dissertation. Ann Arbor, MI: University of Michigan, 1940.

ARTICLES

Avery, Benjamin Parke. "Art Beginnings on the Pacific." *Overland Monthly*, July and August, 1868.

Beaufort, Madeleine Fidell, and Jeanne K. Welcher. "Some Views of Art Buying in New York in the 1870s and 1880s." *Oxford Art Journal* 5, No. 1 (1982).

Buchanan, Agnes Foster. "The Story of a Famous Fraternity of Writers and Artists." *Pacific Monthly*, January 1907.

Emerson, Edwin Jr. "San Francisco at Play." *Sunset*, October 1906.

Fink, Lois Marie. "American Artists in France, 1850-1870." *American Art Journal* 5, No. 2 (November 1973).

_____. "The Innovation of Tradition in Late Nineteenth-Century American Art." *American Art Journal* 10, No. 2 (November 1978).

_____. "19th Century Evolutionary Art." *American Art Review* 4, No. 4 (January 1978).

George, Hardy. "Thomas Hill's 'Driving of the Last Spike,' a Painting Commemorating the Completion of America's Transcontinental Railroad." *Art Quarterly* 27, No. 1 (Spring 1964).

Griswold, Mary Edith. "A Corner in Bohemia." *Western World* 2, No. 17 (August 24, 1907).

Harris, Neil. "The Gilded Age Reconsidered Once Again." *Archives of American Art Journal* 23, No. 4 (1983).

Meservey, Anne Farmer. "The Role of Art in American Life: Critics' Views on Native Art and Literature, 1830-1865." *American Art Journal* 10, No. 1 (May 1978).

Nathan, Marvin R. "San Francisco's *Fin de Siècle*: Bohemian Renaissance." *California History* 61, No. 3 (Fall 1982).

Novak, Barbara. "American Impressionism." *Portfolio* 4, No. 2 (March/April 1982).

_____. "Some American Words: Basic Aesthetic Guidelines, 1825–1870." *American Art Journal* 1, No. 1 (Spring 1969).

Thayer, Donald R. "Early Anatomy Instruction at the National Academy: The Tradition Behind It." *American Art Journal* 8, No. 1 (May 1976).

Troyen, Carol. "Innocents Abroad: American Painters at the 1867 Exposition Universelle, Paris." *American Art Journal* 16, No. 4 (Autumn 1984).

MISCELLANEOUS

Hill McCullough, Flora. "Memoirs of Mr. Thomas Hill, California Landscape Artist," 1962. Yosemite Research Library, Yosemite.

Minutes Book for the San Francisco Art Association, March 21, 1871 - August 29, 1889. Collections of the San Francisco Art Institute.

Robinson, Lillian M. "Personal Letters Regarding Father's Life and Work," 1943. Yosemite Research Library, Yosemite.

INDEX

First Printing

Published in the United States of America 1999

Design by Kurt Hauser
Imaging and production by Navigator Press, Pasadena, California
Printed in Hong Kong
No part of this book may be reproduced in any manner without written
 permission except in the case of brief quotations embodied in
 critical articles and reviews. For information, Balcony Press,
 512 E. Wilson, Suite 306, Glendale, California 91206

Artful Players: Artistic Life in Early San Francisco
 © 1999 Birgitta Hjalmarson

Library of Congress Catalog Card Number: 98-073447

ISBN 1-890449-01-6